# American Artists

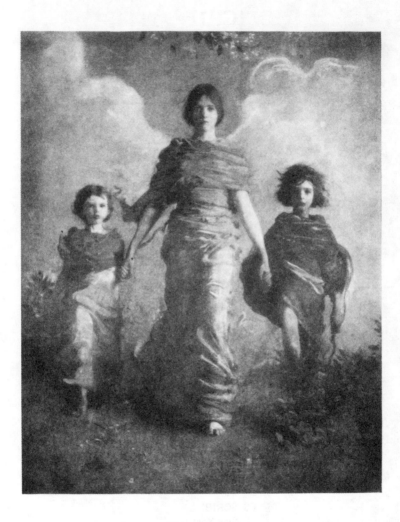

THE VIRGIN

BY ABBOTT H. THAYER

# American Artists

## By Royal Cortissoz

*Essay Index Reprint Series*

*Originally Published by*
CHARLES SCRIBNER'S SONS
New York
1923

 BOOKS FOR LIBRARIES PRESS
FREEPORT, NEW YORK

First Published 1923
Reprinted 1970

INTERNATIONAL STANDARD BOOK NUMBER:

0-8369-1825-8

LIBRARY OF CONGRESS CATALOG CARD NUMBER:

74-128228

PRINTED IN THE UNITED STATES OF AMERICA

# Preface

American art flows not from tradition but, in a
specially marked sense, from the individuality of the
artist.  The men who have played a constructive part
in the building up of our school have in many cases
received their training abroad, but have used it in a
fresh, very personal manner.  It is in appreciation of
some of these men that the following pages have been
composed; in some cases to recall figures not always
remembered at the present day.  My chapters have
been written on various occasions.  I hope, however,
that they have the unity which should come from
years of faithful study of American art and from
whole-hearted delight in the manifestations of its
genius.

<div style="text-align: right">ROYAL CORTISSOZ.</div>

NEW YORK,
    August 20th, 1923.

# Contents

# Illustrations

# Illustrations

# American Artists

# I

# A Critic's Point of View

15

# I

# A CRITIC'S POINT OF VIEW

## I

## ON BEAUTY

*AT a time when the principles of art are much in de-*
*bate and long-accepted rules of æsthetic conduct are*
*assailed as played out, it is proper that the critic should*
*stand up to be counted. He should affirm unequivocally*
*the position he takes, whether it is on the side of con-*
*servatism or on that of radicalism — both rather loose*
*designations but serviceable enough for the present pur-*
*pose. I am a conservative. I believe that through all*
*the mutations of schools and traditions, for many cen-*
*turies, art has recognized the validity of certain funda-*
*mental laws. I believe in the art that is faithful to those*
*laws, that means a sane vision of nature and an honest*
*craftsmanship. I disbelieve in modernism because it*
*seems to me to flout fundamental laws and to repudiate*
*what I take to be the function of art, the creation of*
*beauty. If modernism has anything legitimate to sub-*
*stitute for the experience of the past it is under obliga-*
*tion to make a convincing demonstration; the burden*
*of proof rests with the innovators. I have been watch-*

3

*ing these innovators closely ever since they began, the Post-Impressionists, the Futurists, the Cubists, the Expressionists, the whole variegated company, and, though a conservative, I have watched them with an eye single to the detection of the first glimmer of a rational substitution of new lamps for old. Save in some of the aspects of Post-Impressionism I have observed no sign.*

*I am aware of the opening I give to the reader of modernistic sympathies. He must promptly ask me to define the laws to which I have referred, to define beauty. Something of what I have to say about these subjects may be found, I hope, explicitly and implicitly stated throughout this collection of essays. But as a more or less formulated expression of my convictions I venture to reprint here some remarks invited by my friend and colleague the late Henry Edward Krehbiel. Through his long career as the musical critic of the New York Tribune he fought for a high ideal of art, repelling every movement in the concert-room or opera-house threatening the noble traditions to which he was dedicated. Once, in the winter of 1922, he unburdened his soul in an open letter to me setting forth some of the changes — especially those of an operatic nature — which violated his sacred canons. He wanted sympathy from one whom he knew, from many years of association on the same journal, was fully in accord with him. I wrote the reply which appears below. It contains allusions to matters having, no doubt, little to do with the arts of painting, sculpture, and architecture as they are understood outside of*

*the theatre. But I let them stand as apposite to the broad theme of our discussion, the theme of beauty. I place the letter here as in some sort a profession of faith, embodying the point of view from which I have endeavored to write everything in this book.*

MY DEAR KREHBIEL: Your delightful letter on the bewilderments of the stage-settings at the opera-house requires, you say, no answer. But you ask for sympathy and think that possibly some readers may share in the interest which we both have in this subject. Moreover, through the sad, disillusionizing experiences of which you speak you preserve intact a certain delicately mischievous sense of humor. Confess now, was it not with something like a chuckle that you indited your remarks to a man headed, as you perfectly well knew, only a few days before, toward a performance of "Tristan" illumined by Mr. Urban's magical touch? A fellow-feeling surely makes us wondrous kind. In this case it urges me to be sympathetically articulate. I wrote to you about that extraordinary set last winter. Mercifully I had forgotten all about it and unmercifully it revealed itself again with only the more painful effect after a year's oblivion. The after-deck in the first act might have been extracted from a saga, but the doodads amidships, where the action goes on, still smote my eyes as with the exotic garishness of an Oriental bazaar. The beetling tenement in the sec-

ond act still resembles a modern house of the sky-scraping order, and in the last act I was reminded once more of the kind of masonry affected by our railroad engineers. It was, indeed, as though time had stood still and I was back at my initiation into this latter-day version of a classic. The Isolde was nothing if not the radiant prima donna — where our beloved Lilli Lehman, so many years ago, was content to be Isolde.

And then you talk of intercession with the gods! How shall I respond, I who have also been in this stony, arid Arcadia and have winced as you have winced? You ask for sympathy, for comfort. Well, when you are hurt there is comfort, sometimes, in examining into what hurt you. I have been doing this for years, ever since the scenic incongruities and crudities of which you speak came into my view, trying to find out what it was that hurt. I have concluded that it was the tendency of the stage-designer to see differently rather than to see beautifully. There was, let us admit, a certain amount of excess upholstery about the sets with which Daly and Henry Irving used to fill the eye. In the reaction against it a quantity of furniture was bound to be thrown overboard — though I wonder how many of us would assert, hand on heart, that it really destroyed the illusion sought by those astute builders of theatrical pictures. Still, the surplusage had to go. I never mourned it. But I thought I perceived only a doubt-

ful substitute for it in the elaborately organized simplicity which began with Gordon Craig.

You can't get simplicity, the kind of simplicity that is beautiful, by taking thought. It must arise from the central spring of your inspiration and be a habit of mind; it is of the soul of things, not of their dress. Landor has a word for the literary man here which is equally apposite for the artist. "Never try to say things admirably," he observes; "try only to say them plainly." The new school of "simplicity" never went in for saying things plainly; it strove more often to be admirable, different, new. There has been for me a kind of morbid fascination about the numerous models for stage-settings I have seen. Nominally they have over and over again plumped for simplicity, with a great play of tremendously emphasized horizontal and vertical lines. Actually they have been labored, self-conscious to the last degree. And yet if you are looking for comfort, there is a little to be found in the occasional success of this very school. There have been times in its search for the admirable, the different, the new, when it has hit felicitously upon all three.

I remember when Granville Barker was producing some plays in New York he invited me to see a few of them and I studied especially their scenery. There was a piece, "The Man Who Married a Dumb Wife," with an investiture possessing a charm that still lingers in my memory. It was designed, I think,

by Mr. Robert Edmond Jones, who keeps the dramatic critics so busy, now lifting them to Elysium and now bowling them as low as to the fiends. He was perfect in that piece. He knew all about the simplicity dodge, but he didn't handle it like a conjurer taking a rabbit out of a hat. On the contrary, the skilful arrangement of line which marked his design was the most natural thing in the world; it just happened, arising out of the genius of the little play. Illusion was there. Shortly afterward Barker made a production of "Midsummer Night's Dream" in which the filmy loveliness of that drama was torn and tattered as by bungling hands. What was the cause of the difference between the attacks made upon the two problems? One was seen beautifully, the other was not.

I am not tantalizing you with a phrase, Krehbiel. I am referring you to a fact. Come over to my bailiwick and see. Observe the Italians of the Renaissance. They saw life beautifully, exquisitely. You feel it in the draftsmanship of one of Leonardo's cartoons of a hideous peasant as vividly as you feel it in a Madonna by Raphael. Subject has nothing to do with it. In eighteenth-century France, Chardin saw a scullery maid as beautifully as Watteau saw the frou-frou of courtliness he embarked for enchanted Cytherea. Look at Rembrandt, who, as Whistler said, "saw picturesque grandeur and noble dignity in the Jews' quarter of Amsterdam, and la-

mented not that its inhabitants were not Greeks."
There is nothing in the Metropolitan Museum more
beautiful than Rembrandt's "Old Woman Cutting
Her Nails," a disgusting subject made sublime be-
cause he saw it beautifully. There is nothing to be
formulated about this process. One must simply
attribute it to the creative impulse of the true artist,
transmogrifying what he touches. In the glow and
action of his genius he sees and feels with a super-
natural intensity and the rapture of his vision passes
into what he does. It thus operates in all the arts.
With patience and humility I read a book like "Bab-
bitt," wondering what all the fuss is about. What
distresses me is not the genial Babbitt himself. I
am willing to swallow him whole, willing to believe
that the country is fairly slopping over with Babbitts.
It is the author, as artist, who beats me. He records
his facts with the æsthetic emotion of a man com-
piling a telephone book. Think of what Balzac
would have done with it, Balzac describing a mouldy
wall until you feel that Ver Meer might have painted
it! Balzac sees beautifully

I've been looking at a bundle of photographs from
the scenery painted not long ago for "The Ring," at
the Prinzregenten Theatre in Munich. Lothar Weber
painted it after designs by Leo Pasetti and Adolph
Linnebach. Studied side by side with photographs
of the old scenes, some of these recent effects seem
amazing improvements. They give you symbolical

line and mass in place of old-fashioned florid realism.
Color, I am told by the friend who lends me the pho-
tographs, does not count nearly as much as form,
and often gauze curtains are used still further to
mitigate the tone. The lighting, as is inevitable
nowadays, counts enormously. I infer that if the
scenes come off it is because the simplicity in them
is not too self-consciously organized, and illusion is
created in terms harmonious with the character of
the drama. In poetry, we are told, the illusion is
everything. Is it not so on the stage? That was
the great source of Monroe Hewlett's success when
he made the scenes for "Iphigenia" at the Metro-
politan in 1916. Don't you remember the Homeric
background he gave us for the first act and the tem-
ple scene in the second, how faithful they were to the
spirit of "Iphigenia" — and of Gluck? His scenery
didn't fence in the action, it sympathetically envel-
oped it. I don't know or care whether Hewlett
turned archæologist or not for that enterprise —
toward which, as I understand, Mr. Otto Kahn and
Mr. Gatti-Casazza bent their energies with a view
to the encouragement of American art in the theatre.
I only know that the problem was beautifully seen.

Isn't there consolation in the episode? The opera-
house has its happy moments. Set the "Iphigenia"
against the huge bonded warehouse of stone which
was erected on the stage when Mahler took "Fi-
delio" in hand. Set the delightfully picturesque

"Boris" against the deplorable "Tristan." And set
against all the discouraging things the profound
truth that beauty sooner or later has its way. Says
Andrew Lang:

"There stand two vessels by the golden throne of Zeus,
    on high —
From these he scatters mirth and scatters moan to men
    that die."

Take the mirth and let the moan go. The taw-
driest of settings passes at long last to the scrap-heap.
Whistler knew, and I must quote him again: "We
have then but to wait until — with the mark of the
gods upon him — there comes among us again the
chosen who shall continue what has gone before.
Satisfied that, even were he never to appear, the
story of the beautiful is already complete — hewn
in the marbles of the Parthenon — and broidered,
with the birds, upon the fan of Hokusai — at the
foot of Fusiyama."

Who shall continue what has gone before! I love
that saying. In art there is, spiritually speaking,
no such thing as the past. Chronology is largely a
matter of conversational convenience. The master-
pieces of antiquity are preserved, immobile, in the
rooms of a museum, with dates over the door, but it
is a mistake to think of them as held, in time, in a
kind of atrophy, within airless, water-tight compart-
ments. They are, rather, like the waves of the sea,

that only seem to die as they go on endlessly repro-
ducing themselves, responsive to some ground swell
of divine energy come straight from Olympus. What
a dateless thing is beauty!

I felt this conviction anew the other day when I
went to Duveen's and saw some marvellous old
Italian portraits. There was a curious young bulbous-
browed princess by Pisanello, her impertinent nose
tilted against a background of pure color. Her prim
shoulders were swathed in blue and gold. She was a
little absurd and altogether magnificent — Pisanello
had seen her so beautifully. Then there was the
portrait of a boy by Boltraffio, as realistic as though
it had been painted in the modern world, but fairly
tremulous with the sweetness of the Leonardesque
tradition. Finally came a relief in gray marble by
Desiderio da Settignano, the portrait of some Floren-
tine lady of the fifteenth century. It is a supreme
jewel. The profile is angelically drawn. The face
and throat are modelled in a way to make the modu-
lations of Rodin seem mere superficial virtuosity.
The highest quality of design is in the hair and drap-
ery, not a touch without its subtle eloquence. Musing
before it, I realized this dateless, ever-living beauty
which I commend to you for comfort. It is not a
remote, metaphysical thing. It is as poignantly di-
rect in its touch upon one's consciousness as the taste
of cold water on a burning day. It sprang into
existence under Desiderio's fingers nearly five hun-

dred years ago, and you apprehend it to-day in all
its tingling freshness.  What a portentous vitality it
has!  How actively it counts in the great stream of
beauty that, with the priestlike waters of Keats,
keeps up the task of "pure ablution 'round earth's
human shores."  Says Cleopatra:

> "Bring me my robe, put on my crown,
>   I have immortal longings in me."

The words might have been uttered for all man-
kind.  Our immortal longings are imperious and in
the long run they are satisfied.  Beauty is an ele-
ment, and we must breathe it, like air, else we perish.
"Art," said Blake, "is a means of conversing with
Paradise."  And, since art never dies, why worry
about the passing vagaries of the tactless, egotistic
scene-painter?  You have, too, you of all men, a re-
source on which, in your letter, you touch yourself,
when you allude to the old days in which we let the
music warm our imaginations to such a point that
we forgot or ignored the exasperation latent in a
stage-setting.  Apropos, Mr. Louis N. Parker, the
playwright, whose experience peculiarly qualifies him,
has lately supplied some comfort for you which I
may cite.  After thirty years of devout attendance
upon the performances at Bayreuth he has been
looking back upon them in cold blood, asking and
answering, in "The Golden Hind," some pointed
questions.  Were those performances ideal, were

poem, music, scenery, singing, acting, really so blended as to form a single composite art, as they claimed to be? Alas! he replies, they were not. Could the text be heard better at Bayreuth than elsewhere? No. Were the performers ideal? No. Was the scenery always right? No. He tries to be charitable about the personalities of the singers. "They were as God and a generous diet had made them." He speaks of "podgy Parsifals, perspiring Tristans, globular Iseults, matronly Brunhilds." You see, he, too, has needed comfort. But for him, as for you, the music remains:

"Wagner was first and last, and continuously, the greatest dramatic composer the world has yet seen. He was so great a dramatic music-maker that his music stands as dramatic music without the aid of the drama. Knock all the scaffolding away, take away the stage, the actors, the scenery, even the words, and the music remains, the finest expression of drama. The most perfect performance of Wagner to which you can treat yourself is to read a full score by the side of your hearth; the next best is to listen to a magnificent orchestra without any stage accessories. . . . What magic lantern can add to the effect of the 'Ride of the Valkyries'? What need of silk ribbon fluttering to an electric fan to intensify Brunhild's 'Ring of Fire'? . . . That, I think, is what remains of Wagner, and will remain: music— extraordinarily eloquent, amazingly pictorial, some-

times terrible, sometimes overwhelmingly lovely, always great."

There you have your comfort, heaped up and running over. For the rest, when scene-painters nevertheless annoy, there is nothing like the thought of their impermanence, nothing like holding fast to the gospel of beauty and "conversing with Paradise." Reading the poets is sustaining. So is Plato. You will recall Doctor Johnson and the country squire whom he interrogated as to his philosophical studies. They were progressing very well, but, somehow, "cheerfulness was always breaking in." Plato is your man when you cannot away with the vagaries of the opera-house. He brings both wisdom and cheerfulness. When he contemplates his "vast sea of beauty" he gives you a comfort that shall wipe out the last stain of impossible growths in the Theban desert of "Thais" or of your "vernal zephyr," behaving in "Die Walküre" like a charge of dynamite. That is a glorious passage in the "Symposium," in which Socrates, reporting the words of the sibyl of Mantineia, rises through the graduations of beauty as in some impassioned dithyramb until he reaches the highest inspiration of all. He concludes:

"This is that life above all others which man should live, in the contemplation of beauty absolute; a beauty which if you once beheld, you would see not to be after the measure of gold and garments and

fair boys and youths, whose presence now entrances
you; and you and many a one would be content to
live, seeing them only and conversing with them
without meat or drink, if that were possible — you
only want to look at them and be with them.  But
what if man had eyes to see the true beauty — the
divine beauty, I mean, pure and clear and unalloyed,
not clogged with the pollutions of mortality and all
the colors and vanities of human life — thither look-
ing, and holding converse with the true beauty sim-
ple and divine?  Remember how in that communion
only, beholding beauty with the eye of the mind, he
will be able to bring forth, not images of beauty, but
realities (for he has hold not of an image but of a
reality), and bringing forth and nourishing true virtue
to become the friend of God and be immortal, if
mortal man may.  Would that be an ignoble life?"

He talks of "beauty absolute, separate, simple,
and everlasting, which without diminution and with-
out increase, or any change, is imparted to the ever-
growing and perishing beauties of all other things."
Even stage-settings, I would dare swear.  Why not?
It is a tall order, to be sure, for the busy designers of
operatic scenery in a world full of jazz.  But you
asked for comfort and I protest that it is there.
Wait in patience, with Whistler, for the advent of
"the chosen."  Emerson knew what he was talking
about.  When half-gods go, the gods arrive, and the
half-gods always wear out their welcome.  All that

you need to do meanwhile is to enter your ivory tower, lock the door, and throw away the key. You need not fear that while sympathy, imagination, and humor endure you will miss anything vital that goes on in the surrounding plain. Remember, from the top of the tower one may, perhaps, glimpse "the chosen" as he comes above the horizon. It is the critic's job, thus to watch, and his joy.

## II

## ELLIS ISLAND ART

"Art," said Whistler, in that famous "Ten o' Clock" of his, which he first delivered in London in 1885, "art is upon the town — to be chucked under the chin by the passing gallant." Art is again upon the town, after nearly forty years, but she is no longer gallantly chucked under the chin. On the contrary, she is subjected to strong-arm methods now. Politely speaking, she gets it in the neck. She gets it there at the hands of so many contributors to the exhibitions of the Society of Independent Artists that this organization might seem to rank as a portent by itself. As a matter of fact, its chief interest is that of a symptom. The modernism of which it so rankly savors is all around us and threatens to make increased headway. The practitioners have their fuglemen, mostly timid souls, tremulous with the apprehension of band-wagonomania — fearful of getting left.

Collectors and dealers, here and there, are on the job.
There is something in this art situation analogous to
what has been so long going on in our racial melting-
pot.  The United States is invaded by aliens, thou-
sands of whom constitute so many acute perils to the
health of the body politic.  Modernism is of precisely
the same heterogeneous alien origin and is imperilling
the republic of art in the same way.  It began, as our
excessive immigration began, in an insidiously plausi-
ble manner.  The French post-impressionists — Ce-
zanne, Van Gogh, Gauguin — retained just enough
contact with the normal conventions of art for their
subversive tendencies to be overlooked to a certain
extent.  They were tolerated, and presently they
were free to play into the hands of the half-baked
enthusiasts who are always sure that there is some-
thing good in anything that is exotic and new; the
newness is, for them, talismanic.  By the time the
cubists came along there was an extensive body of
flabby-mindedness ready for their reception here, and
all manner of similarly absurd "movements" have
been assured of a warm welcome, in some quarters at
least, ever since.  Such movements! — crude, crotch-
ety, tasteless, abounding in arrogant assertion, mak-
ing a fetich of ugliness and, above all else, rife in ig-
norance of the technical amenities.  These movements
have been promoted by types not yet fitted for their
first papers in æsthetic naturalization — the makers
of true Ellis Island art.

The compromising observer feels no alarm. "What harm can it do?" he asks. "This is a free country. Let every man have his chance. These people are trying to express themselves. It may lead to something yet. Tolerance is a good thing." "Tolerance" is the wrong word. There should be no tolerance for inimical influences. Especially there should be no toleration of offenses against the integrity of art. Whistler, into whom we may here profitably dip again, has a saying that is pertinent — "Art is art and mathematics is mathematics." What makes modernism intolerable is that it seeks to sap the loyalties inseparable from genuine artistic endeavor. It would not only substitute vagrant shallow impulse and egotism for the wisdom of centuries, but it would put dogmatic vanity in the place of that reverential aspiration which is at the very core of serious work. Consider merely this matter of the approach to art, the humbly industrious ambition from which great art springs. Four hundred years ago that hard-bitten realist Niccolo Machiavelli, working on his sinister political treatise, "The Prince," said in a letter to his friend Vettori some words which are those of a literary man, but which happen to express exactly the idea I have in mind. He said:

The evening being come, I return home and go to my study; at the entrance I pull off my peasant clothes, covered with dust and dirt, and put on my noble court dress and thus becomingly reclothed I pass into the ancient

courts of the men of old where, being lovingly received by
them, I am fed with that food which is mine alone; where
I do not hesitate to speak with them and to ask for the
reason of their actions, and they, in their benignity, an-
swer me, and for four hours I feel no weariness, I forget
every trouble, poverty does not dismay, death does not
terrify me; I am possessed entirely by those great men.

There speaks the artist, disclosing the profound
reverence for his craft which belongs to every faithful
follower of the muses, whether he use the pen or the
brush. And there is a passage in Sir Joshua Reynolds,
in his famous fourteenth discourse, the one he deliv-
ered after the death of Gainsborough, which may fitly
be cited here. "In the study of our art," he says,
"as in the study of all arts, something is the result of
our own observation of nature; something, and that
not a little, the effect of the example of those who
have studied the same nature before us and who have
cultivated before us the same art with diligence and
success." How modest that is! With what thought-
fulness does Reynolds proceed upon his task! Like
Machiavelli, who not only reclothes his body but
cleanses his mind, he attunes himself to a high mis-
sion. Nobody in his senses would expect the artist
to be a perpetually rapt mystic. He is a human
creature, like the rest of us. But he nevertheless rec-
ognizes that art is a sacred thing, not to be chucked
under the chin. He respects his *metier*. I remem-
ber an old story of Walter Pater, told me by a man

who knew him well. Pater was of the "beefy" type
of Englishman, quite John Bullish in some of his
tastes. He had a charming time one evening in an
obscure pub, and a casual acquaintance he made there
said to him at parting: "Blimey, guvnor, but ye're a
strite bloke. I've got a nice little rat-pit down Wap-
ping way and any time yer care to come I'd be glad
to see yer." It is perfectly conceivable that Pater
may have accepted the invitation. What he saw
down Wapping way may even have helped him to
humanize the pages of "Marius." But I am morally
certain that when he sat down to write that book he
purged his mind of rat-pits. There hangs about mod-
ernism an atmosphere as brutalized, as callous, as
theirs.

What the modernist needs is a drastic purgation of
conceit and wilfulness, a thorough educational over-
hauling. Turning to Whistler once more and para-
phrasing him, I may say that art is art, and modern-
ism is, well, modernism. Does this, in its turn, smack
of assertion? Let us suppose a wine-taster, con-
fronted by a dozen filled glasses. As he passes from
vintage to vintage, distinguishing between them, it
never occurs to him to doubt the fundamental nature
of the most differing varieties. But neither does he
have any doubts when he comes to the last glass,
tastes it, and finds that some one has filled it with
assafœtida. He spews it out with the remark that it
is not wine. Would that be assertion, in any arro-

gant, illegitimate sense? Wouldn't it be a rather mild statement of fact? If art as it has been known for some thousands of years is art, then modernism remains plain modernism, a totally different thing.

It springs largely from mental confusion. The army tests showed that out of a multitude of candidates for military service there was a certain astonishing percentage of adult males with the reasoning powers of a child. It is courteous to assume that the delicate and beautiful art of thinking is a universal attribute, but everybody knows perfectly well that there are thousands of nominally intelligent humans going about, creatures well born, well educated, solvent and responsible, who in their moments display the mental power of trepanned rabbits. The central error of modernism is this inability to think things out.

# II
## Abbott Thayer

# II
## ABBOTT THAYER

THE golden age in American painting, foreshadowed nearly a hundred years ago, when George Inness was born in Newburgh in 1825, came to something like maturity in the seventies. It was at about that time that Inness, Winslow Homer, Wyant, Homer Martin, and John La Farge arrived at the point where their importance as a group was more generally recognized. Then and through the two following decades they and certain of their juniors absolutely dominated the scene. By a kind of divine right La Farge took the rank of "old master" in it. He gave to the period its noblest monument in painting, the sublime "Ascension," which belongs to the church of that name in New York. This was the age of Saint-Gaudens in sculpture, of McKim in architecture, and the latter's partner, Stanford White, had, too, a good deal to do with it. He was the inspiring comrade of men like Dewing, Bunce, and Sargent. They made the memorable pictures for which he designed frames that were in themselves works of art. It was our great period of creative personalities. Shining among them all, a remarkable spirit and a remarkable painter, was Abbott H. Thayer, who died on May 29, 1921,

at his home in New Hampshire. We have never had any one more original in character, richer in imaginative genius. He was a naturalist as well as an artist, a master of truth as well as of beauty, equally searching and eloquent in the interpretation of landscape and in the delineation of the figure. On principles discovered by him the art of camouflage was developed in the Great War, and he is thus doubly to be reckoned a benefactor of his time. To dwell upon his career is to dwell upon some of the most precious elements in the history of American art.

Thayer's singularity comes out in his complete detachment from those influences which ordinarily color a painter's work in his formative period. He was born in Boston in 1849. Reared as a boy at a country home in Keene, N. H., he was brought to Brooklyn while still in his teens, and began his artistic studies there. He carried them on also at the Academy of Design in New York. He meant at this time to be an animal-painter, and proceeded to Paris in 1875 with that idea in his head. He entered the Ecole des Beaux-Arts and studied under Gérôme. Here, then, comes the moment at which one naturally expects his talent to receive a more or less lasting mark. But there is not the faintest trace of French academical teaching to be discerned in Thayer's work. If it were to be found at all, it would be found in his draftsmanship and his treatment of form, but as a matter of fact he is peculiarly himself in these matters, pos-

sessed of a method and a style intensely personal.
His interest in animals persisted, as we shall see, but
they soon ceased to provide the themes for his pic-
tures. He painted women instead, angelic women.
Sometimes they were literally winged creatures. The
characteristic figure he chose to portray was a god-
dess, mournful, meditative, protective. But even
without their wings his women were drawn from some
mysterious immortal race. When he painted the
famous "Caritas," which hangs in the Boston Mu-
seum, in which a woman stands with the dignity of a
Greek column, her hands hovering in benediction
above two children, he realized a conception to which
he returned over and over again, the conception of a
spiritual motherhood, ineffable in its strength and
beauty. The same elevation marks his numerous
portraits. One smiles at the thought of Gérôme.
Thayer forgot Paris, as though he had never been
there. He turned his back on the idiom of the Ecole
and used instead "the large utterance of the early
gods." In this language he speaks straight from his
heart. It is the deep feeling in him that more than
anything else makes him unique.

My consciousness of this goes back to my first im-
pressions of him, which date from the eighties. His
eyes seemed to me then to burn with an essentially
spiritual light, his voice to have in it, when it was
warmed by emotion, a finer timbre than one ever
recognized among other men. Above all, his whole

being seemed permeated by a tremendous earnestness. I have observed some artists of decisive originality— La Farge, Whistler, Rodin — all men of absolutely distinctive traits. Thayer was of their company, a man instantly to be known as aloof from the rank and file, following a path of his own. It was his earnestness that I would call his determining quality, and as time went on I saw that what made it moving was its relation to his ruling passion, the passion for beauty. I had occasion once in discussing a picture of his to glance at his possible intention. The meaning of the figure, if angelic, was human, too. It was a spiritual meaning, and in so far as I could explain it at all I allied it with Thayer's ideal of beauty, but I could not assume to say, precisely, what he was driving at. "How you set me talking!" he wrote. "As to what my pictures mean, you see, now, exactly. I want the image of one I worship to become visible, for all time, to this world — voilà tout!"

There was, I am proud to say, complete sympathy between us, and he often wrote to me freely of his ideas. He had none of the narrow-minded painter's prejudice against the art of criticism. It was a useful art as he saw it, so long as the critic was not "a barker," so long as he had "the Old World æsthetic attitude, that of a Latin-blooded beauty-seeker and not a New England measles-hunter." His New England origin must have counted, I think, in his growth as a naturalist, but in matters of art he was of another

country. "Oh, you and I are Mantegnas and Goz-
zolis, not Yankees," he exclaims in one of his letters;
and how, among Yankees, he hated what he called
the "measles-hunter," alike in criticism and in art!
Here are some expressions of his feeling:

To-day people call it not telling the truth if you paint
them the flower or serve them the apple to eat. They
say now that we know both the flower and the apple are
made of the manure in the ground beneath them; you
would tell more truth if you serve them, instead, handfuls
of manure, straight. Here is what they don't know. Be-
ing cheated by the general resemblance of a human figure
in some work of art to everybody they see about them,
and to photographs, while a Beethoven symphony has no
corresponding resemblance to the daily sounds about
them, they don't guess (and never will) that the essential
difference between the artist's figure and the actual hu-
man beings that swarm about us is exactly as total as
that between the symphony and the noises in our daily
life. Both works of art are absolute births, exactly as
real as the physical one. It is the accident of many re-
lated circumstances that the pictured human has so much
more aspect of photography than the symphony has of
phonography. Perhaps Fromentin's "art is nature seen
through a temperament" is almost sufficient, but what
great art means is that it comes out of its matrix consist-
ing of only such, and so much, head, ear, lip, neck, hand,
action, color, etc., as went to make the cherished image
that love set growing in that heart.

The impulse to clarify his thoughts on this problem
overtook him again and again, always carrying him
to the same lofty conclusion. One of his letters is so

illuminating on his point of view that I cite it intact,
as follows:

The violin, whose strings ring whenever their note is
sounded by an outside instrument, is pure symbol of the
poet. In the poet, cumulative images of every form of
beauty begin in earliest infancy to occupy the brain, till,
in his early maturity, these have become true touchstones,
like the violin string. Let the painter once look upon a
person who has, beneath no matter how many surface de-
fects, one dominant greatness — purity at heart and fiery
love of truth and beauty — and in his own heart the image
of such a personality wakes into brilliant ringing clear-
ness and takes the helm, saying: "Watch this being!
Thou wilt surely see, now and then, the being she really
is (it's a she now!) come forth and be fully in sight.
Watch, then, and take in how she looks, for in those
aroused moments she dominates the whole face and body,
ruling all their details into her heavenly form." Now he
who in this way comes to know her looks thereafter waits,
no matter how long. When he finds himself at the end
of his last supply he waits, as it were, outside her window,
sure that when she once more stands there in his sight he
will quickly see how to go on with his picture of her.
Dear Cortissoz, this is absolutely the way I work. You
delineate it almost clearly. It is because you see it that
I feel I could crystallize you a little.

Right you are, alas; the whole trade of art and litera-
ture is for the time off the planet. Man, finding himself
up against that (if he knew it) greatest blessing, the ob-
vious impossibility of ever understanding existence, will
forever swing between periods of worship and periods like
our present one. He is like a frog in a tub; he can see
the light and jump up at it, but never jump out, and
when he tires of this he finds that searching the tub's cor-
ners still offers no escape. So with man, his epochs of

worship will always be followed by a period — such as we are now somewhere near the end of — of self-deluding digging, egged on by the elation of unearthing so many of the never before dreamed-of tools that God evidently uses — gravitation, steam, electricity, radium, etc.

In due time man will again tire of this hope and again be the simple worshipping know-nothing. His cosmos theories will forever be on the same principle as the theories of a worm, hatched in an apple and still in the apple, might be of the apple's external aspect. The world is now all for what they call science, and they weigh music, painting, and poetry by what it can do in this field. Or, say, man is a child that awakes, out of the grass, and gazes awhile at the toys his parents have set about him, till, wider awake, he begins to work them and learn what they can do. Elated at finding out some of the stunts the lightning toy can do and what the steam one, etc., he comes to feel very big and forgets that he doesn't know, and can't, where they came from. So, for the time, there lowers on his horizon no wholesome reminder that he is forever (thank heaven) stumped.

The horrible Nemesis that lies in wait for this individualism is the monkeyfiedness of to-day's craftsmen. Of old, each apprentice strove merely to help some beautiful picture to get born and placed where it would help the world, and this habit of self-subordination attended each of them in his subsequent master years. Behold, now, the whispers creep through the crowd that self must assert itself, and a change begins, growing till "I, I, I! See how well I can do it!" has entirely supplanted "See how beautiful it is!" And then behold these egos all down at the monkey level. Like monkeys they have looked, unseeing, at their master's service, till they catch up the brush to show that they can do it, too. Like the ape, no longer seeing what this act of painting was making, when Gozzoli or Lippi held the brush, they paint and paint. None of them sees that — whether or no it is something to boast

of to be able to turn a back-somersault, or paint an actually delusive counterfeit of one more real shop-girl, when there are more than plenty always to be seen wherever you look — it has no resemblance to being the means of erecting before men's sight the crystal type of any desirable attribute.

The foregoing observations do much to explain the nominally restricted range of Thayer's art. In the list of his works — not strikingly voluminous — such titles as "Winged Figure," "The Virgin," "Caritas," "Diana," "Young Woman," point to the celebration of one theme, womanhood endowed with beauty. Only as his imagination plays about this theme he gives to it in each picture a really new investiture. The figure is generally youthful, but even so it is freighted with implications going deeper than anything in the wonted experience of youth. There are women on Thayer's canvases who with their maidenly bloom have also the heroic dignity of the Roman matron of legend. Their charm is drawn, as I have indicated, from Olympian sources. Yet it is one of their finest traits that they stand with their feet unmistakably on the solid earth. They are profoundly human presences. It is by character, by qualities of the soul, that they triumph, not through any dramatic or other significance derived from a specifically pictorial ingenuity. Once Thayer painted a mural decoration, the lunette symbolizing the city of Florence as protectress of the arts, which was erected in the

Walker Gallery, at Bowdoin College. There are five figures in the composition and, as a composition, it is well put together. But the decorative quality of the thing is not the secret of its spell; that lies in the central winged figure, in the divine creature of the painter's imagination. He was not a great inventive designer. He was just the consummate interpreter of a grand ideal of form.

He was too impatient of material issues ever to become a merely adroit craftsman. Thayer was, technically, a man of superb passages and of careless ones. He would paint a head with the supreme authority of an old master, an arm with the same imperial skill, or a drapery, and then he would brush in a part of his background as though he were in a hurry to get through. There are parts of some of his finest things which look unfinished. But they are never the essential parts. The beauty which he set out to express is always there. If the reader has any doubts about Thayer's technic let him go to the Metropolitan Museum and, after studying the glorious "Young Woman," turn to the "Monadnock," which is also in the Hearn collection. This is one of the greatest landscapes ever painted in America or anywhere else. The foreground is roughly generalized, on a principle which Corot used before Thayer, but which few modern artists have appreciated at its full value. The great mass and the shining crown of the mountain are defined with equal delicacy, precision, and gran-

deur. Only a technician profoundly versed in his mystery could with such piercing truth have interpreted so monumental a subject. The masterpiece is characteristic of Thayer. It is original. No other of our landscape-painters — and the group is an impressive one — could have set down a more personal impression of nature. And none could have exercised a more powerful sweep of the brush.

I have noted the outdoor nature of Thayer's boyhood. All his life long he was a lover of the woods and their inhabitants. His convictions as to the boundaries which are set for science, glanced at in one of the letters already quoted, never kept him from being a scientist himself. It began, unconsciously, I imagine, in those early days in which he painted portraits of dogs and other animals. He gave that occupation up, but he went on studying beasts and birds more and more as he retired to what was to prove his permanent home at Monadnock, N. H. Presently there flowed from those studies an epochmaking discovery, the discovery of what has come to be known as "Thayer's law." It is the law of protective coloration, that strange principle in nature which gives to some at least of the creatures of the wild a safeguard without which they would be handicapped in the struggle for existence. Thayer first announced it to the world in *The Auk*, our American journal of ornithology, in April, 1896. From time to time he made supplementary communications on the

subject, and in 1909, under the title of "Concealing Coloration in the Animal Kingdom," a full exposition of his ideas was published. Gerald Thayer, his son, wrote the text summarizing the matter and produced some of the most brilliant of the illustrations. The book was momentous as a contribution to the science of the naturalist. Its fame has since been greatly heightened by the fact that by the application of "Thayer's law" the art of camouflage was brought into the Great War.

This law established by the painter is not easily stated in bald terms. It is best approached through a moment's consideration of what naturalists previously believed to be the secret of protective coloration — namely, the establishment of an identity of color between a given object and its background. Thus, you would say, roughly, that a bird or butterfly not readily discovered in a tree or a bush "looked like" the web of twigs and leafage against which it had paused because it possessed kindred colors and markings. Much hinges upon that "because." Take, for example, a Plymouth Rock hen and place it against a background of the flat skins of similar hens. You would expect the living creature to achieve at once a certain degree of invisibility. Thayer made precisely this test, only to prove that "a more striking demonstration of the powerlessness of mere similar colors to conceal could hardly be devised." What, then, accounts for the fact — familiar to generations

of men but unexplained until Thayer hit upon the
secret — that many of the denizens of the animal
kingdom remain, under the right conditions, indistin-
guishable from their environment? It is not simply
that the patterns on their coats, both as regards line
and color, are adjusted to the nature of their surround-
ings; it is that these patterns are vitalized as a kind
of protection by the play of light and shade. "Ani-
mals," we are told in the book cited above, "are
painted by nature darkest on those parts which tend
to be most lighted by the sky's light, and vice versa,"
and the net result is that "the two effects cancel each
other." The point is extremely difficult to set forth
without the aid of diagrams and such aids, but I
may, perhaps, clear it up a little by adding that while
the model of a bird painted green all over and placed
against a green background would be unqualifiedly
conspicuous, the countershading of the same model,
according to nature, would cause it to melt into the
background. Where this process among the actual
living creatures becomes enchanting is in the artistic
subtlety with which costume, pattern, and shading
are developed. It is as though nature painted a pic-
ture upon the dress of bird or beast, a picture repro-
ducing the general character of the scene in which it
lives — always assuming life in the bird or beast, the
maintenance of a normal position.

I found the book absorbing, and not long afterward
the opportunity came to observe its principles in op-

eration. In the fall of 1910 Thayer wrote me: "I
wish so much you could by some wild chance be pres-
ent when I show the doubting ornithologists, etc., the
concealing power of brilliant costumes (outdoors, of
course), beginning at 9 A. M. at the Smithsonian in
Washington next week." The chance was one to
seize, and I met Thayer, pottering over the specimens
at the Smithsonian with him as he chose the few which
he deemed sufficient for the first séance. I remem-
ber among the feathered examples a marvellous ruby-
throated humming-bird, but our principal and quite
unforgetable exhibit was a young stuffed prongbuck,
worn by Thayer like a yoke over his head and shoul-
ders as we marched forth to meet the enemy. Per-
haps "enemy" is not altogether the right word.
The scientists brought together under that sunny but
chill November sky were not inimical to the demon-
strator's purpose. But neither were they noticeably
sympathetic. It was not asking too much of them
to ask them to look at the humming-bird, set within
a bush, and to note how it seemed mystically to dis-
appear. But they balked at lying down on their
stomachs in public and gazing up at the stern of the
deer to see the white patches thereon. If they would
do this, Thayer told them, they would see how when
an animal pursuing the prongbuck draws near his
prey and the quarry leaps into the air there is an in-
stant during which those white patches are merged
into the sea of light that falls from the sky. · In that

instant the pursuer may miss his stroke and while re-covering himself give the prongbuck that much of a chance to recover also and continue its flight. The crux of the matter is that the patches must identify themselves with the sky, and that they only do so when the eyes following them look up at them against the sky.

Thayer himself gave years and unimaginable pa-tience to the testing of those principles on which he laid such store, and it hurt when people failed to meet him half-way. There were questions on that morning in Washington. He answered them eagerly and, so far as I could judge, decisively. His demonstration was, to me, complete. I cannot say that the rest were flatly sceptical, but neither were they ardent, and as we went back to the museum, bringing the specimens with us, Thayer exploded wrathfully, not so much against the ornithologists we had just left as against the whole world of doubting Thomases. I speak of it now not to recall an old moment of dis-appointment for him, but because the incident seemed to bring out something very characteristic of Thayer. I have called him, in these things of a naturalist, the scientist. He never stopped being an artist, a lover of beauty. This was what made him so sensitive to an attitude of coldness toward his "law." The law, for him, was one of the most gloriously exciting ideas in the world, a new key to exquisite things. He couldn't understand why an elderly and not precisely

slender ornithologist should object to extending him-
self upon the grass in a public place with his eyes
directed at the behind-end of a stuffed deer. Down
in the West Indies he had stretched himself in the
mud without a qualm so that he might watch the
flamingo in its rose-flushed costume melting into a
background of rosy sky. He was watching more than
a fact — he was watching a "big magic," and the
artist in him was thrilled. He grumbled, at Washing-
ton, as I have said. But the image of him that stays
in my mind is that of a dreamer, with a kind of sweet
wistfulness about him.

He was tireless in his efforts to make others see
the truth as he had seen it. I was convinced when I
had first read the book, but he wanted me to get
closer and closer to his law. From Monadnock he
wrote: "Why don't you come up here as you prom-
ised? I will show you my artificial zebra, large as
life, that is getting ready to do the same stunt that
you saw the deer do, only even more magically. You
must, anyway, come in the next warm weather and
see the worlds of beautiful wonders that all summer
long last year I showed every one here." He wanted
sorely to get Colonel Roosevelt to visit him. T. R.
was a stout critic of the "law" and Thayer's argu-
ments could not move him. On the occasion when I
had a chance to talk with him about it he was still
incredulous. This always seemed to me one of the
gravest of losses to the subject. Met face to face for

long and candid talks, Thayer and Roosevelt would
inevitably have got together on the great central
principle. It was simply a caprice of fate that kept
them apart. All the time the stars in their courses
were fighting the artist's battle. Science more and
more accepted his ideas, and he, for his part, lost no
opportunity to extend their scope. The *Titanic* dis-
aster stimulated him to observations on icebergs,
which he sent me for publication as of the highest
importance. "How many more years of chancing it
at sea," he asked, "before the world realizes its deadly
error in the universal notion that bergs at night are
visible because they are white? It is precisely when
they are purest white that they are at night invisible."
When the war came he saw new possibilities in the
principle of shading and counter-shading he had dis-
covered.

There is a page in the New York *Tribune* of August
13, 1916, filled with a remarkable contribution that
Thayer made to the defensive science of war. It deals
with the proper — and improper — methods of color-
ing war-ships. The subject is, again, too complicated
to be brought within the confines of a brief abstract.
Even when the manuscript was finished and was being
put into type, Thayer would telegraph me changes.
His earnestness was surely in full play that summer.
He preached the gospel of white paint to the British
navy as fervidly as though he were an evangelist.

For the reflection of his mood that it gives I may reproduce another of his letters:

Monadnock, N. H.,
August 3, 1916.

DEAR CORTISSOZ: I am calm now about squashing that horrible Hohenzollern brood.  As one felt sure, it was certain that since he left his neighbors no alternative but practical annihilation, they would not and could not stop till they had become an overwhelming cordon to hunt him down.  We shall see the Germans put him in his box and beg the world to let them exist as a nation if they will do this boxing.

I got clean used up and I am now in great shape after two months at Cape Cod.  This unspeakable strain took me to England last November and December, and five weeks of the first war year to Washington, to try to impress Franklin Roosevelt and so work the Allies.  Even you don't realize that white ships would have saved most of Britain's nine in that fight.  All they have to do is to wait for dark parts of the day to do their fighting in.  Yes, I have done perhaps my best head lately.

Affectionately,
A. H. T.

The line at the close is pure Thayer.  The artist in him, I repeat, could not down.  Half the criticism levelled against his law would have been cancelled, to begin with, if his critics had shared his æsthetic perceptions.  After all, the science of concealing coloration is all intertwined with the beauty of nature.  It was an artistic as well as a scientific principle that Thayer let loose in the war when his law gave the

camoufleurs their start. He went abroad himself, in 1915, as his note relates, to give advice on the concealment of arms and other objects in the field. His cousin, Barry Faulkner, led the artists who, in our own army, brought the art of camouflage to a high pitch in France. In all the armies artists enrolled in this branch of the service and wrought, as the whole world now knows, immeasurable good for their forces. The genesis of that tremendous support given to the Allies is directly traceable to the genius of the American painter, who had loved and studied animals from his childhood, who had surprised the secret of concealing coloration in the animal kingdom, and had revealed "Thayer's law." In writing to me about the article I have mentioned he expressed his anxiety about the title, in which allusion was made to the possibility that the Germans had learned from his book how to avoid errors of naval coloration. "I now believe they did this," he added. "I hear from Switzerland that I am worshipped there about this matter." He might well have been honored, if not worshipped, by the Allies, for he made a priceless gift to their cause.

There was no soldier in the field whose soul was stirred more mightily than was Thayer's by the stress of the war. "I have only yesterday begun again on the war news," he writes in one of his letters, "after refraining two months from knowing a word. I swore off for my health." He lived by imagination, if ever

a man did. Great events swept him like a storm. And, fortunately, they sent him back to the brush. "I am young again and really painting." "You will rejoice that I have this last May done one of my very best heads." "I am very well again and conceive that the things I am painting are going to please you and me. I am full of them." These are the messages from Thayer that I love best to recall. When he says, "I am full of them," he means only one thing, that he is full of ideals of beauty. He was faithful to them to the end. In pure beauty this great artist left to America his truest heritage.

# III
## Thomas W. Dewing

# III

# THOMAS W. DEWING

THE auction-room is a great place for surprises. I don't mean the surprises that spring from big unexpected prices, the transformation of a work of art that once sold for a song into a treasure for which connoisseurs recklessly compete. Let the statistician get what fun he likes out of those mutations. The kind of surprise that I am thinking of is the kind that comes to a mature artist, sitting at ease, engaged in painting the type of picture that has long accounted for his success. All unknown to him, some old collector dies and the pictures from his walls are sent to the auction-room. Among them our supposititious artist discovers one of his own early works, and it is odds that it will give him the surprise of his life, a surprise appreciatively shared in by the critics and the public. I have known countless such incidents. To mention only a few of them at random, I came last winter upon a picture unmistakably of the school of Fortuny in its most glittering phase. As a matter of fact, it was painted by Raffaelli, of all people in the world, though it was the very negation of everything by which that artist is generally known. I have seen an absolutely unbelievable Dagnan-Bouveret which nevertheless bore his authentic signature, an early

47

one.  I have seen a genuine Edwin A. Abbey which
looked as though any one else on earth might have
drawn it, but not Abbey.  And, finally, I have seen
a Thomas W. Dewing which was unquestionably his,
but which was, as his, next door to incredible.  There
are reasons, just the same, why it is delightful to re-
call it.

It was an early Dewing, painted in Paris when he
was a young man there, a student of Lefebvre's,
which is to say a disciple of the immemorial tradition
of the Salon.  It was called "The Sorceress," and
the seated nude it represented didn't even remotely
foreshadow the works which were ultimately to estab-
lish his repute.  There was no mystery in the paint-
ing, no tenderness, no charm.  It was simply a cool,
skilful, academic study of form.  It didn't, as I say,
foreshadow the real Dewing.  Yet there were things
in it without which he couldn't have gone on.  There
was a knowledge of form.  There were linear delicacy
and precision.  There was in the whole picture the
quality of the thoroughgoing workman.  The artist,
I imagine, must have been surprised if he saw it,
brought back across the years.  He must have smiled
as he saw how cold it was, how conventional, com-
pared with what he had since produced.  But I can
hear him murmuring, too: "Well, I started right."
It is for the intimation of that start that I refer to
the picture here.  It clinches a point that is impor-
tant about Dewing, the integrity of his art.  You

will see sometimes in an exhibition a silver-point by him, one of those drawings of a head which must be supremely well done in every touch because silver-point is an instrument permitting no erasures or corrections. The perfection of this portrait is traceable partly to the training whose severe discipline is so well reflected in "The Sorceress." It reminds you, among other things, that Dewing knows his trade.

He has given criticism many an occasion for cordial tribute since his return from France long ago, but there is a special reason for comment upon his art at this time. The work of an artist's lifetime is commonly not brought together until after his death. It is only in memorial shows that we have been permitted to study the chronological development of Whistler, Winslow Homer, Abbott Thayer, Chase, and so on. Sargent is, I think, the only living American painter who has hitherto had a big retrospective exhibition of his own, the one organized some years since by the Copley Society in Boston. Dewing has never been thus exhaustively illustrated, prior to to-day. But now he virtually receives the honor in the recently opened Freer Gallery at Washington. There, where his old comrades Whistler and Thayer are commemorated, he, too, has his place, a room of his own where he has the unique privilege of seeing his work held up at full length before the world while he is still alive. The Freer Gallery owns twenty-seven of his oil-paintings, eleven of his pastels, and three of his

silver-points. There they are, to stay forever. It is a fine feather for a living artist to wear in his cap, and it is interesting to reflect on the qualities in him that justify it. Freer was a lover of the arts who knew very well what he was about. He collected Oriental masters and a few Americans whom he believed to be of the first flight. What, as regards Dewing, may we consider the grounds of his belief? Dewing has not had, on the whole, what the French call "a good press." On the other hand, his works have been steadily acquired by public museums and by the most discriminating of American collectors, one of whom, John Gellatly, has gathered together a group of his pictures rivalling that formed by Freer. Amongst artists Dewing has been enthusiastically esteemed by the leaders of his craft. Why?

His career gives some impressive answers to these questions. I have spoken of the integrity of his art. It involves more than his craftsmanship. That, in its turn, has been dedicated with a rare loyalty to a definite ideal of beauty. When Dewing found himself and superimposed upon his Parisian training a technical idiom of his own, he gave it a very original accent. Ranging himself with certain famous exquisite manipulators of paint, the seventeenth-century Ver Meer of Delft and the nineteenth-century Alfred Stevens, he ranged himself also with Whistler, sharing in that artist's disposition to regard life not so much for its own sake as for the excuse it offers for harmonies

of color and felicities of pure design. I speak of these men because their methods and their points of view have doubtless had a certain influence upon Dewing. But if there is one thing obvious it is that he has painted a kind of picture essentially individual. Ver Meer would make a picture of a woman at a harpsichord and wreak himself on sheer beauty of painted surface. Dewing has painted a woman at an old musical instrument seated before a tapestried wall and has wreaked himself upon sheer beauty of painted surface. In the process the modern artist has worked a magic in every way as personal as that of his remote Dutch predecessor. It is the magic denoted in two words, technic and style. Dewing has touch, the ineffable gift which lends to brush-work what Kreisler lends to the mechanics of violin-playing. It is one of the hardest things in the world to define. All you know is that under the necromancy of touch paint is, as it were, dematerialized, and made a medium for the expression of impalpable loveliness. Art on these terms becomes very delicate, very flowerlike, and, above all things, very personal. That is where it takes on the investiture of style. With extraordinary subtlety it reveals the very core of the man, his way of thinking and feeling, his ideas, his taste, his attitude toward life. It is, after all, easy enough to understand why Dewing has failed to satisfy the palate of some critics. A good deal of the popular art of the day is "strong" to the point of brutal violence;

it has the crudity of rare roast beef. It is, then, not unnatural that those who swear by it have only distaste for a painter who

> "On honey-dew hath fed
> And drunk the milk of Paradise."

They miss the fact that in Dewing's exquisite textures there is really a potent strength.

It is suggestive to observe, too, that for an artist working in such refined airs, striking so lyrical a note, Dewing has shown unusual variety. The works at the Freer Gallery indicate his command over more than one medium. His productions fall otherwise into more than one category. Though he has had few opportunities to paint mural decorations, he has demonstrated his ability in this direction when the chance has come to him to do so. The circular ceiling which he painted for one of Stanford White's buildings, years ago, was one of the finest things of its kind ever done in this country. The lid of the great golden piano which stands in the White House at Washington was decorated by Dewing. He has painted some enchanting screens. Two of them, devoted to "The Four Sylvan Sounds," are in the Freer Gallery. The portrait there of the artist's little daughter, standing with kittens in her arms, was painted to fit a specific space arched in a wall. He knows all about unity of design. I remember one of his earlier compositions called, I think, "The Hours," which was as shrewdly

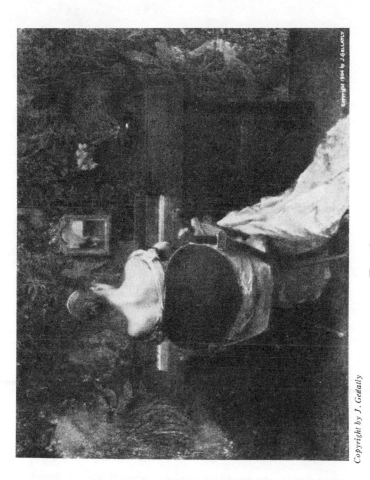

THE SPINET

BY T. W. DEWING

well balanced as the most seasoned mural decorator
could have made it. From decoration he has turned
with absolute ease and authority to portraiture, the
portraiture of men, women, and children. There
comes back to me the memory of his full-length of a
little boy in velvet, posed against a background of
flowers. Nothing could be lighter or more springlike.
And, as I recollect that, I recollect also Dewing's por-
trait of the architect, Joseph M. Wells, a little master-
piece showing forth as in a mirror the very soul of a
man of genius. Decidedly he has more than one
string to his bow.

He has shown this, too, where one would think it
would be peculiarly hard to achieve variety, that is in
the world of the bulk of his easel pictures, a world
where it is always afternoon and never wind blows
loudly. Consider the titles of some of the pictures
in the Freer Gallery: "Girl with Lute," "The Piano,"
"The Blue Dress," "The Mirror," "Black and Rose,"
"Yellow Tulips," "A Lady Playing a Violoncello."
They might be the titles of so many studies of still
life. There is no drama in Dewing's *œuvre*. There
is no pathos, there is no sentiment, there is hardly
any human interest at all. When Alfred Stevens
painted a beauty of the Second Empire he would show
a *billet-doux* clinched in his sitter's hand, he would
corrugate her brow, press her pretty lips together, let
a pearly tear adorn her cheek, and call the picture
"Regrets" or "Revery." He always found a sub-

ject in the anecdotic sense. The emotions of his peo-
ple are frankly uncovered. Dewing's people have no
emotions. It is sufficient for them that they exist.
That they do indubitably exist is the artist's triumph.
Like Whistler, he could never abide the "painted anec-
dote." I do not believe he could tell a story on canvas
if he tried. His function is simply to evoke a pres-
ence and to envelop it in what I can only describe
as a mood. There is a notable picture of his called
"The Hermit-Thrush." Two girls are posed, in eve-
ning dress, upon a grassy slope. They listen presum-
ably to the bird in the tree whose leaning massy
boughs make a screen as of torn clouds across the sky.
There is no action here, yet we share with the two
figures in the beauty of that song. Dewing has been
very fond of painting fair women in idle meditation
out-of-doors, graceful apparitions against a back-
ground of filmy green, with the moon, perhaps, look-
ing on. More often than not he will put his women
in ball gowns. Apropos, it is amusing to note that
these hardly ever "date." That is where, again, he
differs from Stevens. The Belgian's costume makes
his pictures clearly souvenirs of the Paris of his period.
Dewing's figures have no readily recognizable *locale*,
whether they are indoors or in the open air, whether
they hold a lute or a book, a flower or a violin. They
remain always the creatures of his own domain, the
domain of an exquisitely dehumanized beauty.

To say that it is dehumanized is not to say that the

vitality of life is withdrawn from it — quite the con-
trary — but only that Dewing's interest is not in the
things that ordinarily concern mankind. His is the
type of imagination that endues a figure with charac-
ter, with a soul, without forcing it into action — like
the dramatist of the anecdote, whose people impressed
the beholder without saying anything, where those of
his rival impressed by saying fine things. Dewing's
women are very real, the more so because they are not
images portrayed but entities created. I put this
creative power of his first, and just after it I would
place his color. Like everything else in his art, it is
new, original. It runs through one of the subtlest
scales I know in modern painting. A given scheme
of his is broadly simple, based on two or three notes
at most, but it is as full of modulations as the irides-
cence on the plumage of a dove. There is never a
plangent element in it, though as "The Blue Dress"
in the Freer Gallery plainly indicates, the artist can
be rich, weighty, and forceful when he wishes. For
startling emphasis he has no predilection. It would
obscure the clarity, dislocate the steadiness, of his
serene vision.

It is his vision of the world that makes him of par-
ticular value to American art. He sees his subject
and he sees his craft in the same gracious light. His
work is a standing rebuke to the modern cult for ugli-
ness and for technical license. To the young mod-
ernist who thinks that draftsmanship is a mode, to

be made over from year to year like a fashion in woman's dress, his art commends draftsmanship as an eternal organic element in the well-being of painting, unchangeable in its essential principles. To the dabbler in strange chromatic discords he shows the virtue that lies in pure harmony, reminding him that good taste is inseparable from good color. Taste, refinement, distinction, the things that mean artistic breeding — these are the things of which a picture by him is all compact. Was there ever greater need of them than at present, when so many would-be painters are constantly asserting through their works that to be raucous and coarse and altogether crude is to be artistic? Dewing's room at the Freer Gallery provides a shelter from all that false philosophy, a shelter and an inspiration.

# IV
## George Fuller

# IV

## GEORGE FULLER

GEORGE FULLER had genius. In that fact lies the justification of his work. He belongs to that rather small body of American painters, dating chiefly from the first half of the nineteenth century, for whom technic functioned distinctly as a means to an end. Like La Farge, Vedder, and A. P. Ryder, he had imagination, and turned to the making of pictures because he had something to say. Careful students of our art history have always been aware of him. There must be many, however, to whom he is hardly more than a name.

Mr. Augustus Vincent Tack allies Fuller to the impressionists, in that he was a seeker after the secrets of atmospheric light. But he allies him also on the same grounds with Corot and Whistler. In other words, Fuller was a man of broad principles, not the disciple of a formula, a school. There was, indeed, nothing conventional about his development. One is conscious, in that, of nothing save a personality feeling its way little by little toward an original mode of expression. For his beginnings the best source of information is the charming essay printed long ago in *The Century*, which first made his qualities known to

the world, the essay written by Mrs. Schuyler Van
Rensselaer.  She says:

Mr. Fuller was born of Puritan stock at Deerfield,
Mass., in the year 1822.  An instinct for art had already
shown itself in several members of his family, and from
childhood his own tastes led him toward a painter's brush
and palette.  He went to Illinois at the age of fourteen
with a party of railroad engineers, and remained two
years, during which time he was much in the company of
the sculptor Henry Kirke Brown.  Between the ages of
sixteen and twenty Mr. Fuller was again at Deerfield,
following a school course, but making constant essays in
painting, chiefly in the way of portraiture.  In 1842 he
wrote for counsel to Mr. Brown, then established in a
studio at Albany, and gladly accepted the sculptor's invi-
tation to go thither and study under his tuition.  At Al-
bany he remained nearly a year, when Mr. Brown went
to Europe and Mr. Fuller to Boston, where, painting por-
traits as before, he devoted himself also to the study of
whatever works of art the city then afforded — especially
the pictures of Stuart, Allston, and Alexander.  A few
years later he removed to New York, and, at an age when
most painters have finished their student courses, went
diligently to work in the life classes of the academy.  His
first public success seems to have been gained in 1857,
when he was already thirty-five years old.  He then ex-
hibited a portrait of his first friend in art, Mr. Brown,
and on the strength of its good qualities was elected an
Associate of the National Academy.

About two years later he went abroad and mused
among the old masters.  Long afterward, when Mr.
W. B. Closson asked him his opinion on the value of
European training to the young American artist, his

reply was unfavorable. "I have seen the work of
the great men," he said. "I remember it and it is
all I want. I don't want to see it again." He did
not need to see it again, for his peculiar requirements.
Such inspiration as was his he drew from within. He
went back to Deerfield and painted only as he was
permitted to do so by the tasks of a farmer. In 1876
he emerged from this retirement, exhibiting a number
of pictures in Boston and immediately winning sub-
stantial appreciation. Mrs. Van Rensselaer notes the
oddity of his reappearance in New York in 1878, when
he returned to the academy "not a beginner but a
veteran in art, yet as a débutant once more." She
indicates that he was "skied" by the hanging com-
mittee. But the younger generation was more sym-
pathetic and he was presently elected to the Society
of American Artists, then in the first flush of its ardor
for newer ideals. He was an exhibitor with the
society down to the time of his death in 1884. This
is one evidence that he was in the van of American
art, yet it is important to note the singularity of his
position there.

When the Society of American Artists was founded
the slogan of "art for art's sake" was in the air, and
most of the men active in this organization were
frankly rebellious against academic routine. They
had been greatly stirred by counsels received in Paris,
and they were passionately interested in craftsman-
ship. Merely to know how to paint was half the bat-

tle. Here Fuller parted company with the very men among whom he was content to dwell, though he had undoubtedly the painter's point of view. From a private letter of his Mrs. Van Rensselaer cites some characteristic observations on technic:

> I have long since learned to look on the painter's stubborn means as a lion in the path, to be overcome without leaving evidence of the struggle. . . . I am much controlled by the work before me, being greatly influenced by suggestions which come through much scraping off, glazing, scumbling, etc., in trying to extricate myself from difficulties which my way of working entails upon me — always striving for general truth. Indeed, the object to be attained must always be reached through our own methods. The great painters tell us this and leave us to fight it out. They only insist upon gradation, the law of which governs values, tone, and harmony, so no detail must interfere with its truth. The main thing is to express broadly and simply, hiding our doing, realizing representation, not reproduction — to get ourselves above our matter. A picture is a world in itself. The great thing is, first, to have an idea — to eliminate and to clear away the obstructions that surround it. It is more what is left out than what is put in. The manipulation admired by some the true painter seeks to hide. The question must forever be, What is below the surface?

The essentials in this programme are obvious in his pictures. There you see Fuller's principles in action, and especially you may see how indispensable for him, how inseparable from his specific quality, was the essence lying below the surface. His is absolutely a work of the spirit, a strain of beauty exquisitely felt and transmitted to the beholder with a certain power.

But it is interesting also to see that he lost something even in that moment in which he elected to follow an upward path. A clew to it lies in a phrase from the foregoing passage, "the painter's stubborn means." Technic was unquestionably a lion he found it difficult if not impossible to subdue. The mere "manipulation" which he would have the true painter hide has, after all, its elements which cannot be hidden — elements of accuracy and force. His "Arethusa" throws light upon the point. It is a charming nude, but in draftsmanship and in modelling it is weak. The workmanship is commonplace, though the idea and Fuller's emotional interpretation of the idea are not. One realizes here the force of the painter's own words, his effort to "extricate" himself from difficulties, his striving after truth through a thorny jungle of technical obstacles. He faces the latter with a high heart, but, lion-like, they bear him down. Fuller had the right feeling about technic, as I have said. It was for him simply a means to an end. Only he never so mastered it that he could successfully hide it. With ironical persistence it is always getting between him and the spectator. He never draws with a clear, firm touch, so that you lose sight of the mechanics of art in enjoyment of what they produce. On the contrary, there is something nerveless and dragging about his handling of a contour, and you notice that even as you respond to the witchery he has nevertheless contrived to spread upon the canvas.

Form as he defines it is a little labored. Tone also

— and it is by tone that he lives — is never built up by
a strong sweep of the brush, but is so teased and chev-
ied between what is expressive of nature and what
is merely obscure that there are passages in which he
seems the fumbling amateur rather than the "veteran
painter." He had, on the whole, a status somewhere
between the two. Form as he portrays it hasn't an
atom of the linear authority, the grasp upon structure,
which belong to Millet. Beside the Frenchman's his
technic seems positively feeble. But he is easily
comparable to Millet in the character and distinction
of his figures. That is where his faith in "an idea"
comes in. That is where he draws us to what is
"below the surface." He is one of the few poetic
personalities in American art. Like Ryder he was
indifferent to "manipulation," and like Ryder he tri-
umphed through the creative imagination.

His conceptions have a singular vitality and beauty,
the proof of which resides not only in the convincing
accent which he could lay upon a "Psyche" or a
"Nydia," but in the haunting magic with which he
could endue a subject nominally prosaic. Look at his
"Gatherer of Simples," or his "Girl with Turkeys,"
or even a homely pastoral like "Driving Home the
Calf." He lifts a simple, familiar scene to a higher
power. He turns some farm episode into true artistic
stuff, the stuff of which dreams of beauty are made.
"Driving Home the Calf" is a prodigious picture.
The boy and the animal are not precisely negligible,

but they fall into a subordinate relation to a landscape
almost mystical in its beauty.  There is a little pic-
ture of Fuller's called "The Gossips," in which the
two figures are well-nigh lost in a dim penumbra.
Yet these figures have a curiously human, arresting
quality, and the landscape in which they are set is
poetry itself.  A first impression of this and many of
his other pictures suggests a kind of monotony in
Fuller's art.  His grays and greens and browns point
to the same chromatic preoccupation.  He paints in
practically one key.  But he is not really monotonous,
because in every instance he exercises a genuine faculty
of evocation, imbues his theme with life, and, above
all things, makes it beautiful.  How are you to quar-
rel with the possibly overdone tonality of an artist
when he repeatedly extorts from it a magical effect?
How, by the same token, are you to attach any great
weight to any of his technical limitations when he
liberates in each of his pictures a definite idea and
brings it home to you with an ineffably sensitive and
personal touch?

There is much in that remark of his that "the ob-
ject to be attained must always be reached through
our own methods."  Fuller's methods, though defi-
cient in the brilliance of sheer painting, were his own,
and with them he attained objects that are rare and
gracious.  His portraits, with few exceptions, leave
me cold.  But the moment he paints an ideal figure
or a subject from farm life in which fact has stirred

him to finer issues, we share with him in the radiance of a lovely vision, the warmth of a rich emotion. His work is a precious reminder and stimulus. It embodies a protest against sterile dexterity, against mindless "manipulation," against vulgar taste. Fuller may not have been a masterly painter, but he was an artist to his finger-tips, dedicated utterly to imagination and idealism. There are American craftsmen who can define form with thrice his ability, who use a purer palette, who can be triumphantly exact where he is tentative and weak. And they are the painters who ought to sit reverently at his feet.

# V
# George De Forest Brush

# V

## GEORGE DE FOREST BRUSH

BRUSH'S artistic character is original and distinguished, one of the finest in the history of American art. From the beginning he has pursued a high ideal in both the substance and the form of his work. The polished technic he developed long ago has been placed at the service of elevated thought. Wherever a painting of his has appeared it has given a lift to its surroundings. Outside the circle of his friends very little is known about him. The scant records tell us that he was born at Shelbyville, Tenn., in 1855. He went to Paris in the seventies and studied under Gérôme. He was elected an Academician here in New York in 1908. Beyond these details almost the only souvenir of him that I have been able to run down is contained in a reminiscence of his printed in the preface to a Thayer exhibition at Pittsburgh in 1919. The two men were close friends. Brush says: "We all went to Paris about the same time. Everybody was going. And I can say that, coming into that strange life of the Paris Latin Quarter, I know many of the young Americans, along with myself, were stunned by it. It seemed at first a great shock. As it was, finding ourselves in a universe that would be bad anywhere — in New York to-day — most of the

young students easily gave in to the rather low point
of view of the community of students of all nations
that formed the Quarter.  And Abbott was the in-
fluence that I know must have held many a young
man up to an ideal of conduct.  It was his stand as
against the drift of the Quarter that endeared him to
many of us.  It is what attracted me to him."  I
quote the passage for the sake of the point of view it
discloses.  That has steadily been characteristic of
Brush.  Once, in a lecture at Philadelphia, he de-
nounced the commercialism of the day and adverted
upon what he considers the degenerate elements in
the art of Rodin.  Art is for him a divine adventure
or it is nothing.  With this spirituality of his there
has gone a profound devotion to constructive disci-
pline.

In the lecture aforesaid he made these observations:
"A student learns nothing until he comes under a
master.  In this democracy, with its ignorance of the
wisdom of the ages and its craze for trying things new,
painters would rather experiment than read.  I would
advise them to read — read Cennino Cennini.  In
him they have a library that will last two or three
years.  Here is some one who can tell them how.
We must not run after new things.  We must find
out what the masters knew."  Brush has practised
what he preaches.  He has found out.  At the Ecole
des Beaux-Arts, for example, under Gérôme, he found
out the importance of good drawing.  There never

was anything of the superman about him. It is not apparent that he ever took any short cuts. He drew, rather, as he was taught, in the years during which he was forming himself. Great personal draftsmanship was to come to him later. At the outset he was a faithful disciple of academic principles, and his earlier works emphasize the fact. He came back to America with what I can only call a Parisian sense of form, the method which spells care and scholarship. You see it in those Indian subjects which he painted in the eighties. It was Saint-Gaudens, I believe, who humorously characterized the Indian subject as the youthful sin of every American artist. Brush raised it to a higher power. There must have been a rich feeling for nature in him when he tackled those bronze models of his in their sylvan habitat, an instinctive response to the *silenzio verde* of the poet. The paddling hunter with gaze uplifted at the flying wild goose in "The Silence Broken" is an immobile, statuesque figure, but the still water on which he floats and the thick trees behind him are murmurous with the sweet life of the forest.

"The Sculptor and the King," which dates from about the same period, is more markedly in the manner of Gérôme, and throws into sharper relief the academic nature of Brush's earlier draftsmanship. But it was possibly the plastic implications of the subject that kept his line a little hard, a little inflexible. Breadth was not by any means beyond his reach.

His "Leda," which was painted as far back as 1883, is touched with a beautiful ease and freedom. Curiously, the big "Andromeda," a work of recent years, is a comparatively inelastic performance. It is tempting to go on in traversal of Brush's Indians and nudes, but, brilliant as they have often been, they nevertheless are subordinated to another theme in his annals. Like his friend Thayer, he has dedicated his major energies to the interpretation of womanhood and childhood. Unlike Thayer, who was always racily American in his art, Brush has preserved, subtly but unmistakably, a certain alliance with the historic schools. I well remember the strange and beautiful impression he left when his first "Mother and Child" came into view. It had an old-masterish mellowness and depth. There was not the smallest hint of imitation, but one was conscious of an unspoken kinship between Brush and such a painter, say, as Terburg. The color scheme he adopted then was very low in key. The figures were seen almost in shadow. They loomed forth as warmly sympathetic human creatures, pensive and serene, simple in costume and in attitude, not so posed as to suggest the Madonna type, but with an atmosphere of sacredness hanging about them. Technically, the earliest of these canvases proclaimed the merits which Brush has ever since maintained, the merits of dignified composition, pure tone, and exquisite drawing.

How exquisitely he can draw may be seen from his

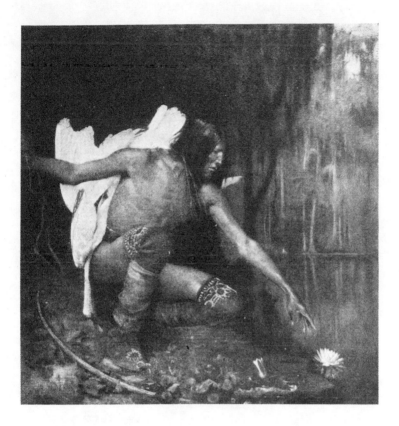

THE INDIAN AND THE LILY

BY GEORGE DE FOREST BRUSH

pencil studies of form and drapery. Observing his mastery over the fold of a robe, his uncanny skill in the linear expression of it, one thinks of the drawings of Leonardo and Dürer. In the definition of form he is less impressive. There he is neither as sensitive as Leonardo nor as powerful as Dürer. But he is worthy of them both in the fineness of his touch and, above all, in the beauty with which he invests his delicate fragments. Turn back to the paintings and you note the same fidelity to a noble idealism, both in technic and in emotion. He has, I believe, been much in Italy. The experience is reflected in what he does. Florentine influences crop out in his family groups. I surmise that of Ghirlandajo and, here and there, the influence of earlier masters. The wonderful "Portrait of a Lady," at Smith College, is Florentine in line, but in its sumptuous tones, in the whole opulence of its beauty, it recalls the glow of the Venetian school. In color, as in the arrangement of form, the later works point decisively to contact with the Renaissance masters. The low key of his beginnings is persistent for years, but the tints grow warmer after a while, and occasionally, as in the "Mother and Child," in the Brooklyn Museum, an almost blond note prevails. Of luminosity in the modern impressionistic sense there is nowhere any trace. In his light Brush adheres to the restraint of the old masters. He is a studio painter, not an outdoor man, despite his Indian subjects of long ago. With his still airs, his reveren-

tial drawing, his calm, and his ordered beauty, he remains, no doubt, a conservative.  But it is amusing to think of the disparaging turn which would be given to the phrase in its application to him by your latter-day "modernist."  It spells, of course, only the rectitude of art, the loyalty of an original mind and a masterly technician to a fine ideal.

# VI
## Thomas Eakins

# VI

## THOMAS EAKINS

THE art of Thomas Eakins is so honest and straight-
forward, so full of a kind of clean-cut American
energy, so sincere and so plainly developed with re-
flective care, that it is impossible to observe its mani-
festations without an instinctive response to its sober
purpose. Its genuineness is particularly acceptable at
this time, when so many false short cuts to artistic
triumph are being peddled about by — the victims of
short cuts. Eakins travelled the well-worn path. He
was an old man when he died in 1916. His pupilage
dated from the sixties, when he studied in Paris with
Gérôme and Bonnat. Just when and how he came
under the influence of Courbet's sturdy naturalism I
do not know. It may be that he never consciously
did so. Yet it is of Courbet rather than of his aca-
demic instructors that we think in the presence of
many of his paintings. Certainly his formal training
failed to turn him into a coldly and rigidly accurate
Academician. He developed, rather, into a broad
realist, a realist steadied, no doubt, by the admoni-
tions of Gérôme, but lifted into a freer world by the
outlook which we associate with Courbet — by the
outlook, and, a little, by the method.

In the bold, direct statement of fact Eakins disclosed a sterling gift. He had a thoroughgoing
knowledge of form and a good deal of slow, dogged
skill in the notation of it. At the back of his mind,
too, there was that feeling for nature without which
an artist is, of course, pretty nearly helpless. There
are landscapes of his which reveal him as caring for
something more than the gray light and arrested
movement of the studio. He was interested in life —
never was a painter more interested — and this virtue
comes out superbly in the heads in practically all his
portraits. In the analysis of character and the grave,
dignified revelations of it, he was exceptionally strong.
Now and then he makes you feel that he might be
capable of anything. But it is only now and then,
and at long intervals. With a recognition of that fact
we come swiftly, and rather disconcertingly, upon his
limitations. Mr. Bryson Burroughs, who has said
admirably the best that is to be said about Eakins,
also gives us a hint of the worst in the following brief
passage: "He was the most consistent of American
realists, and throughout the forty-five years of his
artistic career his point of view remained practically
the same." That is eulogy only if we forget what
Eakins's point of view was in the first place, and if
we ignore the dangers of isolation in any profession.
Eakins began with a realistic point of view which
completely excluded the operation of the imagination, a point of view insensitive to taste, to beauty,

and his consistency, whatever its fortifying powers may have been, blinded him to all that was happening in the art of his time.

The conquest over problems of light, achieved by the impressionists, left him indifferent. The potentialities of tone, as they were exploited by Whistler, for example, left him cold, and he was as neglectful of the qualities of surface illustrated in the art of Alfred Stevens. It would be easy to retort that he was occupied in realizing his own talent — that an artist must be himself. Yes, but what if fate has left out of his make-up certain indispensable elements? I do not cite the masters upon whom he turned his back as types that he should have imitated. I mention them merely as exemplifying traits that he needed. In the renunciation of those traits he helps us toward a better understanding of his precise significance as a painter. Consider the matter of taste. That would spell, assuredly, a certain delicacy, a certain feeling, where color is concerned. Well, as a colorist Eakins simply did not exist. His color is worse than prosaic; it is dully repellent. Perhaps the most flagrant example is his big full length, "The Concert Singer," where the banality of the greens and pinks, set forth with callous resolution, is almost pathetically disillusioning, but everywhere we meet the same rebuff. The few gleams of charming color in him are the harbingers of a dawn that never breaks. As a colorist Eakins never knew the magic of the sun, the transforming power of

light. He was a perfectly sound technician who never sensed the full scope of technic. He could draw accurately, sometimes powerfully, but never with an atom of charm.

In the transcendently important sphere of composition he moved about, equally unaware of his losses, as in worlds not realized. Much of the celebrity which he won was based upon his two ambitious hospital scenes, "The Gross Clinic" and "The Agnew Clinic." The great example of Rembrandt was there to sanction his daring purpose, but somehow the massive simplicity of "The Anatomy Lesson" woke in him no kindling response to the master's principle of design. Of design, in the fine sense, his two huge canvases show no trace. Both are teased with figures and heads, both are "slices of life" instead of being pictures. Painting a portrait, he occasionally placed the figure with uncommon good judgment. The moment he tackled a crowded problem, the moment he dealt in accessories, his weakness was betrayed. The clutter of musical instruments in his "Mrs. Frishmuth" is an instance, in no wise to be excused from a pictorial point of view by the hobby of the sitter. Redundancies such as mark this canvas and others like it one might conceive as yielding to a purely scientific study of design. Even with his cool temperament Eakins might have worked out a better ideal of composition if he had chosen to sit at the feet of any one of half a dozen old or modern masters. But he would still have

been handicapped by his want of artistic passion, of enthusiasm for pure beauty, of imaginative fervor.

It is, after all, through imaginative fire that an artistic talent must pass to be tempered in taste, in subtlety, in all that carries drawing, color, and design to a thrilling plane. The severest test faced by Eakins is that which he essayed to meet in "The Crucifixion." It is an old story that the dead body in art can only justify itself in proportion to its emergence from the atmosphere of the charnel-house. It must be more than a dead body. A phenomenal exception, like Holbein's famous "Dead Christ" at Bale, remains, when all is said, a phenomenal exception. Michael Angelo was a realist, if ever there was one, in his "Pietà" in St. Peter's, but he saved his stark truth by bathing it in exquisite beauty. Eakins paints only the dead body. Better men than he have fallen into the same error. Velasquez himself, who could, as Whistler said, lend to an Infanta in her impossible farthingale the distinction of the Elgin Marbles, failed deplorably when he attempted to paint Christ on the Cross. And from the same cause as Eakins — his imagination could not reach that far. The test, as I have said, is terribly severe. But with Eakins the failure points, alas! to a deficiency that tells all along the line. You respect him for his sincerity and strength. He gives you no joy, no exaltation, because he gives you no beauty. If his work has the vitality of life it lacks the vitality of art. The fact is placed

unmistakably before us, but not charged with the personal, imponderable qualities which alone make the painted fact worth while. Beauty is truth and truth is beauty, we have been told. As Eakins would have it, truth may stand by itself, and, if not exactly inimical to beauty, at all events may remain unconcerned with its myriad mysterious sources.

# VII
## Kenyon Cox

# VII

# KENYON COX

WHEN Kenyon Cox was a student in Paris, under Gérôme and Carolus-Duran, he achieved a prodigious repute. He could draw then with an ability that astonished his masters and his comrades. It was as a man of unique ability — and training — that he started his career in this country. The fame of a remarkable draftsman followed him all his life long. But the determining element in his art, which he brought back from Paris, was really one which he had taken with him on his youthful journey to the French capital. It was an instinct for the life of an artist as something more than an affair of technic, of the things that can be acquired. He made himself a sound workman as a means to an end. The end, as he saw it, was art enriched by thought and imagination. He was a type of the old school that, as the saying has it, mixed its palette with brains.

He cared for what the French exemplars of his youth loved to call the *ordonnance* of a picture, the orderly arrangement in it of logical ideas. At the root of this preoccupation of his there resided a splendid sincerity and self-respect. Whatever he did he strove to do superlatively well. Years ago he made for *The Century Magazine* certain drawings from pho-

85

tographs of noted French actors, Coquelin, Mounet-Sully, Réjane. Those were the days of the pen, golden days, in which artists accustomed to that instrument used it with the conscientiousness of painters using the brush. Cox was, in this particular field, as brilliant as when, in Paris, he had drawn from the nude. His portraits from photographs were not perfunctory. They were works of art.

He had a rich experience as illustrator, making a memorable series of designs for Rossetti's "Blessed Damozel," but he had a large, intellectual feeling for his art, and it was inevitable that he should have sought commensurate opportunities, becoming one of the leading mural painters of his time. He gravitated to wall decoration with a kind of natural authority. I remember watching the first real burgeoning of our school as a school, seizing its first great public chance, on the occasion of the World's Fair at Chicago in 1893. Cox took hold of the space allotted to him, one of the domes, with the grasp of an old hand. Strengthening that grasp all the time as the years went on and as one important commission after another came to him, he affirmed himself more and more as a man not only of technical proficiency but of high ideals.

Composition, monumental composition, was to him a fairly sacred trust. It was because he felt its grandeur so intensely, because it was so allied in his imagination with the finest and most spiritual side of

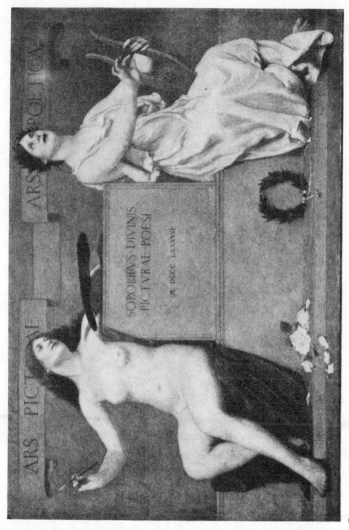

*From a photograph, copyright by Curtis & Cameron*

A DECORATION

BY KENYON COX

painting, that he was positively passionate in his reprobation of the Bolsheviki in art. I talked with him once at the celebrated Armory Show, before some of the cubistic fantasticalities of that enterprise. They had upon him the effect of a vulgar affront. He fought eccentric pretense in art, not out of any wanton opposition to progressive ideas as such, but because he knew that instruction, discipline, conscience are inseparable from the painting that endures. He was no follower of convention, no idolater of great names. When foolish and indiscriminate admiration of poor drawings by Rodin revolted him he frankly said so. Nothing old appealed to him simply because it was old. He turned to the past because he had the inspiration to see wherein the past was superbly right. In the education of American taste he had unquestionably a most salutary influence. The Bolsheviki did not like him, and whenever Cox stumbled as a colorist, whenever he failed to equal *ordonnance* with *enveloppe*, they were wont to objurgate both his example and his precept. They missed the essential point of his work, which was a point making honestly and constructively for art in the grand style.

Cox had, too, besides his power as a craftsman, a vein of very fine, delicate emotion. I recall an afternoon with him on the veranda of his New Hampshire home and his talk of the beautiful elements of design in the scene of hill and valley roundabout. If it was a tribute to what he knew of arrangement in art it

was also a tribute to what he felt in the imponderable charm of nature. A thoughtful, lettered man, he wrote and lectured as he painted, with an ever-wakeful consciousness of lofty standards. He was a penetrating critic, composing essays as delightfully readable as they are wise and suggestive. His brief study of Holbein is one of the finest things ever written on that master. He had imagination, poetic imagination, and on occasion this manifested itself in charming verse. Years ago, when he made one of the best of his drawings, a profile of the famous "Femme Inconnue" in the Louvre, he accompanied it by lines which make a singularly faithful souvenir of the quality of the artist and the man:

### THE UNKNOWN WOMAN

#### I

*She lived in Florence centuries ago,*
  *That lady smiling there.*
*What was her name or rank I do not know —*
  *I know that she was fair.*

#### II

*For some great man — his name, like hers, forgot*
  *And faded from men's sight —*
*Loved her — he must have loved her — and has wrought*
  *This bust for our delight.*

#### III

*Whether he gained her love or had her scorn*
  *Full happy was his fate.*

*He saw her, heard her speak; he was not born*
*Four hundred years too late.*

### IV

*The palace throngs in every room but this —*
*Here I am left alone.*
*Love, there is none to see — I press a kiss*
*Upon thy lips of stone.*

# VIII
# Poets in Paint

# VIII

## POETS IN PAINT

### I

### ELIHU VEDDER

THE prevailing tendency in American art has been toward an objective treatment of the facts of nature. This renders all the more conspicuous — and valuable — the work of a man rich in imagination. Such a man was Elihu Vedder, who died recently in Rome. He had lived there so long, detached from the familiar movements of his time, that there are probably thousands of his countrymen who never even heard of him. Yet he was one of our "old masters," one of those artists with whom the American historian inevitably will have to reckon. Born in 1836, he began his career in the late fifties, a period in which some of the finest painters we have had — such as Whistler, La Farge, and Winslow Homer — were feeling their way toward the expression of original ideas. Vedder was one of the most potential in the group.

He belonged happily to a generation that was not afraid of a romantic or symbolical subject. Later Americans, rallying to the slogan of "art for art's sake," narrowly interpreted it as excluding an inter-

est in theme. Absorbed in the study of technic, they shrank in horror from the interpretation of an idea drawn from poetry or myth. Vedder pounced upon it. He had a remarkable gift for landscape and used it as a background that invariably partook of the dramatic significance attaching to his main motive. Thus "The Lair of the Sea Serpent" evokes a chill of dread, not only through the vast coil of the monster but through the grimness of the scene in which it is placed. He painted "The Cumæan Sibyl" and heightened enormously the effect of the swarthy woman, striding along in her swirling draperies, by the grandeur of her background. "The Lost Mind," that impressive example of his art which hangs in the Metropolitan Museum, owes much of its beauty to the austere cliffs beneath which the unhappy woman wanders.

The power indicated in this fine exploitation of landscape in Vedder's pictures is, of course, the power of design. That was his great resource, the trait which sprang in him from something like genius. He was extraordinarily fecund in invention, and there was a delightful naturalness and ease, too, in his mode of composition. There was nothing academic about him. His style was, perhaps, a little heavy-handed, but it was free from convention; it denoted personality. Allied to the beauty of his imaginative conceptions it ought to have won for Vedder a European as well as an American celebrity. He had in him a

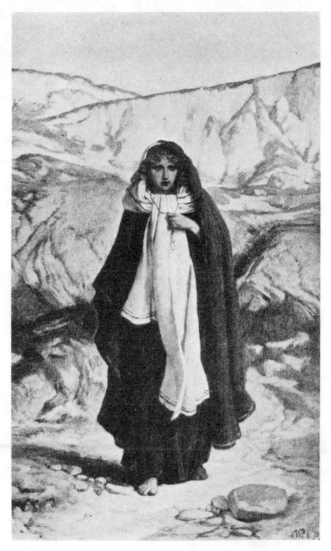

THE LOST MIND
BY ELIHU VEDDER

strain ranking him with Gustave Moreau in France, with the pre-Raphaelites in England. What was it that kept him from achieving a greater status than that which he actually enjoyed? The very isolation in Rome which, from one point of view, should have aided him. Just as his juniors lost much through sacrificing the idea to technic, he lost much by sacrificing technic to the idea.

His touch was, as I have said, heavy-handed. His painted surfaces were often drab, inert, leathery. His color was opaque. Draftsmanship he had, of a high order, and it pulled him through; but Vedder would have been twice the artist he was if, to put it ruthlessly, he had thoroughly learned how to paint; if he had profited by impressionistic example and brought light into his work; if, in a word, he had kept pace with the progress of modern art instead of scornfully rejecting it. I say "scornfully" advisedly. He was a proud and even opinionated artist. Once at a Roman dinner-table he met a friendly allusion of mine to Fortuny with the disgusted observation that the Spaniard knew no more than the literal painting of the buttons on a coat. He despised what he thought was mere manual dexterity. As a matter of fact, an infusion of Fortuny's technical adroitness would have been the making of him.

But draftsmanship, I repeat, pulled him through. The conclusive triumph denied him as a painter pure and simple he won when he made his famous designs

for "Omar Khayyam" in the eighties, and the mono-
tone of the reproductions withdrew attention from
everything save his felicities of design and the grace-
ful eloquence of his line.  He had the mind and spirit
of a poet and responded to the magic of FitzGerald's
quatrains with a clairvoyant sympathy, leaving his
pictorial accompaniment one of the great monuments
in modern illustration.  He made the drawings within
a year, a *tour de force* if ever there was one.  The
rapidity of the work, its beauty, and its absolutely
convincing character all testify to Vedder's rôle as
that of an essentially creative artist.  There have
been youngsters in the American school who could
outpaint him, as it were, without trying.  In his orig-
inality and in the fervor of his inspiration he remains
unique.

## II

## ALBERT P. RYDER

Ryder wrote verses, and I can sniff the offense this
circumstance would give to a certain type of artist.
Clearly, such a commentator would tell us, they in-
dicate that he had in his temperament the taint of
the literary man.  There would be, too, the further
justification for this view of the matter that he had
a passion for literary subjects, and to clinch the busi-
ness there is the damning fact that he had, in our
smart modern sense, no technic at all.  What student,

fresh from Paris or even from the League, could not
have shown him how to draw? Are not the trees in
his landscapes the woolliest things imaginable? He
knew nothing about impressionism. For the lumi-
nosity of nature itself, which Monet and his followers
have taught us to value so highly, he chose to substi-
tute the light of the poet, the light that never was on
land or sea. His apocalyptic skies are flatly incredi-
ble as skies in the ordinary understanding of the
word, skies filled with an authentic blue and relieved
by accurately modelled cloud forms. Yet Ryder re-
mains an enchanting artist, the very foibles at which
I have glanced playing into his hands, assisting rather
than retarding the flow of his inspiration.

He had inspiration — that is the all-important point.
Where many painters infinitely better equipped, tech-
nically, have nothing whatever to say, and conse-
quently bore us to death, Ryder was so rich in imagi-
native thought and feeling that we almost forget his
technical limitations. He had personality, the mys-
terious magic which in some indefinable way com-
municates to the beholder a sensation of beauty.
Perhaps the most eloquent proof of this lies in one of
the least obviously imaginative of all his works, a
landscape called "Weir's Orchard." It is a simple
pastoral motive, the sort of thing almost any land-
scape man might have chosen to treat, and, subjected
to the test of technic, the first impression it yields is
that almost any landscape man might have made a

better job of it. But what of the atmosphere enveloping it and the personal note it strikes? When Lowell heard Emerson lecture in the time of his declension, when vagueness had descended upon him like a garment, he could not make head nor tail of the discourse; but he left the place feeling that "something beautiful had passed that way." That is the conviction with which you turn from this landscape. It is a sadly fumbled affair, but Ryder has passed that way and you are inordinately glad of it. I have alluded to his skies. Look, for example, at a marine like his "Under a Cloud," in which a dark sailboat scuds over a dark sea, beneath a darker cloud. As a study of natural phenomena the picture is hopelessly inadequate, but as a bit of poetic symbolism it is so thrilling and so beautiful that one would not exchange it for a dozen of the finest marines Dupré ever painted.

How potent is the sway of the artist who dreams exquisite dreams and paints them with sublime sincerity! Ryder's handicaps were of a nature to have discouraged most men beyond all patience. Even in the field of color, where he was the more favorably endowed, he was confined to a rather narrow scale, and he had a tendency to muddy the deep bluish greens, the tawny reds, and the golden yellows with which he dealt. At times he seems to have practically lost control of color, as witness the "Macbeth and the Witches," in which figures and landscapes are withdrawn into an almost impenetrable penumbra. Yet

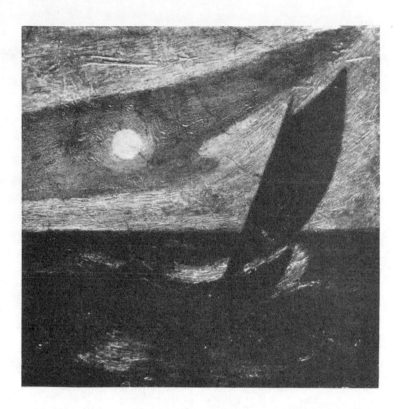

MOONRISE AT SEA

BY A. P. RYDER

from amongst the thousands of Shakespearian illustra-
tions I have seen I can recall not one that is even to
be compared with this. Indeed, its only rival as a
foot-note to the play is that amazing essay of De
Quincey's, "On the Knocking at the Gate, in 'Mac-
beth,'" with its kindred spiritual insight into the core
of the drama. I can imagine Ryder's response to the
poignant simplicity of the famous stage directions —
"Scene, an open place. Enter three witches." He is
as free himself from surplusage. We behold his vision
as in a flash between thunder-claps; it goes as swiftly
as it comes, and, thanks to the dense obscurity to
which I have referred, we feel for a moment as we
sometimes feel in life, as if we have imagined the
thing which we had seen. Drama like this, on can-
vas, is surely extraordinary achievement.

There is one supreme merit in Ryder which inclines
me to rank him far above any of the men with whom
he might be said to have a certain alliance — such
men as Burne-Jones, Rossetti, Blake, Moreau, Boeck-
lin, and Klinger. This is his prodigious variety.
Take the works of any of the artists I have mentioned
and you will find running through them all the "family
likeness," due to persistent cultivation of a definite
line of thought. Ryder's imagination has no fixed
haven. He would paint a horse in its stable and then
"The Temple of the Mind." In his masterpiece, the
"Jonah," he seems in the mood of Michael Angelo,
but presently, in "Siegfried and the Rhine Maidens,"

he exchanges the grand style for the truly operatic. He is lyrical, if ever a painter was, in his two versions of "Pegasus," in his "Dancing Dryads," in "The Lovers," and when he paints the "Resurrection" it is as if he had taken Milton, "chief of organic numbers," as a guide to the sweetest solemnity of his strain. I might cite indefinitely the mutations of his genius, the transition from the homely charm of such a rustic theme as is disclosed in "Mending the Harness," to the romanticism of his "Forest of Arden," from the pathos of his religious subjects to the mere sensuous beauty of his sea-pieces. But I prefer to go back to the central source of all these different keys — his wide-reaching imagination, the passion in him, always leading on to some new adventure, which I can only define as the passion for beauty. I think for a moment of Monticelli, and that gift of his for color which carried him sometimes to the very borders of fairyland. Ryder crossed the borders. He got at the very heart of things fairylike, remote, poetic. Color helped him, but the genius of the poet helped him most of all.

## III

## ARTHUR B. DAVIES

Wordsworth is not primarily a painter's poet, but there are some lines in one of his sonnets which are ideally descriptive of the spirit governing a certain type of artist. He might have been speaking for that type when he said:

"Great God! I'd rather be
A Pagan suckled in a creed outworn,
So might I, standing on this pleasant lea,
Have glimpses that would make me less forlorn;
Have sight of Proteus rising from the sea,
Or hear old Triton blow his wreathèd horn."

The familiar passage is almost uncannily exact in its expression of the general emotion and the particular point of view characteristic of a race of painters having a place of its own in the history of art, a race rebelling against the prosaic reality of things and driven for its imaginative sustenance not merely to the past, but to a world outside of human experience. The progenitors of this race flourished in Italy, in the time of the Renaissance. "Wistful" is the epithet which Walter Pater somewhere applies to Botticelli, the greatest of them all, and no other word could so felicitously connote the pensive, fragile sentiment informing the works of these romantic dreamers. They are forever hungering for something which they can-

not quite attain, forever pursuing an elusive vision. There are, perhaps, the seeds of sadness in their art, but they are themselves unaware of the pathos about their high adventure. They are too much in love with beauty to be consciously sorrowful. They win the nearer to their goal, too, in proportion to the success with which they preserve their simplicity, their naïveté.

In painting of this kind, as Matthew Arnold said of poetry, illusion is everything, and the illusion depends upon the childlike faith which the artist can maintain. I have alluded to the greatness of Botticelli. That was due to the weight and volume of his genius, the power of *ordonnance* he exercised in the making of a picture. But it is not always the greatest artist who most hauntingly expresses the subtle, evanescent quality of the sort of picture we have in mind. The "Primavera" or the "Venus" might be said to sacrifice illusion to brilliance of design. For the true spirit of the school, disclosed in its most intimate aspect, I would cite, rather, such a master as Piero di Cosimo. He hadn't a tithe of Botticelli's gift for composition, his technic was immeasurably weaker, but he illustrates to perfection the charm of the painter artlessly seeking after glimpses that would make him less forlorn. When he paints the death of Procris, when he commemorates the feats of Perseus or portrays Hylas among the nymphs, he impresses us as a child wandering with touching confidence in some golden fairy-

land. His allegories are obscurity itself, yet we share
in the joy that he had in painting them. Long ago
Arthur B. Davies struck me as in some sort a modern
Piero di Cosimo. That resemblance still persists.

It is a poetic, imaginative resemblance. What
Davies sees is important to him, but it is what he
feels that is important to us. One looks in the first
place, to be sure, at what he makes of nature, and it
is instantly obvious that he has a very close and sym-
pathetic grasp upon landscape. His "Lake in the
Sierras," one of a fairly large group of long, horizon-
tal panels, makes it plain that he could rest a sub-
stantial repute simply upon his work as a painter of
forest and water. But his landscape is chiefly a set-
ting for his ideas. When he painted his remarkable
"Unicorns" he painted a scene by itself superb, but
its majesty as a transcript from nature is not so mov-
ing as its curious expression of the mystery envelop-
ing the unicorns and their attendants. The scene is
eloquent of nature, yes, but also of the artist's mind.
The truth of the visible world that it records hardly
counts beside the play of his imagination. With
Davies, too, as with Piero, the precise imaginative
meaning of the work is of less importance than the
vague pervasive sense of mythical romance and
beauty. It is a characteristic of the type represented
by Davies that it suggests rather than explains. Art
in this field is episodical, fragmentary, moved by cre-
ative passion that comes in vagrant gusts. It gains

thereby in spontaneity and it loses something — something of architectural bigness and balance. Look at Gustave Moreau, Odilon Redon, and Ary Renan in France. They all have their quality, but none of them rises to quite the authority of Puvis de Chavannes. We must pay for our whistle. We cannot make friends with the fairies and develop that strain which the French have in mind when they designate a work "magisterial." Within the confines of an easel picture Davies can capture something of the magic of the grand style, but I wonder if he could do the same thing in a sizable mural decoration.

Yet there are some strong steadying influences at work in his cosmos that might conceivably make him as successful on a great wall as on a modest canvas. I have marvelled at the manner in which modernism touched him without hurting him. At one time it seemed to have got him firmly in its toils. He painted queer cubistic things. They led nowhere. It was pathetic to think of a man of his gifts winding up in that impasse. But he emerged without a scratch. He had been trying a new thing and having exhausted it he reverted to his natural mode of expression. I think the steadying influences aforesaid had something to do with it, his knowledge of form and respect for its truths, his sound habit as a draftsman — in a word, his instinctive feeling for the fundamental laws of nature and of art. Above all, the thing that saved him from drifting about in a sea of theory was

his interest in life, his ardor for humanity, the very world from which he departs on sublime adventures. This dreamer of dreams is, paradoxically, never wafted by them away from contact with the spirit of man. Heaven and earth are inextricably woven together in his visions.

# IX

## American Art Out-of-Doors

# IX

# AMERICAN ART OUT-OF-DOORS

## I

### THE HUDSON RIVER SCHOOL

To come upon a collection of pictures by artists of the Hudson River school is like revisiting a world in which the traditions on which most of us have been living had not yet gained a foothold. To the men who made such collections the Barbizon painters were unknown. From the impressionists, I imagine, they would have positively recoiled. Their standards were not what the criticism of to-day calls modern. It is imaginable, therefore, that to many observers any return to that comparatively recent past must seem dispiriting and profitless. Yet there is interest in the adventure for those who would make it sympathetically and with a desire to appreciate what was good in our pioneers. Go a bit farther back, back to the earlier American portrait-painters. There is no mistaking certain virtues which they contributed to the school filling the gap between the old eighteenth-century régime and the newer movements characteristic of our own time. They had a fine sincerity, they had great respect for themselves and their craft, they made "thorough" their watchword. It is well to

ponder the value of such virtues before indulging in
any light dismissal of the old landscape-painters as
completely outmoded. They have been outmoded,
yes, but not completely. It is curious to observe how
fine an atmosphere pervades any body of their works.
It is the atmosphere of artists who were, after all, as
genuinely enthusiastic as any that ever lived, and, in
their way, were remarkably accomplished. Accord-
ing to their lights, they did what they had to do super-
latively well.

Kensett, Casilear, Cropsey, Durand, and the rest
perfectly well illustrate good craftsmanship as it was
understood in the middle of the last century among
American artists. They drew with prodigious care,
conscientiously, and with a certain dry precision. Be-
cause their precision was so dry their work has lost
savor to the modern taste. It functions in a pellucid
but lifeless light. No personal distinction endues this
meticulous draftsmanship with æsthetic vitality. And
in color, as in form and texture, the prevailing tone
is too cold, too conventional. It seems almost incred-
ible that our painters could ever have been satisfied
with the calm, literal, depersonalized sort of report
from nature which is given in, say, a "View from
Dobbs Ferry," by Kensett. It is as unemotional as
a time-table, and of the charm of paint as paint the
artist had evidently no intimation whatever. Yet, I
repeat, such pictures have not utterly worn out their
welcome. They are too sincere for that, and they

are too firmly founded upon a technical excellence
which is rare in any epoch. This is the excellence of
workmanlike composition.

There are few pictures of this period which, like the
"Mountain Stream" of Wyant, have in them the faint
glow of genius. The sylvan magic of Worthington
Whittredge's "Trout Stream" is rarely felt. In the
main these artists call up constantly the epithet I
have already used, they are dry, and we pass their
works, realizing that that is why one seems very like
another. But the broad impression they convey is
more interesting, and good composition is at the bot-
tom of it. Their pictures are gracefully and well put
together. The point of view is judiciously chosen.
The scheme is then worked out with a sense of bal-
ance, and — curiously, considering their close analyti-
cal habit — with tact as to what to leave out. They
were almost afraid of nature, painting her with aca-
demic moderation, grooming her out of all knowledge,
and yet the fact remains that they made pictures, not
casual fragments. In their polished serenity, their
discreet lighting, their neat disposal of details, these
pictures have a certain museum-like charm. They
cloy, after a while. One craves more vigorous airs,
stronger color — above all, greater breadth and free-
dom. Nevertheless, in the absence of these things
one need not ignore the refinement of the Hudson
River men, their wholesome and even elevated spirit.
They needed a modernized technic. Without it the

spark of artistic longevity has gone out of their work.
But they had glimpses of beauty, of something which
they had the taste to cultivate — if only the gods had
given them the secret of painting as the true painter
knows it.

## II

## GEORGE INNESS

The honor of having lifted our school of landscape-
painting to the high plane on which it has successfully
challenged the modern masters of Europe must be
divided among several men.   Alexander H. Wyant,
Homer Martin, Winslow Homer, were all potent pio-
neers in this matter, and some credit belongs also to
John La Farge, whose Newport scene, the "Paradise
Valley," painted in the sixties, established a landmark
in its field.   What gives Inness his place apart is the
peculiar fulness with which his work describes the
progress of an idea.   Born in 1825 and dying in 1894,
he embraced in his long career the whole gamut of
landscape-painting, save for that French impression-
ism which was just coming into its own as he was get-
ting ready to lay down the brush.   His pictures vividly
expose the evolution of a man of genius, proceeding
step by step in the beating out of a style.   None
of his contemporaries can show so transparently se-
quential a record.   And none, I may add, is more in-
tensely personal in the quality of his effort.   Inness

had no preliminary training that amounted to any-
thing. There is mention of a French mediocrity,
Regis Gignoux, in his biography, but it has no signifi-
cance. Nature appears to have been his chief source
of inspiration from the beginning, reinforced by travel
in Italy and contact with the works of the French
naturalistic and romanticist painters of 1830. But, of
course, he was subject to the influences around him,
in the air, and at the outset he naturally painted in
the meticulous fashion characteristic of the old Hud-
son River school. The habit of his young manhood
is well disclosed in his "Juniata River near Harris-
burg." That picture, which dates from 1856, sums
up the traits of his formative period. It is a thing of
minutely observed detail. One can almost count the
leaves on the trees. From the point of view of the
matured Inness this map-like, photographic transcript
of so many laboriously studied facts ought to be as
dead as Pharaoh. But what a queer thing is genius!
This picture cannot die. A mysterious life is stirring
it, the energizing touch of an artist who could not be
merely photographic though he tried. The vitalizing
factor is not easily definable but it is there. The ex-
cessive detail, which nominally should kill the whole,
is not, after all, incompatible with a certain largeness
of feeling. All the time that Inness was just taking
pains with his subject there was at the back of his
mind the generalizing instinct that goes to the mak-
ing of great works of art.

In Mr. Daingerfield's illuminating little book about
him the statement is made that "he early began a
laborious, even servile, copying of the landscape he
saw with his own eyes, nor suffered rules or formula
to guide his pencil." The second point here made is,
if anything, more important than the first, indicating
as it does the individual nature of Inness's realism.
There is no landscape-painter of his time, here or
abroad, who possesses more of the character of the
discoverer, the master of research. And here comes
in one of the most exciting elements in his history, the
resolution with which he used his studies as only a
means to an end. Roughly speaking, one would say
that, beside Rousseau, for example, Inness knew noth-
ing about tree and ground forms. These are given in
the work of the Frenchman a salience never observed
in the American's — once the early period of the lat-
ter is left behind — and they have, often, an extraor-
dinary interest. But when Inness called the forms in
Rousseau "petty," as, according to Mr. Daingerfield,
he frequently did, the criticism, if hardly fair to Rous-
seau, has by indirection a certain instructive bearing
on his own art. They are not "petty," as it seems to
me, when seen in the whole perspective of Rousseau's
special hypothesis, but they would have been "petty"
for Inness. By the nature of his genius he was im-
pelled to go on where Rousseau often left off, to syn-
thesize his forms and thereby raise them to a higher
power. If he did not always actually do this it was

not because his principle was wrong, but because he was a creature of mood, having his good and his bad moments.

The discipline in which he trained himself was but an aid to memory, the foundation supplied by the fact for the realization of the dream. "My forms are at my finger-tips, as the alphabet is on the tongue of a schoolboy," he used to say, and perhaps the best story ever told to show the confidence with which he could rely upon them is the one about the landscape, with cows, in which the cows were only notes of color. The man who had purchased it at the Academy fetched it to Inness and asked him to "touch up" the cattle. When he came back he found that his landscape had been turned into a sunset glowing over a stormy sea! Could anything more completely destroy an artist's repute for painting with his eye on the object? But that wasn't precisely the repute that Inness was looking for. He was, at bottom, something of an improvisatore, like Monticelli or Bunce; something of a "symphonist," like Whistler. Only that alphabet of his was always creeping in; the fundamental knowledge of as clear-eyed a realist as ever lived was at the base of his most fervid improvisation.

To get a good idea of this underlying truth of his as regards form the student should make a point of paying special attention to his water-colors. Let him observe more particularly the studies of trees and rocks, and those of Alpine structure. He will see how

penetrating Inness was, and how exact. And he will see, again, even in these little sketches, the action of that subtle feeling to which I have alluded in speaking of his "Juniata River." Inness may be never so careful as to the object before him, and yet he will turn it into a picture, enveloping it in the quality of his style. Yes, he knew all about form. But to have emphasized it in his paintings would have been, for him, petty. He saw his scene as a whole, saw it emotionally; saw it, too, as a colorist. Hence the not infrequent treatment of the earth in his compositions as matter having next to no anatomy. This cavalier handling of the problem is sometimes disconcerting. One wishes for a little more solidity, a little more structure. But to ask that is to ask Inness to be some one else, and, incidentally, to overlook what he is really driving at. That is the broad impression of atmospheric truth, doubled with sensuous charm. And when a painter achieves these things in terms of beauty, how absurd it is to repine over the elements that he chooses to omit!

There was a period when he gave that structural impression to which reference has just been made, and, though not a puissant colorist, secured some wonderfully beautiful effects. It is the period of the seventies and of his travels in Italy. The very spirit of an old Italian hill town is in a certain little "Albano" of his, and with it, besides great beauty of composition, faintly suggestive of the classical influ-

ences surrounding him, just the clarity of statement which we occasionally miss in the works of his prime. The "Albano" is a gem, a perfect illustration of the painter's middle period. He went on from that stage, from the triumphs of the faithful interpreter to those of the landscape poet, from the skill of the accomplished craftsman to the bravura of the virtuoso, the emotional affirmations of the inspired colorist — with nature still his guide. Nature has her way, the fact is stated, but we are moving now in a new world of air and color, in a world transmogrified by imagination, made radiant with beauty. It is Inness using his forms, I repeat, as a means to an end, turning a landscape into a marine and violating no truths in the process, remembering the thing seen, but commemorating it as a thing felt — in a word, lifting landscape art to a nobler estate.

How far he travelled from the patient notation of ponderable details! And yet how consistent was his evolution, how steadily expressive through all its phases of nothing more nor less than a passion for the loveliness of nature! It is interesting to note the persistence in his work of the racy, elemental quality which belongs to the American countryside, which makes him one of the most characteristic figures American art has ever known. The classical influences he found in Italy never fixed themselves upon him. It is significant that while he painted quite a number of more or less heroic canvases he never made

any of them "monumental" in the strict sense of the term. In the matter of design he was by no means uniformly apt. Some of his motives have a haphazard air. Others suggest his having cared more for the sentiment of a given scene than for the pictorial balance which meant so much to the Barbizon school. But what if the sentiment is masterfully expressed? He was no more in sympathy with the composition of Barbizon than with the composition of Claude. What he lived and painted for was the artless beauty of the fields and woods, the fascination of a sky torn by the storm, not "built up" into a glorious pattern. The glory would be there, if he got the soul of the storm. It is curious to examine one's sensations after a stay with the paintings of Inness — how full they are of the sounds and smells of nature, the rustling of leaves, the tang of burning brushwood. And sun and shadow are all about one — or the cold light of winter. It is our summer, our winter, that he paints, the very grain and savor of our soil —

> "God made sech nights, all white an' still,
>     Fur'z you can look or listen,
>  Moonshine an' snow on field an' hill,
>     All silence an' all glisten."

Inness, in painting, has done what Lowell has done in verse, capturing the simplest, homeliest, friendliest, aspect of the American scene. His art — and he was full of art — is free from the slenderest trace of arti-

fice. His is the "natural magic" which makes us free of the beauty of the visible world without romanticizing it. He was a great colorist who held fast to the truth, a virtuoso with the heart of a child.

## III

## WINSLOW HOMER

Winslow Homer was perhaps the most intensely American painter of his time. He lived and worked in America almost uninterruptedly, and through his career he chose his subjects from the life about him. His art was born in him; it grew as he grew; it was nurtured from his youth on the racy elements of American character. Of all our conspicuous painters there has been none more generic, more national in the substance of his work, more true to his country in the wholesome simplicity of his point of view. In being true to his nation Homer was true to himself. He did not paint American pictures because American life seemed to him, from the outside, to be fruitful of pictorial inspiration. He painted them because his temperament was in tune with his materials, because his sympathies spontaneously, and, one might say, unconsciously, found an outlet in the celebration of homespun themes. His nationality, in short, is to be found in the very grain of his art.

At this point, however, it is interesting and even a

little amusing to make a certain distinction. When Winslow Homer was made an associate of the Academy of Design, in 1864, most of his colleagues were tinctured with the "literary" spirit which the next generation was to oppose with all its energies. As a war artist he was bound to respect the purely human motive, and, indeed, it never lost for him a profoundly poignant interest. But it seems never to have occurred to him to tell a story in paint after the manner of the artist to whom the anecdote is everything. Homer was, in his way, quite as distinctly the artist pure and simple as Alfred Stevens, say, with his passion for the caressing of surface. As a matter of fact, he never developed the sensuous charm that belongs to the Belgian master, but he had the same intensely artistic emotion. When he attacked a theme he gave it its full value, but never let it encroach upon the integrity of his technic. His art was beautifully balanced. You admire it for its own sake, yet this does not keep you from admiring its subject. Indeed, the very perfection of the equilibrium he established gives to each phase of his work the fullest possible force. Thus, while his technic is of the highest interest, nature speaks through his work with a peculiar richness and fulness. Though, as we have said, he had nothing of the literary man about him, it so happens that we may discover a clew to his secret in some sayings by a master of literature.

Matthew Arnold, in his essay on Maurice de Guérin,

wrote some memorable things on what he called "natural magic," the power of the poet so to interpret nature as to give us "a wonderfully full, new, and intimate" sense of it. He laid stress upon the fact that true natural magic placed nature before us in its very essence, not overlaid by anything peculiar to the poet. It expressed with magical felicity "the physiognomy and movement of the outward world," and, paying tribute to Keats and Guérin for their possession of this faculty, he added: "When they speak of the world they speak like Adam naming by divine inspiration the creatures; their expression corresponds with the thing's essential reality." There you have the distinguishing trait of Winslow Homer, his "natural magic." The visible world is mirrored in his work with so much emotion, with so much beauty, and, in many cases, with so obvious a feeling for mankind, that your first impulse is to think of him as a man who sought in life so much raw material and then proceeded to subordinate it to some higher artistic purpose. On second thoughts, you see that this view of the matter is not quite accurate. The actual situation leaves Homer more in the rôle of a passive clairvoyant, through whom nature had its way. Consider, for example, the comparative rarity of those episodes in his art disclosing a deliberately dramatic purpose. When a subject of his is positively thrilling, you are struck by the fact that it seems a subject observed, never a subject invented.

Look at that astounding picture of his, "The Gulf Stream," in which a negro adrift in a disabled boat lies waiting the final catastrophe. That is Homer's "Raft of the Medusa," it is his "Don Juan," which is to say that it is his equivalent for the drama of a Gericault or a Delacroix. And how much divides him from those masters! For them the tragic motive was necessarily surcharged with a certain romantic fervor. Homer is almost passionless in his delineation of a lurid scene. He stands aside and leaves his facts to speak for themselves. *His expression corresponds with the thing's essential reality.* But that he took no sides, that he was, as I have said, almost passionless, does not mean that his work is wanting in heart. On the contrary, that is precisely what it is full of, from beginning to end. There is one painting of his I recall, the "Cape Trinity, Saguenay River," a moonlight scene, which has, whether intended or not, a remote and even fantastic effect. By accident, as it were, Homer would appear to have stumbled in this instance upon a note recalling Arnold Boecklin. But in the bulk of his work there is nothing fantastic, there is nothing remote. In his early war subjects, in his Northern sea-pieces and hunting scenes, and in his water-colors painted in the tropics, one is conscious, above all, of what can only be described as a kind of artless simplicity, a frank interest in familiar things making those things curiously real and touching. Yes, there is heart in these pictures, a man's sensitiveness to the appeal of men, a nature-lover's kindling

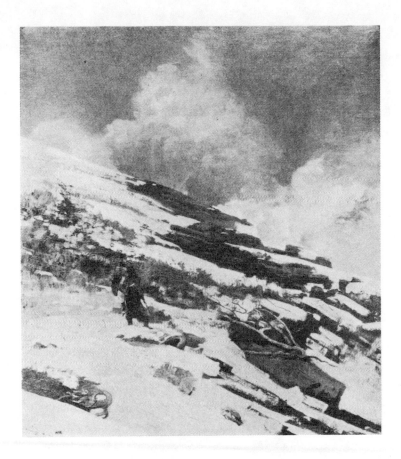

THE STORM

BY WINSLOW HOMER

emotion in the presence of his native land. It is impossible to avoid the reflection that the Maine coast had a sort of personal fascination for Homer. He was not by any means indifferent to the charms of Europe. He painted well in England, as he painted in the Bahamas. But he was extraordinarily at home when he painted on the New England coast. Something stirred him then, an inspiration to be found nowhere else. The very soul of Winslow Homer is in pictures like his "Banks Fishermen" or that "Coast in Winter" which has something titanic about its power, something of classical weight and simplicity about its noble impression of stark loneliness — for the figure of the hunter in this picture only serves to emphasize its character as a study of wild nature.

Technically Homer varies according to the medium he uses. As an artist employing oils he is a powerful designer, a powerful definer of form; he is not a master of *facture*, a technician deft in the exploitation of the sensuous nuance, the exquisiteness of mere painted surface. But he assumes the rôle of the refined technician when he paints in water-colors. It is a curious instance of the *flair* of an artist for his medium. It took a long time for Homer to conquer the stubborn character of oil-paint, and he never used it, as a colorist, with complete authority. For the lighter vehicle his sympathy declared itself at an early period. Even before he had adopted it he helped to organize the American Water Color Society, in 1866, and when once he had practically savored its allurements he

handled it with an ever-increasing enthusiasm and skill. His touch at first was more or less deliberate. It is the touch of such a picture as "A Voice from the Cliff," painted at Tynemouth in the early eighties. Later, and more characteristically, he developed the method we know.

It is the method of an accurate observer who knew how to give details their full value and yet subordinate them to the synthetic purpose of a true colorist. In these lightly touched notes Winslow Homer is indeed a man for whom the visible world exists, a world of sylvan greenery, swift waters, animals, fishes, and sportsmen, all bathed in searching light. His eye catches every vivid glint in the spectacle, every beauty, and it is unerring in its capture of the truth. Once a friend, Mr. John W. Beatty, said to him: "Mr. Homer, do you ever take the liberty, in painting nature, of modifying the color of any part?" The reply of the artist has the value of a profession of faith: "When I have selected the thing carefully, I paint it exactly as it appears." He cited as a particular example of this method the painting, "A Summer Night," which was purchased by the French Government at the Paris Exposition of 1900, and now hangs in the national collection of foreign work. Painting in oil, he achieved with labor the effect of "simple and absolute truth." Painting in water-color, he achieved it at a stroke, with the certainty of the artist having an inborn gift for a medium, and in perfect fulfilment

of the law of spontaneity which is the law of the water-colorist's art.

This truth of Homer's, this directness, this almost blunt naturalism, and, finally, this crisp spontaneity, are intensely American, befitting the atmosphere of his themes. In technic and in subject one always comes back to his Americanism. His work is saturated in the spirit of place. Even in his pictures of the sea, pictures of a grandeur excluding thoughts of mere race, there is still a savor, a subtle something, which reminds us that the sea, as he knew it, was the stormy sea of our own Northern shores. There is much to be said about Winslow Homer in his more narrowly artistic aspect, about his simple force as a draftsman, about his uneven but sometimes beautiful color, and about the beauty of his composition, a quality through which his genius shone resplendent. But it is the special purpose of these brief notes to indicate the simple vitality of his art, its fidelity to nature, the wonderful way in which it takes us away from ideas of paint and the like and makes us rejoice in the salt winds of the sea, the loveliness of sky and water, the fundamental charm of human nature bearing itself bravely and effectively in the face of the elements. Homer was one of those great artists who, having something to say, as well as a way in which to say it, as well as a style, have a certain universality of character. They are very rare, very distinguished.

IV

## WILLIAM GEDNEY BUNCE

Bunce was born at Hartford in 1840.   He died there
in 1916.   The long life enframed by these dates re-
ceived its unity from a passion for one thing, the en-
chantment of Venice.   He painted it with the hand
of a master.   There has been no one else quite like
him in American painting or in any other school.
One appreciates the unique character of his work the
more, too, when one considers the circumstances from
which he wrested a career.   He began life in the last
environment in the world calculated to stimulate
æsthetic aspiration, in a Connecticut country store.
But he had a sense of beauty even then and there.
It is said of him that one reason why he shrank in
after-years from revisiting the scenes of his boyhood
was that he had a nightmarish memory of certain
door-knobs at home, horrible in color and in shape.
Something of the same repulsion must have gone with
his thoughts of the mode of painting which prevailed
here during the time of his pupilage, back in the six-
ties.   When he escaped from the store it was to enter
the school at Cooper Union, and the tradition first
confronting him was that of our Hudson River group.
William Hart gave him instruction, an estimable
painter, but not by any means the type that Bunce
was destined to emulate.   In Munich later he studied

under Achenbach and in Antwerp under Clays. The last-mentioned is the only artist whose influence is at all to be recognized in his characteristic work, and upon what he learned from Clays he was soon to overlay a totally dissimilar quality. For the placid realism of the Belgian he was to substitute a romanticism utterly his own. This came into being when he discovered Venice, made it henceforth his stamping-ground for nearly a lifetime, and identified his art with it as conclusively as the art of Diaz, say, is identified with the forest of Fontainebleau.

Though their styles have nothing in common, there were points of contact between the Frenchman and the American. They both thought in terms of color. They both poetized their subject in the sense that they took nature as the basis for a kind of revery. It would be a mistake, however, to think of Bunce as a deliberately imaginative painter, going about his work with a definite idea of transforming his portrait of a place into a preconceived unit of design. He simply painted what he saw, and, with his nature and vision, he saw Venice in a sensuous glow, almost, but not quite, a phantom city, drifting above the lagoons as in some opalescent mirage. He never lost his hold on the tangible elements in the scene. The bulk and majesty of the great campanile were never rendered insubstantial in his pictures. For one thing, he knew how to draw. The sails of his boats and the hulls beneath them are defined with a precision as keen as

that bestowed upon his towers. But realism with him was only a means to an end. It was into the super-structure of a painting that he threw his genius, making beautiful a subtle web of color.

Foregathering with him from time to time over a long period of years, I found a clew to his artistic achievements in his personality. That was absolutely original. His very silences were expressive, seeming to cover fruitful musings. He would come out of them with unconventional and sometimes very penetrating sayings. Life had had its unpleasantnesses, but he could chuckle over them. His own point of view was so real to him and so valid that he couldn't altogether understand the person who failed to see eye to eye with him. There was no conceit in his single-mindedness; there was, rather, a kind of naïvete. Some of his narratives of experiences in Venice and at Davos, where he frequently visited, were delectably droll, not so much for their intrinsic comedy as for the detached, amused way in which Bunce looked at them.

Influences? They are, when all is said, unimaginable in his art. He was the Venetian painter, as he was Bunce, because he couldn't help himself. What was it that gave him his pre-eminence in the depiction of Venice? I have spoken of his color, but his singularity goes deeper than that. His vision of Venice endures because it is, in the old phrase, "simple, truthful, and impassioned." Convention generally places the great name of Turner in the foreground of this

subject, and, as is the way of convention, a little too conspicuously. The English master saw Venice as a pageant. Golden glories of her historic past reverberate through his pictures. It never mattered a rush to Bunce that "once she held the gorgeous East in fee." He was content with the Venice existing before his eyes. It was Turner, I believe, who retorted to the lady who complained that she could never see sunsets like his with the ironic words: "Don't you wish you could?" Between Bunce and the beholder of one of his paintings there is a closer tie, though he, too, put something into his sunsets beyond the experience of most of us. It was his simplicity that largely helped to establish the bond, his acceptance of the long, low-lying roof line, his refusal to fret it with too many pinnacles, his introduction of only a few boats into the foreground, his shrewd concentration upon what are, after all, the main elements in the Venetian scene, the sea and sky, with a glittering or shadowy strip of buildings in between. He abhorred niggling details. I have known Martin Rico in Venice and have watched him at work, drawing some church or palazzo with meticulous accuracy against a flat blue sky. He always made an authentic record. But that would never have satisfied Bunce. He enveloped his record, and the truth, as I have said, is magnificently there, in the shimmering fabric of color that was inseparable from his Venice, the color, and something for which there is only one word — sentiment.

The other painters of Venice — whose name is legion — from the canonical Turner himself down to Whistler, Miss Montalba, Ziem, Hopkinson Smith, any number of the most varying types, have done charming things; but for Bunce, as it seems to me, there was reserved the privilege of interpreting the most elusive essence of the city's genius.   Sea and sky, there are the keynotes.   He plays with them lovingly, caressingly, and with a positively magical touch.   Having painted his first impression and given it the indispensable solidity, he enriches the panel with one thin glazing after another.   The sea grows more transparent, the sky more nacreous.   More and more diaphanous grows the vision, and, paradoxically, more and more convincing, more and more like unto life itself.   I have seen hundreds of Bunces, floating about Venice in a gondola.   But to be lifted to their highest power they have always needed Bunce's intervention, his translation of the tones of nature into his blues and golds, his greens and grays; and they have needed, above all, the final accent of his style.

He had his meed of appreciation.   Years ago the late Daniel Cottier, one of the most discerning dealers who ever lived, recognized the importance of Bunce and steadfastly promoted the sale of his pictures. Two fine Bunces are among the Hearn paintings at the Metropolitan, and he is represented in many other American museums.   He is in countless private collections.   His fame is well established.   None of our

painters more richly deserves honor. He deserves it because he was a true creative artist, having an ideal of beauty which he served unfaltering and competently. He had something to say, and said it with the technic of a master.

## V

## THEODORE ROBINSON

Perhaps the most striking thing about the work of Theodore Robinson is its fresh, contemporaneous quality. His pictures have come but rarely on the scene since his death in 1896. When they have appeared they have not "dated." On the contrary, they have seemed as vitalized as they were when they were produced. He was forty-six when he died, a strong member of the little company of artists imbued with the spirit of Claude Monet. Robinson had the strict Ecole des Beaux-Arts training sought by the younger Americans settling in Paris back in the seventies and eighties. Carolus-Duran and Gérôme were his masters. Something of the sort would be inferred from his handling of the figure, which is always crisply accurate, the handling of a good and disciplined draftsman. But he found himself in tackling problems of light, under the guidance of Monet. The great impressionist has never been famous for complaisance in the matter of teaching, but he appears to have had an unusually friendly attitude toward Rob-

inson.   Probably it was because the young American came to him with so obviously genuine a talent.

He must have seen, for one thing, that Robinson would never crassly imitate him.   The contact between the two was too close for the disciple wholly to avoid a tincture of the master's manner.   But as Robinson went on he struck his own gait and kept to it. Like Twachtman, he used the impressionistic idiom from a personal point of view.   The important thing was to fill his pictures with light.   He did this very skilfully and sensitively.   There are subtleties of illumination in his work which tell particularly in his color.   There he is admirably rich and varied, achieving a diversity of tone rare to this day amongst all save the great leaders in impressionism.

Robinson was a rarely competent and even brilliant painter, but any discriminating analysis of his art must take account of the fact that the subtlety to which I have alluded was a matter of purely visual observation and was developed through skill alone, with next to no aid from temperament or emotion. There is something dry, if not positively prosaic, about his view of the universe.   For landscape sentiment as it is understood by the tonalist he had no *flair* whatever.   The poetry of earth never creeps into his pictures.   In this he failed to learn one of Monet's most important lessons.   Monet has made some of his foggy Thames scenes, some of his Venetian impressions, almost romantic, he has interpreted so delicately

the vague, evanescent phenomena of atmosphere. Robinson worked almost invariably in a kind of dry light, scientific in its abstention from anything like poetic effect. Yet he had his moments not wholly unimaginative. In one of them he painted his "Girl with Lilies," an upright decorative panel in which a graceful figure is set among flowers whose slender stalks harmonize with its stately lines. It is suggestive of more than the simple realism with which the painter was ordinarily content. It is not a characteristic picture. But it is very beautiful, especially in its sumptuous color. What a sterling workman he was! That is one of the many reasons we have for deploring his untimely death. The impressionistic contingent in American art suffered a grievous loss when he died.

## VI

## JOHN H. TWACHTMAN

Twachtman was a born painter, which is to say that he had in him at the outset the principle of growth, so that his works are not to be divided into good and bad, weak and strong, according to period, but have, at whatever stage of his development they appear, a certain vitality apart from other questions of merit or demerit. It is always so with the genuine artist. Every great painter springs, in a sense, full armed from the brow of Jove. In the earliest of

Michael Angelo's drawings there is the germ of the Sistine ceiling.  But it is perceptible in accent, gesture, atmosphere.  You feel the prophecy of great things to come, not in any very definite way, but rather in the broad sense of power conveyed.  It is this stamp of potency, fascinating in itself to the connoisseur, that made Twachtman a notable figure even before he achieved his full fame.  It was often possible to criticise his work adversely and sometimes to deplore lapses in him from the standard he had erected for himself.  It was never possible to ignore him.

The character of his earlier work is better understood when we recall that he began his studies in Cincinnati (where he was born, in 1853), getting his training under Frank Duveneck, and then, in 1875, proceeding to Munich.  Duveneck was a perfect master for him, inasmuch as he was bound to inoculate him with a sound conception of technic, but also Duveneck's very preoccupation with the mysteries of paint made him a master of what we must call studio tradition.  Hence, as a young man Twachtman was addicted to an hypothesis ordaining that nature should be painted in a gray north light and that it should be brought within the compass of a well-balanced type of pictorial design.  Saturate yourself in that tradition, seeing nothing else, and as a landscape-painter, at all events, you are in peril.  Your impressions of nature sooner or later become juiceless and pallid.  Your pattern remains — only pattern.  Twachtman

had to skirt these dangers in his formative period. Some of his earlier works are banal. But others are interesting foreshadowings of what he was ultimately to do. They are landscapes painted in France. There is in them the spirit of the Salon, which can be hateful when it spells mere mechanical picture-making but which can be delightful when it spells the easy, free mastery of the mechanics of picture-making. That is what marks Twachtman in his first and middle years, the faculty for making a good picture according to an old recipe, but with a touch of his own giving it freshness and charm.

He shed the purely factitious side of the studio tradition very rapidly, retaining from Duveneck's teaching all that was sound and carrying over nothing from it that was alien to his spontaneous, wholesomely human talent. Mr. Hassam has spoken of his always having been impressed by his friend's "great beauty of design." It is the right phrase. Only I would underline the "beauty." Twachtman achieved good design largely for the reason at which I have already glanced, because he received a rigorous training. He raised it to a higher power because he had a passion for beauty. This is the element in his work which manifestly enkindles it and holds it together. I remember how at the great exposition in San Francisco the room dedicated to Twachtman carried off all the honors, wearing a distinction which no other individual exhibit could quite claim. It fairly exhaled char-

acter, and this not because of any towering technical superiority, but because the pictures in it were all so alive with a beauty as original and delicate as it was unmistakable. Follow the sequence of his development and you will see how easily his pre-eminence is explained. He begins by knowing his trade, painting in all the earlier, cooler, more conventional landscapes a type of picture that is beautiful in composition and truthful into the bargain. Then, as time goes on, and he discovers the possibilities in the impressionism of Claude Monet, the new refinements of atmosphere, the subtler nuances of light and color, he discovers himself also and finds that with this more flexible method he can give fuller expression to his instinctive predilections. He no longer paints Salon pictures. He paints Twachtmans, and that not in the vein of the popular success, who repeats himself, but in the vein of the lover of nature and beauty who sees new combinations in every landscape problem he attacks.

It is interesting to observe his variety, to compare the young Twachtman, painting a "Blue Jay," with the utmost solicitude for closeness of modelling, solidity of color, and the sensuous quality of rich pigment, with the older man seeking a diaphanous texture or playing with shimmering opalescence. The reader will notice, however, that I am reckoning here with modifications of methods. The important point to observe where Twachtman's variety is concerned is diversity of mood. He paints his Connecticut home,

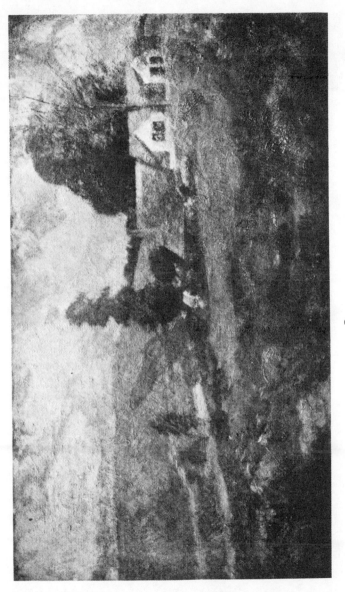

LANDSCAPE

BY J. H. TWACHTMAN

a little cottage in a fold of the hills, in the most sharply contrasted seasons and aspects, and always extorts from the theme a new and lovely charm. Three notable studies of this subject, exhibiting it under clearly differentiated conditions, illustrate three individualized modes of approach. In the "Greenwich Hills in Winter" the house is almost smothered in snow, and the essence of the picture lies in the modulation of gray-white masses — a triumph of values. In "From the Upper Terrace" it is the opulence of color, brought into an exquisite harmony through the play of sunny light, that counts. Here Twachtman is the simple poet, where, in the winter scene, he is the technical virtuoso. And in, perhaps, the greatest of the three, the splendid "Summer," he is the master of landscape art in something like the grand style, planning a big scene, defining his ground forms in a broad, bold manner, and enveloping them in air, atmosphere, with a stroke that I would call panoramic if it were not for the note of intimacy which here, as always with this artist, has a way of creeping in.

It was, after all, the imaginative interpreter in him that had the last word. Throughout his many moods he was faithful to his feeling for whatever in nature was dainty, elusive, tenderly charming. His pastels of flowers expressed perhaps the most fragile sentiment in the scale through which he ranged over the poetic, more evanescent side of nature. But I end as I began, not caring overmuch whether a given pic-

ture of Twachtman's is a complete triumph or what
may be termed, for the sake of the distinction, a lesser
achievement. In any case, it is always a vivid, per-
sonal impression, original and true.

# VII

## CHILDE HASSAM

As Mr. John C. Van Dyke has tersely pointed out,
a lot of good American painting has been, in a sense,
good French painting. Glancing chronologically
through the work of Childe Hassam, I recall a picture
well confirming this hypothesis. It is the "Autumn,"
a full-length portrait of a shabby old harpist sham-
bling across a tall canvas, first shown in the Salon of
1888. It is unmistakably a Salon picture. It could
have been painted only in France, under the influence
of French ideas. Like so many Salon pictures, it
wears a rather faded air. One feels that it served its
purpose long ago. Long ago Hassam travelled to a
much higher plane. Yet it makes its mild appeal in
genuine fashion and the point is significant. The in-
durated Salonnier is known by the barefaced nature
of his tricks. He wants to "make a hole in the wall,"
to attract attention, and to this end he is capable of
almost any sensationalism. One thing that saves the
"Autumn" is its sincerity. It is painted not to make
a hole in the wall, but because the artist was interested

in his technic for its own sake. Hassam grows in his art, you see as you follow his chronology, paints better and better, always spurred on by his love for his medium. Little by little there develops from this ardor something which transcends the French character of his work. There develops the personal touch, the individual qualities of color, texture, brush-work, which give the artist his rank.

He has founded his art not on any recondite ideas. He has no interest in subject as subject. There are few traces of sentiment in him. But all through his paintings there is disclosed the best foundation of all — a feeling for beauty. There are times when decorative beauty attracts him. But as a rule the beauty for which he searches is in no wise confined within the borders of a pattern. It is, instead, the beauty of nature pure and simple, an affair of light and color, of some casual moment of sensuous charm. Superficially considered, Hassam seems a versatile type. He uses all the mediums. He paints the figure and he paints landscape. Still life interests him. He has wandered far and wide, here and in Europe, in pursuit of his themes, and wherever he goes he interprets what he sees with marked sympathy and understanding. Nothing could be more intensely "local" than his souvenirs of places. There is versatility, I suppose, in his ranging up and down. Yet there is one thing which he does better than anything else.

This is his typical coast scene. It inspires the sur-

mise that if Mr. Hassam had devoted himself alto-
gether to landscape he might have made himself one
of the greatest pillars of our school. He has the sa-
lient merit of our school, which is to exploit the infor-
mal episode in nature rather than to work out the
academically balanced composition. His open-air
subjects are never forced — they happen. He has a
wonderful gift for the definition of ground forms, for
the free but exact delineation of rocky shores, for the
painting of green things, and the clear, cool illumina-
tion of skies. The sylvan sweetness of a forest pic-
ture of his is beyond praise. He has dealt over and
over again with the motive, and in those versions of
it which have set nude figures against a screen of trees
he has sometimes deviated into a somewhat specious
effect. But as a rule the composition doesn't harbor
a single meretricious stroke. His wonted sincerity
wins the day.

So long as Mr. Hassam paints landscape he is on
safe ground. The charm of his pictures may vary,
but fundamentally they maintain their vital, interest-
ing quality. With the figure he takes his chances,
sometimes hits the mark, but as often stumbles. The
nude, brought well into the foreground, frequently
baffles him. The gleaming bodies now and then en-
livening his outdoor scenes are painted on a small
scale, they are no more than piquant accents on the
main theme, and they fit pleasantly into the picture.
Isolated and studied at full length, they are sadly

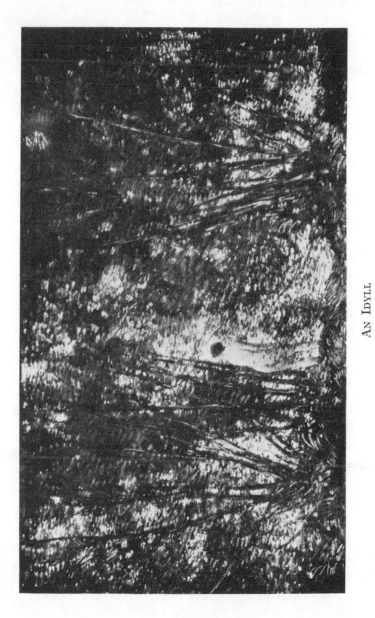

An Idyll

BY CHILDE HASSAM

disappointing. They are pretty bits, but that is all. They disclose no distinction of line, no skill in modelling. Curiously, they do not even reflect the gusto which is ordinarily inseparable from Mr. Hassam's work. They seem to have been painted doggedly, by main strength, and at the same time, if I may risk the seeming contradiction in terms, feebly. What has become of that personal touch on which I am inclined to lay so much stress? The answer brings me back to our original problem. The personal touch, precious as it is, potential as it is, will not always tell the whole story. There are phases of art in which it is helpless without academic discipline. The ivory tower is a blissful habitation, but there is nothing talismanic about it. To dwell therein is not necessarily to be dowered with all of an artist's resources.

It is possible to say of an enormous amount of the work done by this exceptionally prolific artist that it is "painted," meaning that it is packed with sound, authoritative technic. It is rarely possible to say of one of his nudes that it is "drawn," meaning that the draftsmanship in it is thoroughgoing and distinguished. He has better luck with the draped figure. Whenever he has the color in stuffs, in flowers, and other accessories to deal with he paints with a surer brush; and if he can bring plenty of sunny air into his scheme the prospects for a good picture are even more favorable. But his figure subjects are not, in general, the canvases on which it is most agreeable to linger.

They have their attractive points. On the other
hand, they are not so much indicative of Hassam's
strength as they are of his weakness. His weakness,
concisely expressed, would appear to reside in his at-
tempting to carry the effectiveness of the personal
touch too far, in assuming that it will endow almost
any production with artistic vitality. It is at first
blush inspiriting to observe a talent as versatile as
his, to watch its operations in so many fields, but it is
disconcerting to find that while some of the etchings,
for example, are charming, others are empty, and that
the lithographs and water-colors are in the same un-
certain case.

Is not this suggestive of the very perils which lurk
in that personal quality on which I have paused with
so much appreciation? It is indispensable in art.
Lacking it, the artist might as well put up the shut-
ters. It has worked and still works something like
miracles for Hassam. It has placed him in the front
rank of American painters. Because he has it, his
work remains an admirable example of "good Ameri-
can painting." And yet I never see a collection of
his pictures, rich in sensations for which I am grate-
ful, without wishing that divers other virtues had
been added unto him. Think of what his nudes would
be like if they were put together with more construc-
tive power! Think of what his art would be with
finer elements of inventive design, with a deeper imag-
inative glow, with a wider scope as to ideas! But to

think these thoughts is possibly to go a little nearer than we ought to go to the unlawful process of asking Mr. Hassam to be somebody else. Let us rejoice, instead, that his ardor for beauty, for light and color, and for the sheer joy of painting takes him as far as it does. It takes him a long way.

## VIII

## WILLARD L. METCALF

The determining factor in the work of Willard Metcalf is only to be designated by the old phrase about "the joy of living." He unmistakably delights in his subjects. There is little that is pensive about him; he has no dreams and few reveries. Nature as it touches him is nature eloquent only of its own charms, its flashing colors, its keen airs, its intensely characteristic forms. I have long felt in his paintings the force of what has been called "the spirit of place." He paints portraits of landscape. They vary in key. At one moment the Americanism which is a peculiarly constant element in his work is expressed in a very intimate manner. At another he tackles a big and even panoramic composition. The source of his diversity is to be found not simply in change of scene but in his concern for design.

His technic tells most obviously in the handling of tree forms. No contemporary landscape-painter can

beat him in draftsmanship.  But there is a subtler and possibly more important virtue in his manner of putting a picture together, giving it unity without the loss of spontaneity.  He can give you a seemingly unstudied episode from the Maine coast in which the composition is nevertheless almost formal in the perfection of its balance.  Along with his purely pictorial quality there goes a delightfully vitalized interpretation of sunshine and air, of birches that are truly as blithe as the June in which they were painted, of clear and misty weather, of old houses saturated in the feeling of their rustic environment, of American landscape, in short, stated in the mode of penetrating realism.

Sometimes into Metcalf's paintings there steals a touching tenderness.  He has portrayed in his "Benediction" an old white meeting-house lying silent in the night.  Again his draftsmanship stands him in good stead.  Buildings and trees alike are delicately defined.  But it is the serene beauty of his subject that he has most effectively expressed, not romanticizing it in any adventitious manner, but disclosing the romance implicit in the church and its surroundings as in a mirror.  His work has ordinarily a direct appeal.  In this picture it takes on a certain subtlety.  The manual skill which always belongs to him is lifted to a higher power.  Almost I would call it the outstanding canvas in the whole long list that Metcalf has produced, but he painted at a later date, in his

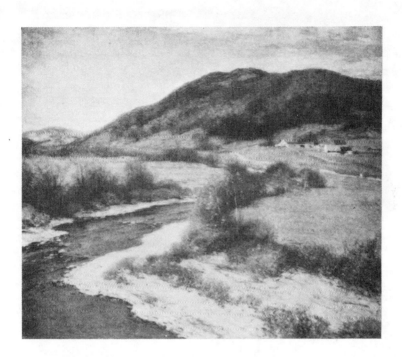

INDIAN SUMMER

BY WILLARD L. METCALF

"Indian Summer," a design perhaps more justly to be regarded as his fullest triumph.

It is larger in scale than anything previously painted by him. His special gift has always been for the notation of intimate episodes in landscape, the clump of flaming maples, the winding brook, the pasture lot confined within its straggling stone walls. In this "Indian Summer" he attacks a statelier motive. The problem was the more complicated, no doubt, but his success in the treatment of it springs from nothing so much as from his simplification of the great masses traversed. The difficulty, of course, in the painting of a panoramic scene, is the difficulty of pulling it together, giving it unity without baldness or stiffness. Metcalf surveyed his subject from the bottom of a long valley. Looking beyond the stream in the foreground he saw farm buildings nestling in the middle distance, at the foot of rounded hills. The resonant blues in the water at his feet struck the deepest note in a rich color scheme. He had brilliant hues all around him, and he had to fuse them in a harmony as simple, as pure, as that made by his vast ground forms and the great swinging line made by the river-banks. He had to give his panorama that sifting which is essential to pictorial felicity. Never in all the landscapes which he has brought forward in recent years has he so completely mastered his theme and painted it so happily with the tact, the selective skill, which I have in mind. This "Indian Summer" is a splen-

did affirmation of design, of nature defined with absolute truth, but filtered through the art of composition. It is, as such things go, a museum picture, but it preserves the same freshness and magic that have so long belonged to what I may call the artist's more informal studies.

## IX

## RALPH BLAKELOCK

Blakelock's strength resided always in his imaginative conception of landscape, his instinct for the poetizing of his themes. In the recent revival of interest in him some of his admirers have been more fervid than discreet. They would have it that he was a great artist, one of the greatest of his time. Hyperbole does him no honor. But if there is any excuse for speaking of him in superlative terms it lies in his gift for beauty, for the glamour which an artist does not so much find in nature as impose upon it. Toward nature, indeed, Blakelock had an attitude not unlike that of Whistler. It gave him inspiration, but he used it in his own way. Moreover, he had subjected himself to even less discipline in the matter than was accepted by his notoriously independent countryman. Whistler arrived at the painting of his Nocturnes by way of a training that included the naturalism of Courbet. From Mr. Daingerfield's admirable little monograph of Blakelock we gather that the latter

had no training at all, and while he is credited with an early love of the old masters, the critic hints that this must have been nourished on photographs instead of the real thing. This last is a reasonable hypothesis. The absence of light and air from Blakelock's pictures confirms the idea that he got at the visible world through many veils.

For the essential clew to his art I would direct the reader not to the studies of sunset or moonlight, which are nominally most characteristic of him, but to a picture like the "Spring Rock Cove," which is almost a monotone, and in a subdued key at that. He discloses there what he made of nature even when he was most scrupulous in observation of her tangible aspects. The ground forms and the trees are drawn with what was for him extraordinary care. He gives us a tolerably faithful statement of fact. But this is only the beginning of the transaction. Having accounted for the basis of his picture, he proceeds to develop the thing that really interests him, a rich surface of tone, a subtle harmony of grays and greens turning the landscape into a unit of romantically sensuous color. There is an element of surprise in a comprehensive study of his work. It appears then that he could paint in light, delicate tones as well as in the heavy scale by which he is chiefly known. But all his pictures bring us back to the same judgment — that he belongs to the race of arbitrary harmonists, of painters like Monticelli and Whistler. The true

Blakelock is that artist who saw nature *en silhouette*, just as Monticelli saw it in the dim perspective of a shadowy sylvan glade.   A tree was for him a kind of screen, whose boughs etched a curious pattern across the sky.   Local color left him cold or moved him to brush it out of his way.   There he differs from Diaz, whose traits he otherwise often recalls.   The French-man loved to record the very texture of a tree in the foreground.   Blakelock left it to take care of itself, while he revelled in the manipulation of contrasts. These were mostly of a very decisive nature.   He could produce a delicate, almost fragile nuance of tone, but he did so only in passing.   His effects, on the whole, are full, plangent, the unmistakable effects which spring from the silhouette rather than from the design having many planes.

Diaz, and Rousseau, too, would have sympathized with Blakelock, recognizing in him a painter of their own romantic strain, but Rousseau especially would have been embarrassed by his indifference to the structural elements in landscape art, wondering why he did not pay more attention to the modelling of forms, particularly when he was dealing with clouds. And I can understand how many artists would ques-tion certain aspects of Blakelock's technic, deprecating the thick impasto which he often used.   The palette knife rather than the brush is suggested by some of his surfaces, and though that is not in itself a matter for criticism, one cannot help feeling, in this case, that

it points to a fumbled sort of workmanship. There
are pictures of his which seem lucky chance hits rather
than solid achievements. Which is but another way
of saying that Blakelock is one more of those artists
who have the defects of their qualities. He is the
poet, the dreamer, who feels his way through picture
after picture and sometimes strikes twelve. When he
does so he is just the irresponsible enchanter, the care-
free improvisatore, whose iridescent webs are so lovely
that we do not mind his now and then dropping a
thread. We do not ask the figures in his Indian pic-
tures to look like Indians. If they did, and were dis-
tinctly realistic about it, they would break the artist's
spell. The points of the horse in his "Pegasus" do
not matter, nor are we concerned about the individ-
uality or purpose of its rider. It is the vision of a
poetic scene that counts. One of his glorious pictures
is the "Moonlight," belonging to Mr. Sherman. In
the softly vibrating tones of the sky we are reminded
at once of Jongkind. But as we think of him we re-
member how the most romantic of his paintings is
nevertheless a portrait of some waterway in the Low
Countries, and we have, more vividly than before,
a sense of Blakelock's imaginative quality. In his
painting you can identify no scene. You know, in-
stead, that you are in a marvellous land of his inven-
tion, a world of pure beauty.

## X

## J. FRANCIS MURPHY

This distinguished American painter of landscape had the privilege in his later years of seeing his art become the object of something like a cult among collectors. He had been appreciated for a long time, but when his full popularity came it was with a rush. The evidence of its development was most conspicuously registered in the auction-room. Born in 1853, Murphy was nearly fifty when his "October" figured in the dispersal of the Thomas B. Clarke collection. The picture fetched $2,100 and passed into the Corcoran Gallery at Washington. The story runs that Murphy watched the sale at Chickering Hall and was moved to happy tears when he saw his work thus acquired for a public collection. For some time thereafter he had what might be described as a comfortable market, but his hour of triumph — so far as the auction-room could bring it — came at the George A. Hearn sale in 1918. Pictures of his then brought $3,000, $5,000, or $7,000, and one of them, called simply "Landscape," was bought by Senator W. A. Clark for $15,600. This made a sensation, and placed Murphy alongside such men as George Inness and Winslow Homer as regards the commercial value of his work. I speak of these records because, to tell the truth, there was something positively dramatic

about them and because they signified something more than the growth in "commercial value" to which I have referred. Murphy's success under the hammer was indicative of the wider and deeper appreciation of American landscape art that had steadily been going forward. It was representative of a striking movement in American taste.

It is interesting to reflect on the purely artistic nature of Murphy's contribution to that movement. He came to manhood in the seventies, when the tradition of the Hudson River school was just beginning to go out, under the influence of those pioneers who, having genius, were fitted to make over all its hypotheses. He found his point of departure, therefore, in a comparatively free and naturalistic conception of landscape. Was he, in his turn, a man of genius? Hardly. He had, at the most, a modest spark of the divine fire. The smallness of it is suggested by the fact that his earlier work never left any very memorable impression. It disclosed a sensitive interpreter of nature, a competent craftsman, and some individuality, but not enough original force to excite particular comment, and certainly no distinction of style. In composition, for a long time, Murphy was a type of agreeable picture-making, with the wholesome American habit of avoiding academic formality in design. In respect to details he was strongest in the definition of tree forms. Murphy's trees always had solidity and character. He was untouched by impressionism

in the ordinary acceptation of that term. I can recall
nothing of his in which light plays the part that it
plays in the works of Monet and his followers. But
this did not mean that he fell back upon the specious
uniformity of a studio light. He was too sincere an
observer of life for that, and as his art mellowed it
was plain that its strengthening was due to a fine ob-
servation of authentic phenomenon.

He was slowly transformed from the maker of agree-
able pictures into the painter of canvases having emo-
tional quality. There persisted in him, however, a
trait distinguishing him from such masters as Inness
and Homer Martin. They had the creative passion
which gives to each of a man's canvases the beauty
of a new invention. A dozen pictures by George
Inness will all have an unmistakable family likeness,
but each one of the twelve commemorates a discov-
ery, a new leap into the artist's world. Murphy went
forth as Inness went forth, with a kindling sense of
the magic in the woods and skies, and he carried that
magic with such feeling into his work that we owe him
a heavy debt. Yet all the time we are aware of the
fact that he would go on looking at his themes through
precisely the same spectacles. The bulk of the can-
vas would show us a field or pasture broadly general-
ized. To the left or perhaps nearer to the centre of
the composition there would be a clump of trees,
their upright trunks masterfully painted. Above the
horizon there would stretch a subtly modelled sky.

The whole scene would be expressed in very reserved terms of color, silvery grays and greens, with a certain delicately tawny hue prevailing. Murphy's honeyed browns became as characteristic of him as his tree-trunks, his vibrating skies, or the logs lying upon his fields. Now, there is nothing intrinsically dangerous in a painter's choice of one effect, to paint over and over again. Consider what Corot did with his tremulous leafage. He very nearly crystallized it into a formula. What saved him from this peril was sheer genius, a power of style which enabled him to repeat himself and never rub the bloom off his art.

Murphy lacked the same preservative. I have wondered, sometimes, if greater vigor, a more robust mode of workmanship, would have pulled him through. The work which finally made him famous, the work which excited the competition of the collectors, is unquestionably beautiful work, so far as it goes, and it goes very far. It is truthful, it embraces poetic feeling and sensuous tone; it is the work of a man who looked at landscape in his own way. What more need one ask? Only the touch that spells liberation from a *parti pris*, only a little greater elasticity about the artist's point of view, only the flash of the spirit which proclaims not only the consummate interpreter, but the creative master. Murphy's surfaces, giving to his canvases a special merit, are the surfaces of a painter having a peculiar appreciation of the beauty of pigment caressingly manipulated. But in this very vir-

tue there always lurks the pitfall of preciosity. If
Murphy was not quite entrapped into it, his work nev-
ertheless was tinctured by its atmosphere. Though
he escaped the deadening influence of a north light,
there remains in his work the faintest hint of a studio
gesture. He is one of the fine figures in the American
school, but not one of the greatest.

# X
# The Lure of Technic

I. Frank Duveneck
II. William M. Chase

# X

# THE LURE OF TECHNIC

## I

### FRANK DUVENECK

IN Boston one night I heard the late William M. Chase deliver his amusing talk on Whistler. Duveneck was there, and after the lecture he sat with Chase and some other artists to discuss the subject over a mug of beer. But Duveneck, who had heaps to say about Whistler if ever a man had, said next to nothing. He was content to listen, a large, rather heavy man with a kindly smile, a twinkle in his eye, and impenetrable reserve. He knew all about that past into which Chase had been dipping. He had been part of it. In a sense, he went on living in it. · Most of the men at that Boston table were his juniors, and they were still active, still ardent, very much in the van. Duveneck, who had trained and inspired some of them, seemed satisfied to let the van go by. His quiet, half-amused detachment on that occasion has always stayed in my memory as somehow symbolical of the man and his career. When he had his hour, back in the seventies, it was a resplendent hour, one in which the disciples who gathered around him in Munich be-

lieved that there was no leader quite like him, and that his fame would only wax the greater as the years went on. His fame did not precisely wane, but it rested where he left it thirty or forty years ago.

He was married in Paris, in 1886, but enjoyed his happiness for only two years. Following his wife's death he returned to his home in Cincinnati, and although his biographer notes some travels — such as a holiday in Spain, during which he copied Velasquez — he remained on this side until his death, in 1919. He never lacked appreciation. Cincinnati was always keen upon doing him honor. He had great weight in the affairs of the museum there, and he continued in his rôle of teacher to be of substantial service. At the San Francisco Exposition a large room was hung with his pictures and a special medal was created to be awarded to him. Yet he remained a figure of the past, aloof from impressionism and from all subsequent artistic movements, a curiously isolated member of our school. He will always remain thus apart, and, by the same token, he will always exert a certain fascination for the connoisseur.

To speak of "painter's painting" is to use a phrase which criticism should never have been compelled to invent. But it connotes a kind of painting which can be classified in no other way, just as "character acting" has come to mean something on the stage which everybody understands, foolish as it seems to employ such a saying where all acting is supposed

to involve the impersonation of character. Every painter is nominally assumed to paint, but there are thousands of artists who spend their lives squeezing colors out of tubes without the faintest suspicion of the fact that they are placing on the palette the ingredients of a big magic. The painter's painter is the man who in a gust of exultation raises the materials of his craft to their highest power and invests both pigment and technic with an incomparable beauty. Franz Hals is such a master and Velasquez is another. Manet is a good modern type, and with him I might mention Alfred Stevens, the celebrated Belgian. Duveneck was of this great tradition, deriving his special inspiration from Rembrandt and the Dutch school.

There are two ways of approaching his work. Looked at for its intrinsic merits, as work constituting his credentials, one sees very quickly why his isolation supervened and brought with it a certain dampening of public enthusiasm. He sat almost too devotedly at the feet of Rembrandt, made himself too much of an old master. The thing that Manet hated and was wont to call "the brown sauce of the old masters" enveloped his paintings in a rather factitious penumbra, and this became more disconcerting when his surfaces began to crack. Duveneck would have been twice the artist that he actually was if he had allowed himself to be touched by the impressionistic hypothesis and had exchanged the atmosphere of the studio for that of the open air. But to say all this is

to exhaust only one mode of approach to the subject. Another remains and leads us to a more exhilarating conclusion. It is the approach which dismisses, almost as though irrelevant, the qualities lying on the surface of Duveneck's work and looks altogether to the question of what this man meant at the particular time of his appearance upon the scene. He meant a revival of painter's painting.

His was, to begin with, a personality born to excite sympathy and devotion. Young artists coming under his influence were bound to develop an enthusiasm for the kind of painting that interested him. American art in the seventies, strengthened enormously by pioneers like Inness and La Farge, was nevertheless in sore need of technical renovation. Duveneck found one of the secrets for this in Munich; he brought it back here, and so stirred up the youngsters that when he started a school of his own in the Bavarian capital he had presently a troop of clever Americans around him. The burthen of his teaching is well summed up in his "Man in Spanish Coat." Painting this portrait, Duveneck showed his disciples, in the first place, how important it was to give the torso solidity and depth, how important it was literally to construct the head, making it a vitalized affair of veritable flesh and bone; and then, having demonstrated the value of sound modelling and drawing, he proceeded to enkindle his class with the spectacle of a brush flashing over the canvas as in a kind of joyous bravura, taking

A Man in Spanish Coat

BY FRANK DUVENECK

care of all humdrum matters of definition and super-
imposing upon these the enchantment of pigment
caressingly applied. The figure represented is inter-
esting, of course. Duveneck put life and character
into a portrait. But, as is proper in a work of art, the
chief element is just Duveneck — Duveneck's brush-
work, Duveneck's flesh painting, Duveneck's ador-
able technic.

There is an odd phenomenon to be noted at this
point. Since he set such a wonderful example he
ought, of course, to have reared up a true nest of sing-
ing birds. Well, he didn't do quite that. But that
is, perhaps, because no man can work miracles. His
disciples went their several ways, which is, after all,
as it always should be. John Twachtman learned a
lot from him, but went on to win distinction through
painting a totally different sort of picture. If he
learned much from Duveneck he learned more from
nature, and, trusting to his own genius, he became a
greater artist than Duveneck could ever have made
him. John W. Alexander also diverged into a differ-
ent path, though not altogether with the happiest re-
sults. When he emerged from under Duveneck's in-
fluence and gave himself to the making of those deco-
rative patterns by which he is chiefly remembered, he
lost something which he never regained. There are
other individuals, comrades and pupils, whose careers
it might be amusing to trace, analysis pursuing the
limitation of the Duveneck influence under the pres-

sure of the years.   The circle as a circle has, too, its
personal side, and it brings in the matter of etching.
Whistler, Otto Bacher, and Joseph Pennell command
attention, and there are men like Frank Currier, A. G.
Reinhardt, and F. W. Freer on whom I would like to
pause.   But these various points of departure would
take me too far afield.   What is especially important
to observe is Duveneck's passion for good workman-
ship and his success in instilling it among young men
of talent, many of whom, whether in his way or in
ways of their own, afterward helped to lift American
painting to a new level.

There is a droll story, which may or may not be
susceptible of absolute documentation, which brings
out the potency of Duveneck as a human force.   It
involves Whistler also.   In old Venetian days, when
Whistler had a chorus about him, he bade farewell to
its members, so the story runs, bestowing upon each
of them a curious souvenir.   Taking a proof of one of
his etchings, printed on the press which several of the
artists had used, he cut it into strips and distributed
these priceless fragments.   On another occasion Du-
veneck said good-by to a number of his "boys," and,
putting before them a group of his painted studies,
told each artist to take his choice.   The first anec-
dote, apocryphal or not, may have been not at all
like Whistler.   The second was indubitably very like
Duveneck.   A lot of sentiment must have gone to the
development of his authority over those "boys" of

his. All the reminiscences that bear upon the subject denote the positive rapture in work that he inspired in Munich, and afterward when he painted and etched in Italy. Every one was on fire with Duveneck's ideal. He swept aside the dead-wood by which our method at home was encumbered. He brought paint back into its own. He made craftsmanship thrilling.

## II

## WILLIAM M. CHASE

There is nothing about Chase more important than his date, and by this I mean not the year of his birth, but the time of his entrance into artistic affairs in this country. His biographer must note, of course, that he was born (at Franklin, Ind.) in 1849, that he was a student in the Academy here twenty years later, and that he went to Munich in 1872. But it is on his return from Europe in 1878 that his career becomes really interesting, and, in a serious sense, places him. He came back at a psychological moment. The American school was vaguely getting ready to emerge from a period of stagnation. Its landscape men, led by George Inness, were moving steadily in the direction of the new naturalism discovered by Bonington and developed by the Barbizon group, but its figure-painters, save for La Farge, were still in a backward mood. Progress was retarded by misconceptions

deep rooted in American tradition.  When the industrious Dunlap sat down to write his "History of the Rise and Progress of the Arts of Design in the United States," nearly a hundred years ago, he exposed the heart of this tradition in one of his earliest passages. "The arts of design," he says, "are usually considered as commentators upon history and poetry.  Truly they are the most impressive of commentators.  But to consider them only as such is to degrade them.  To invent belongs to the artist as well as to the poet, . . . it is no less his to invent the fable than to illustrate it."  Yes, the artist could invent, but whether as inventor or as commentator he was dedicated, as a matter of course, to a quasi-literary function.  The painter, in our modern sense, was practically unknown to Dunlap, for all that he had a measure of appreciation for technical qualities.  Neither he nor his followers, for a long time, could see the possibilities lying in technic as technic.  Chase saw them.  His eyes had been opened in Munich, and it was in helping to open the eyes of the rising generation which he returned to instruct that he ranged himself.

It is important to keep this point in mind when in the presence of the earliest of his paintings and to distinguish amongst the later.  Some of his old Munich *envois* superficially indicate an intense preoccupation with the old masters.  He seems an imitator, and a rather docile imitator at that.  But look more closely at one of them, the well-remembered "Ready

for the Ride," and you are struck by the breadth with which it is painted, you notice especially the good quality of the blacks — a quality only accessible to a man who has begun to feel the glamour of sheer pigment. That is the kind of picture that Duveneck and Currier were painting. They threw convention overboard, gave themselves up to the stimulus of brush-work as Rembrandt and Hals understood it, and affirmed the principle that an artist justified himself in so far as he showed himself in sympathy with the genius of his material. They gave paint its chance — brought into the foreground the manipulation of it for its own sake, erected manual dexterity into a talismanic factor. Chase cultivated this point of view heart and soul, and brought to its application a trait lacked by his accomplished fellows, namely, a blither taste in color. Duveneck and Currier were much addicted to "brown sauce." They found it harder to get away from the old masters. Chase was ready to strike a gayer note, he was a little nearer in his sympathies to the more luminous keys presently to be brought into fashion by the impressionists. Thus equipped, is it any wonder that he exercised a tremendous influence when he came home?

He had boldness, vivacity, the inspiriting qualities of a dashing realist, and, above all, he had ease, cleverness, the gift for playing amusing tricks with the brush. He took charge of a painting class at the Art Students' League in 1878. He participated in the

early doings of the Society of American Artists. His
big studio in the old building on West Tenth Street
became a rallying-ground. These things are signifi-
cant. They take the memory back to a period in
which American art was being made over — with
Chase as one of the leaders in the transformation. He
kept on teaching all his life, and both by precept and
example he asserted the dignity of technic, pure and
simple. It is because he cared for good craftsman-
ship, practised it, and promoted it in others, that he is
to be gratefully remembered. When we forget Chase's
influence and consider only the intrinsic value of his
work, our impressions are a little mixed. Chase's ver-
satility consisted in assimilating with extraordinary
aplomb something of the technical spirit of one artist
after another — Leibl, Fortuny, Alfred Stevens, Bol-
dini — and he did it with so infectious a gusto that
no one could ever dream of charging him with plagia-
rism. But he paid the penalty of his eclectic habit in
a strange subsidence of personality. Has Chase a
style? The question is hardly to be answered in the
affirmative. Pure line subjects him to the severest
test. There is nothing individualized in his drafts-
manship. I can readily visualize a clever pupil of
Chase's doing exactly what Chase did with charcoal
or pencil and doing it, on the whole, as well. As for
his "wide range of subject," to use a phrase applied
to him by Kenyon Cox, that again is a matter requir-
ing some qualification. There is width of range, nom-

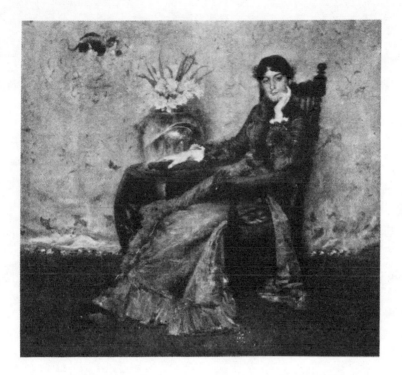

MISS DORA WHEELER

BY W. M. CHASE

inally, in the art that embraces the interior with figures, the portrait, landscape, still life. But it is suggestive to remark that among his paintings there is not one which approximates to the "subject picture" — save as a costume study with a piquant title, like "The Court Jester," might savor of "invention" — and as I recall the vast bulk of Chase's work, seen over a long period of years, my search is no better rewarded. Only in a very dry, limited sense had he a wide range of subject. From old Dunlap's old-fashioned hypothesis he went to the other extreme. It was his virtue that he kept his eye on the object and painted it as he saw it, but what he painted was only a ponderable object, a peg on which to hang an exercise in technic. Of imagination he never revealed even the faintest trace.

Man never is, but always to be, blest. Chase was always on the verge of painting a great picture and never quite pulling it off. Perhaps, years from now, when time shall have enriched its surfaces, we may be confuted by a still-life like one of his numerous studies of fish. But it is not my business to anticipate; I can only look at things as they are. Thus scrutinized, his pictures give pleasure without rousing enthusiasm. It is, after all, a good deal. If Chase was not a great painter, he was at all events a prodigiously clever one. We may think of a thousand conventional Salon portraits, of Carolus and his ilk, before "The Sisters" or the "Clyde Fitch," but we enjoy the Whistlerian to-

nality in the "Mother and Child," recognizing that the charm of the portrait isn't merely Whistlerian, either.

Chase was indeed a finished craftsman, so adroit, so full of vitality, that it seems grudging to harp upon his limitations. How bright, how decorative, he is! With what a crackle of technical facility does he dash off his portraits, and with what ardor, everywhere, does he pursue the *frou frou* of life as he apprehended it! He plays with the blue-green velvet in his "Meditation" as though textures were all in the world that at the moment interested him. When he paints his "Hide and Seek" you know that he is enchanted with the staccato effect of his two little girls flung against an almost opaque background. Sometimes his mood changes, and from the flashing, rather brittle, coloration of his most characteristic works he will pass to an engaging bloom and to soft blacks. Decidedly all this vim, all this accomplishment, must leave us with a grateful sense of Chase's enkindling sincerity as an artist, of his solid achievement as a craftsman.

Why could not some of the rarer gifts have been added unto him? One makes the vain interrogation with a sigh of regret, thinking wistfully of what he might have become if he had had a fund of originality, and that central fire which inspires and controls a creative artist, unifying his work from beginning to end. In that case Chase's vivid hues would have been invested with the magic of distinguished color; the pigment which he handled so well would have

taken on a finer quality; as imagination and style came within his ideal of beauty he would have expressed himself in more interesting terms of design. He would have been, then, a master. As it is, he remains one of the loyalest followers of the masters.

# XI
# The Slashing Stroke

# XI

# THE SLASHING STROKE

## I

### GEORGE LUKS

THROUGH all the pictures painted by George Luks, early and late, there runs the unifying element of a kindling interest in life. He is left quite untouched, I gather, by insensate things. He can paint flowers with a certain sympathy for their color if not for their subtler, more evanescent charm. But I do not recall ever observing him intent upon still life. His themes are humanized, always. They are only the more poignant as he paints them, too, because there is nothing anecdotic about him. He has no leaning toward the mood of Balzac or Dickens. He could not romanticize a subject if he tried. He is nearer in spirit to Manet, a recorder rather than an interpreter. His rôle is that of the realist. In it he discloses great power, and incidentally reveals the defect of his quality. I am always oscillating between two states of mind when I am looking at the work of George Luks. I respond to his force and his truth. And I wish all the time that both were made more alluring, that both were fused with a finer sense of beauty.

What beauty? Not the beauty of subject. On the contrary, there is something profoundly appealing about his homespun types. There is positive sweetness, too, in such a picture of his as his "Boy with Guitar." The child in this is adorable. His ragged street types are never repellent in themselves. But they frequently repel through the rough, summary fashion in which they are painted, as though the artist exhausted his energy in the first jet and refused to refine his work. Yet he can do this when he chooses. Witness "The Little Milliner," which recaptures me every time I see it through its sheer loveliness, its sheer charm. No, it is not in his outlook upon life that I miss the touch of beauty; it is on the side of pure technic.

"The Little Milliner" shows what Luks can do with the brush when it suits him, handling pigment with something like a caress, seeking beauty of tone and getting it, making brush-work magical. There are passages significant of the same æsthetic preoccupation in more than one of his paintings. But they are only passages. Now and then the painted surface is all of a piece. But his full-rounded achievements are rare. Too often Luks seems content with a garish crudity, or is merely painty. Is he trusting to time to mellow his canvases? I might point to Manet as supplying a suggestive precedent. The years have helped his work. They may help that of Luks. But Manet never needed it as Luks needs it. Pure color is half

THE LITTLE MILLINER

BY GEORGE LUKS

the battle, color laid on with a touch as firm and precise as it is lavish. That is what Mr. Luks seems to me to lack. He leaves the impression, for all his masculine bluntness and weight, of a painter feeling his way rather than exercising an absolutely certain and authoritative process of attack. It is very puzzling. It would be absurd to deny his proficiency. But it is fair to question his use of it. Is it some hobgoblin of taste that gets between him and the perfect expression of his large, zestful, vigorous talent? Is it some ingrained insensitiveness to the nuance, the tenderness that is one of the prime resources of the painter, keen as he is upon the potentialities of mere paint? Preciosity, of course, is unthinkable in the equipment of so ardent a realist. Well, there is no preciosity about Manet, but I have seen blacks, grays, yellows, blues, and flesh-tints of Manet's that had the limpid charm of the paint of Velasquez.

Luks hovers again and again on the edge of felicity. He paints a sketch like his "Closing of the Café," an old souvenir of Paris, and you feel that he is on the way to the happy haven of an Alfred Stevens. Years afterward he does "The Sand Artist," and the tawny tones seem once more on the verge of sensuous beauty. Is it an unconscious renunciation of beauty that he makes, or is it deliberate? "The Little Milliner" is there to make it plain that beauty is within the artist's reach. Why, then, is it so often missing? Does he disdain it? The persistence of my questionings

gives the measure of my sympathy for Luks. There is no American artist who wakes in me a more wistful craving for a greater satisfaction.

## II

## GEORGE BELLOWS

George Bellows has remarkable power. There was a time when I wondered if he was not moving about in worlds unrealized, if he was not painting the slums from a factitious point of view and with a mistaken reliance upon technical methods formed, a little naïvely, on those of Manet and his circle. All that has gone down the wind. More and more it has become apparent that he paints as he does because he cannot help himself, having a personal outlook and a personal manner. There is still a studio-like air about his work, he still sticks to a cold key of light and to an excessively prosaic sort of realism. It is surprising to find a June landscape of his more or less true to its title, and recalling in its bosky background the very sweetness of the time suggested. How did he stray into such a mood of almost poetic emotion? As a rule his temper, though not precisely unsympathetic, seems a little heavy, if not grim. Is it that he is learning that while to paint for the sake of painting is great sport, there is even more fun in painting for the sake of beauty? One delights in his strong, direct technic. When he

paints his portrait of "Jimmy Flannigan" and uses brush-work so broad, so swift, so tingling with life, that for a moment we think of Hals, we want only to cheer him on. And yet to go back to his coast scenes and to watch him painting sky and water with so much feeling for the sensuous charm in them is to wish that he might give an ever larger part of his time to such beautiful themes. It cannot but react upon his art, giving to that art a greater depth, a more sensitive quality, and a truer individuality.

His doings as a lithographer are interesting. They give one a positively refreshing sensation of technical virtuosity. He has alluded to the fact that work upon the stone demands "a marriage of science and art," and has spoken of the knowledge of chemistry and physics required. Of course. But it is when he speaks of the lithographer's needing "a very special love of the work" that we come closest to the secret of his own success. He draws on the stone with all of the gusto that I have so often observed in his painted work — and with a good deal more of that magic of touch which spells complete initiation into the heart of a medium. His blacks, which are the first to show a lithographer's skill in attack, are magnificent, but appreciation deepens as we watch his handling of grays, of all those delicate half-tones and fleeting modulations which make the stone a source of æsthetic joy. The print which is, I suppose, the most popular ever made by Bellows, the "Murder of

Edith Cavell," has great richness of color; a bloom rests upon it despite its portentous scale. But for the fine flavor of his lithography I would urge the reader to consider even more exhaustively his various heads of children. These exquisitely reveal the craftsman's mastery over an enchanting form of artistic expression.

I wish there were an enchantment of style, of feeling, to match that which attaches to Mr. Bellows's lithographs as technical triumphs. But apparently he is dedicated too whole-heartedly to the depiction of what is prosaic in life to care a straw about what is poetic, what is beautiful. The print called "Reducing" is representative of his taste. While her husband snores in bed a fat woman reclines upon the floor and uplifts a hideous leg. He offers it as "a study which started out in a humorous vein but developed into a drama of light and dark." The reference to "a drama" is ingenious, but of no effect in lessening what is repulsive in the subject. The subject, as a subject, might pass. It is the mere ugliness of form, an ugliness unredeemed by beauty of drawing or style, which repels, and I speak here not of a quality which is accidental, belonging only to this print, but to a quality running through practically all the lithographs. It crops out even in the studies from the nude. Life, as Bellows sees it, is singularly barren of charm. Whether he is studying the nude model or drawing the heroes of the prize-ring, he ap-

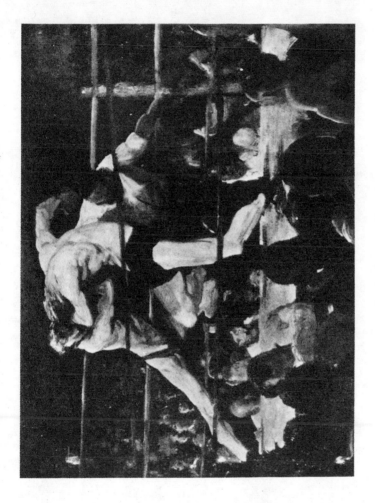

A Stag at Sharkey's
BY GEORGE BELLOWS

pears to find form an affair of brute strength, never of beauty, and this view of the matter enters the very grain of his art.

## III

## ROBERT HENRI

Robert Henri is content to keep his eye on the object, to register the truth. He has a *flair* for the brilliant manipulation of pigment. If you look in his work for an æsthetic emotion charging the representation of form with the glamour of style you will be disappointed, but if you are looking for spirited technic he will give it to you. Perhaps he has his vision of beauty. Perhaps when he painted certain nudes of his he was aware of some charm of form and made some effort to put that charm on canvas. But I am not sure. All I am sure of is that he enjoyed the play of his brush and exercised it with a fervor that communicates itself to the beholder. There are moments when the virtuoso in him is a shade too evident. He turns the trick with a deftness suggesting the mobile hand of the conjurer. Observe him defining the eyebrow of one of his models, and then go to the next canvas and see how skilfully the touch is repeated. I can never shake off from my apprehension of Henri a vague sense of the professor taking one *tour de force* after another out of his bag. But suppose he does do this rather mechanical thing? Suppose his painting

of an eyebrow does hint at a formula? Have not the detectives of early Italian art based their discoveries sometimes upon a given master's way of painting an ear or a toe? On the other hand, we may remark in passing, the Florentine Primitive had a way of giving us something besides a mannerism in the matter of form. Though there is no imagination in Henri's paintings, furnishing forth pictorial inventions, there is a good deal of interesting characterization. He has painted Spanish and other exotic types, and they make a welcome contrast to the dull *frou-frou* of which we see so much. He paints with an infectious appreciation the rich physiognomy and the warm flesh of an Hawaiian or Indian type. He makes a positive personage out of the Borrowesque matron of his "Madre Jitana." There are personalities mirrored in his canvases. Nevertheless, we return, when all is said, to just flashing technic.

# XII
# Women in Impressionism

I. Mary Cassatt
II. Berthe Morisot

# XII

## WOMEN IN IMPRESSIONISM

### I

### MARY CASSATT

IN the literature of the impressionistic movement comparatively few pages of a biographical nature have been given to Miss Mary Cassatt. Criticism has paid her work full homage, but through her own reticence details about her career have rarely cropped out. It was delightful to students of the history of modern painting, therefore, when at last she permitted herself to talk freely to M. Achille Segard and aided him in the production of a small but sufficient volume, "Mary Cassatt: Une Peintre des Enfants et des Mères." It satisfies a legitimate curiosity and places on record facts which in view of the painter's importance it is well for the public to possess.

Miss Cassatt spoke concisely but freely to her interlocutor. Impressing upon him that she was a thorough American, she went on to add that her family was of French origin, bearing the name of Cossart when the first of her ancestors to come to this country left his native land in the seventeenth century. It was not long afterward that her mother's forefathers

came here from Scotland.  The Cassatts have always
been established in Pennsylvania, and the artist was
born there, in Pittsburgh, something over sixty years
ago.  Her father was a banker of liberal educational
ideas and the entire household appears to have been
sympathetic to French culture.  Miss Cassatt was
not more than five or six years old when she first saw
Paris, and she was still in her teens when, having made
up her mind to become a painter, she began the life
abroad which she has led ever since.  She had had
then no serious instruction, and, for that matter, her
temperament inclined her to rely for her training
more upon the museums than upon the schools.  She
went to Italy, and for eight months lived at Parma,
sitting at the feet of Correggio.  Then she went to
Spain.  Presumably she was interested in Velasquez,
but she says nothing about having felt his influence.
On the other hand, she speaks of her enthusiasm for
the works of Rubens in the Prado, and, in fact, next
turned her steps to Antwerp, where for a whole sum-
mer she devoted herself to the Flemish master.  There
followed a visit to Rome and after that a return to
Paris, where, in 1874, she permanently settled herself.
M. Segard tells us of her unshaken loyalty to the
French capital.  She has never been a zealous trav-
eller.  From 1874 to 1897 she did not quit the city
or its environs, and though she has long had a beau-
tiful country house at Mesnil-Theribus, it is significant
that it is only two hours away from her Paris home.

The first work that she sent to the Salon, in 1872, was a picture of two young women throwing bonbons in the carnival. It was painted at Parma and clearly showed, she says, her feeling for Correggio. In 1873 she sent the picture of a girl offering a glass of water to a bull-fighter. The following year she was represented by the head of a young girl which she had painted at Rome under the influence of Rubens. When her offering for 1875, a portrait of her sister, was rejected, she divined that the jury had not been satisfied with the background, so she painted it over again, lowering the key, which had been found too light, and in the next Salon the same portrait was accepted. In 1877 she was again refused, but this time had no occasion to do her work over again. On the contrary, at this moment Degas asked her to exhibit with him and his friends, the impressionist group then rising into view, and she accepted with joy. "Already," she said, "I had recognized who were my true masters. I admired Manet, Courbet, and Degas. I hated conventional art. Now I began to live." That had been a lucky day for her when, at the time of her stay in Antwerp, she had made the acquaintance of M. Tourny, the man who had copied the old masters for Thiers. He was walking through the Salon of 1874 with Degas one day when he stopped his friend before the portrait in the manner of Rubens mentioned above, the one sent from Rome. The great artist looked and said: "That is genuine. There

is one who sees as I do." It was Tourny who ulti-
mately took Degas to visit Miss Cassatt, and it was
on the occasion of that visit that he asked her to join
his circle.

She helped to make history. When in the spring
of 1879 Degas and his comrades organized, at No. 28
Avenue de l'Opéra, the fourth exhibition through
which they sought to challenge the official wing of
the French school, they were still outlaws, but were
beginning to make themselves felt. They got their
name from "Impression," the title of a picture con-
tributed by Monet. Degas didn't like it. He wanted
them to call themselves "Independents." If they
had done so, Miss Cassatt, too, would have been
pleased. She was thinking then of a broad indepen-
dence, not of any tradition, old or just invented. The
merest glimpse of the atelier of Chaplin, to which she
seems to have been introduced early in her career, was
enough to confirm her distaste for convention of any
sort. When she took part in the revolt against au-
thority in which Degas had asked her to participate
she was not merely assisting in a quarrel, but giving
free rein to an inborn instinct toward freedom. One
can read between the lines of M. Segard's narrative
the story of a fervor even more fiery than that which
he actually describes. Miss Cassatt's devotion to
art truly amounted to a passion. There is a char-
acteristic incident relating to this exhibition of 1879.
The painters represented may have been unpopular

in some quarters, but seventeen thousand persons paid a franc each to see their works, and when all expenses were paid there was a considerable sum left in the exchequer. Each exhibitor got his share. Forain, it is said, bought a watch upon which he had long cast envious eyes. Miss Cassatt bought a Degas and a Monet. Her purchases were made, let us note in passing, only after the show was ended. The public had bought nothing. She must have been amused when, at the Rouart sale, a picture of hers fetched eleven thousand seven hundred francs. How far the whole subject has travelled since 1879, when she made her effective début!

It was a beautiful and very fresh, accomplished bit of painting, the "Jeune Femme dans une Loge," with which she signalized her entrance into the company of Degas and the rest. It was, too, in perfect harmony with the general drift of their various performances. But it is at this point that M. Segard is at pains to disengage both the artist and her work from the background against which both have been, if we are to accept his judgment, a little too closely viewed. It has long been taken for granted that Miss Cassatt was pretty literally a disciple of more than one of the impressionists. M. Segard states that, as a matter of fact, she had few personal relations with Manet or Renoir, even fewer with Sisley. And, in spite of her being a neighbor of Pissarro's in the country, she went to him for no counsel. Her biographer notes, too,

that she painted the figure where Monet, Sisley, and Pissarro painted landscape, and he adds that while Degas has always kept close to his studio she has done her work in the open air. From neither Degas nor Manet did she seek formal lessons. To the influence of both, however, she was frankly susceptible, drawing inspiration from their works as she had drawn it from Correggio and Rubens. At the centre of her being there burned with a steady flame a resolution to use in her own way whatever she could learn from her old and modern masters. A masculine self-confidence was at the bottom of all her efforts, and with it something of masculine strength. Gauguin is quoted in this book as having said of her, on a visit to the exhibition of 1879: "Miss Cassatt has much charm, but she has more force." M. Segard emphasizes this trait, and it plays into his hands as he seeks further to develop his conception of this artist as a person of high individuality.

He lays stress upon her intellectuality and upon her sentiment, suggestively exposing the salience which she derives from the emotion and distinction with which she has painted her favorite models, babies and their mothers. He speaks also of her predominant interest in draftsmanship and her gift for linear pattern, a gift greatly strengthened by her study of Japanese art and her emulation of its style in the color prints she has made. All this, as he easily and, by the way, very charmingly demonstrates, unques-

tionably presents Miss Cassatt as an independent among independents, a painter well preserving her individuality for all that she has owed so much both to Degas and to Manet. It is at first a little difficult to accept the author's exceedingly appreciative hypothesis, yet on reflection it does not seem overdrawn. On the contrary, as we weigh all the arguments put forward in this penetrating study, we cannot but confess to a new realization of the essential individuality of the paintings traversed. Obviously associated, as they must always be, with a particular movement in modern art, they affirm Miss Cassatt's creative faculty, her claim to the honor of having played not an imitative but a personal and constructive part in a memorable campaign. Her style partakes of the style of others; her draftsmanship, her composition, her light and her color, are her own. Incidentally I would say that she had registered a tremendous triumph for her sex if it were not that she enforces the irrelevance of questions of sex where good painting is concerned. There are qualities of tenderness in her work which could have been put there, perhaps, only by a woman. But the qualities which make that work of lasting value are those of which you can only say that they were put there by a good painter. Degas, with his sardonic humor, once looked at a picture of hers and gruffly made denial that a woman could draw so well. He has always been one of her loyal admirers and one of her most helpful critics.

## II

## BERTHE MORISOT

Amongst the women painters in modern history the
late Berthe Morisot achieved a distinction equalled
only by that of our own countrywoman, Mary Cas-
satt.  Her gifts did not at once receive wide public
recognition, but they were ultimately estimated at
their true value, and in recent years they have won
more and more appreciation.  She was an interesting
type.  Degas once said of her that she painted pic-
tures as she made bonnets, the saying not being in-
tended as a malicious witticism, but as a suggestion
of the femininely instinctive and impulsive action of
her talent.  One source of her strength, however, was
the thoroughness of her training.  She was not one
of those idle women who dabble in water-colors for
amusement.  As M. Theodore Duret, one of her old
friends, makes plain in his useful book on "Les
Peintres Impressionnistes," she was an artist in the
serious sense from the beginning.

Her father, Tiburce Morisot, an official at Bourges,
where she was born in 1841, was not so absorbed in
his legal duties as to be indifferent to artistic things.
He saw that his daughter's tastes were genuine, and
when the time came he made it easy for her to develop
her faculties.  She and her sister Edma were sent for
instruction to one Guichard, a follower of the school

of Ingres, who had no great genius but was at least a
sound guide. Later the two girls fell under the in-
fluence of Corot, who gave them a serviceable teacher
in his disciple Oudinot. Edma Morisot abandoned
painting when she married in the sixties, but Berthe
continued to labor with the brush, exhibiting at the
Salon and in every way giving herself to her profes-
sion. It was while she was making copies from old
masters in the Louvre that she first came to know
Manet, then occupied in the same way. Later their
families entered into very friendly relations, and
Berthe became intimate with the great impressionist,
modifying her style in the light of his example and
developing the broad, vivid qualities for which her
works are prized to-day. In 1874 she married Eugene
Manet, the brother of the poet, and M. Duret de-
scribes her as the hostess of a delightful circle. De-
gas, Renoir, Pissarro, and Monet frequented her
house, as did the poet Stéphane Mallarmé. She con-
tinued to paint, signing her pictures with the name
by which she is still remembered in artistic annals,
but for some reason or other, perhaps because of her
sex, criticism insisted upon placing her as a kind of
dilettante and subordinate figure in the impressionist
group. Her rank as an artist was obscured by her
position as a woman of the world. She suffered under
this injustice, but she had stanch friends who worked
hard to secure for her the consideration she deserved.
Duret and Mallarmé moved heaven and earth until,

shortly before her death, in 1895, they succeeded in
persuading the authorities to purchase one of her pic-
tures for the Luxembourg. The incident made her
profoundly happy.

Her claim to be represented in the famous museum
is now generally admitted. She was not, it is true, a
creative artist. It may even be said that she would
not have made the progress that is shown in her best
works, would not have given them their special char-
acter, if Manet had not been there to help her to form
her style. They were fast friends. He made her por-
trait more than once, painted her in several of his
pictures, and dominated the current of artistic ideas
in which she lived. Without his influence it is doubt-
ful if she would have realized as she did the beauty and
value of light and air, the importance of these elements
in the manipulation of effects of color, and the virtues
of breadth and directness in handling. Yet upon the
groundwork that she owed to her contact with Manet
she superimposed qualities of her own. There is a
delicate fragrance about her art, a certain feminine
subtlety and charm, through which she approved her-
self an individualized painter.

# XIII

## Edwin A. Abbey as a Mural Painter

# XIII
## EDWIN A. ABBEY AS A MURAL PAINTER

WHEN from his home in England Abbey sent to America, in 1908, the eight mural decorations he had then completed for the State Capitol in Harrisburg, he, himself, addressed the huge packing-case containing them. He sent them to "The Commonwealth of Pennsylvania." In imagination I can see him hovering over the box, brush in hand, half humorously taking pains with his lettering, but setting forth the words just cited with a kind of affectionate gravity, as though even in this trifling matter he would render due honor to his native State. The episode is, indeed, usefully illustrative. These paintings of his have a meaning apart from their artistic character. We are forbidden to mix patriotism and art, lest we breed a most unprofitable confusion of ideas, but sometimes the two elements are so felicitously intertwined that we would not separate them if we could. Abbey loved Pennsylvania and its history, and it is in nowise sentimental to think of his work for Harrisburg as promoted by a genuinely patriotic enthusiasm. When he undertook it he was not concerned merely to execute a commission, but to pay tribute to his countrymen; and this is only another way of

saying that he was passionately *interested*, a state of mind not by any means as common in the history of modern mural decoration as one would naturally take it to be.

The painter called upon to fill a given space necessarily gives his first thought to the purely decorative aspects of his problem. Since he must lay his theme upon a more or less Procrustean bed, it is not surprising that in some cases he ends by leaving the theme to take care of itself, a colorless affair of academic types and symbols, subordinated to conventions of design. The result is about as thrilling as a geometrical diagram. To be saved from this the artist needs nothing so much as a tingling, living interest in the substance as well as in the form of his work. There is a story of Vasari's which is apposite here. It relates to Ghirlandajo, Abbey's Renaissance prototype in decorative narration. The old Florentine was an eager business man, who thought that no job was too small to be accepted in his *bottega*. But as he got more and more authoritatively into his stride the artist in him snuffed the finer airs of battle and he flung sordid motives and obligations upon the shoulders of his brother David. "Leave me to work and do thou provide," he said, "for now that I have begun to get into the spirit and comprehend the method of this art I grudge that they do not commission me to paint the whole circuit of all the walls of Florence with stories." Vasari tells in this illustration of "the

resolved and invincible character" of Ghirlandajo's mind, and as showing the pleasure he took in his work. That was like Abbey. He was in love with his work and his themes, and Harrisburg was his Florence. It is said that when there was some temporary uncertainty as to the funds available for part of his decorative scheme, he hastened to assure the authorities that it would nevertheless be carried out by him, even if he had to finish some of the panels without any remuneration whatever. I can well believe it. Thus he would have discharged a debt of gratitude.

He was born in Philadelphia, on April 1, 1852. He was educated there. At the Pennsylvania Academy of Fine Arts he took the first steps in his artistic training. His loyalty to the scene of his birth and early upbringing must have been fostered, too, by certain historical associations in his profession. Other men of Pennsylvanian origin before him had developed their careers in London, in ways not dissimilar from those marking his own success there. Benjamin West and Charles Robert Leslie had both fixed Pennsylvanian names in the roster of the Royal Academy. The first had done much in the service of George III, and the second had painted one of the pictures officially commemorating the accession of Queen Victoria. Abbey, rising to a powerful position in the Royal Academy, and painting, by the King's wish, the coronation of Edward VII, doubtless mused appreciatively on the peculiar links between himself and his two

predecessors.  Being a modest man, it is improbable that he ever dwelt on the fact which others may legitimately observe, that in his art he had affirmed the energy of the soil from which he sprang far more effectively than either Leslie or West.

The truism that quantity has nothing to do with quality should not obscure for us a really important suggestion lying in the mere bulk of what he achieved. Looking back over that life that came so untimely to an end, in London, on August 1, 1911, one is impressed by its range and fertility, and is moved to reflect on how intensely like his own people Abbey was, for all that he made his home in the Old World, and spent so much of his time in the interpretation of the least modern side of its genius.  I find his Americanism coming out very strongly in what I can only describe as his wonderful driving power.  When he sprang into fame, years ago, with his illustrations for Herrick, the charm he exerted was that of a sunny afternoon in some old English garden close; but then and always thereafter Abbey was emphatically a creature of great nervous force, unremittingly ardent, and capable of labors seemingly out of all proportion to his frame. As a matter of fact, though he had no great stature, he was strong.  One felt this in friendly intercourse with him, when his jolly spirit came bubbling to the surface and he made you realize how rich he was in sheer force, how quick, how kindling to the mood and movement of his time.  I remember sitting with

him one bleak winter's morning in New York when
he was working over his "Ophelia." The studio he
had secured for a short time contained few "proper-
ties," romantic or otherwise, and its atmosphere was
indeed thousands of miles removed from that to which
he was accustomed in his Gloucestershire home. Out-
side, instead of the drowsy repose of the English coun-
tryside, flat commonplace held sway, summed up and
defiantly expressed in the clatter of the elevated rail-
road. Abbey did not care a fig for the prosaic pres-
sure of his environment, and I do not mean by that
that it had driven him within himself. On the con-
trary, it exhilarated him, he was absolutely at home,
and it was good to look on at the vivacity and firm-
ness with which he pursued his so poetic task. I got
there a clew to his art. Mr. James, speculating as to
what a charming story-teller he would be who should
write as Abbey drew, goes on to ask: "How, for in-
stance, can Mr. Abbey explain the manner in which
he directly *observes* figures, scenes, places, that exist
only in the fairyland of his fancy?" I think it was a
quality of race, cropping out no matter how far back
in time he threw his imagination. It was the Ameri-
can in him, the man who lives by reality, who lives in
the moment, who keeps his eye on the fact. The poet
in Abbey brought forth the composition; but once his
images stepped into his mind, he saw them steadily
and saw them whole. In the process of painting them
he gave them a vitality which was none the less au-

thentic because it differed profoundly from that sought in certain contemporary schools other than the one to which he belonged.

It is suggestive to think of a notable friendship of his, that with John Sargent. Could any two comrades in painting be more drastically unlike one another? Intimate for years, and often painting side by side in the big studio at Fairford, one stood for the every essence of modernity — which the other seemed to regard incuriously, and even with something like disdain. If, in the mind's eye, we were to conceive of the friends as painting, for the fun of it, the same subject, we know just how the good-natured rivalry would have ended. Sargent's canvas, in its rapid, synthetic handling of form, and, above all, in its play of light, would have an actuality lacking to Abbey's. But let us put the matter in another way. Let us suppose the subject to be a man of to-day in evening dress, and this actuality of Sargent's would without question obliterate the rival picture. On the other hand, let us suppose the reconstruction of some figure out of the past, a model perfectly clothed and posed as a great mediæval churchman, or the heroine of a Shakespearian comedy. The connoisseur of technic for its own sake might still prefer the Sargent, but if he kept his mind open he would be bound to admit that Abbey's presentation of the dead and gone type carried conviction far deeper. Reality in the true and final sense, he would see, had been followed, and

caught, by different roads. Each man, obeying the dictates of his genius, had in the long run got the thing itself. With Abbey it wore a romantic garment, but the true source of it, and its best warrant, remains that American energy of which I have spoken, his instinct for things living and tangible.

He always wanted to know, to make himself free of the organic secrets of his material. At the start, when as a youth he began drawing illustrations for *Harper's Weekly*, his facility not seldom enabled him, it is said, to call up a picture out of verbal suggestion, without the aid of models or accessories; but he very soon disclosed an eagerness to know absolutely what he was about. In order to draw the Herrick designs, he made himself acquainted with English landscape, and the sentiment of its ancient architectural monuments. I have a picturesque memory of him hunting up architectural details in a vast collection of photographs. He threw himself upon the books in a positive fever. One of the stories that he liked to tell about his archæological adventures related to the pillars in "Sir Galahad's Vision of the Holy Grail," one of the panels in the Boston Public Library. He found just the capitals he wanted for those pillars in a little French town and instantly set about copying them. Then a fussy mayor turned up, with a thousand objections, and the artist was in torment. Finally, his friend, the late Sir Frederick Leighton, came to the rescue, and between them they reduced the trouble-

some functionary to good nature. Abbey was forever carrying on his work in this studious fashion. When they gave him a degree at Yale, in 1897, Professor Fisher, in presenting the sheepskin, praised him for his imagination, but, he justly added, "this original power would be inadequate were it not allied with cultivation of a high order and patient researches." When he undertook to illustrate the Grail legend in the paintings at Boston, he read everything that could help to initiate him into his subject, and even went to Bayreuth to hear "Parsifal" and see if Wagner could in any way enlarge his horizon. I dwell on all this not alone in order to enforce Abbey's care for accuracy — a care which has been manifested by some of the driest and most uninspiring painters who have ever lived — but far more for the purpose of exposing the true nature of Abbey's inspiration. It was that of an artist whose industry was animated by thought and emotion. All the work that he did for many years was at bottom a preparation for that with which he rounded out his busy life. The pen drawings with which he illustrated Shakespeare, Herrick, and other English poets, the oils, water-colors, and pastels in which he revived scenes from old English and Italian life, were ever heightening his powers of observation and making his sympathies more flexible, so that he might come to his great enterprise at Harrisburg equipped to cover the walls there with really living forms.

At Harrisburg, Abbey was invited to exercise the functions of the mural decorator on high grounds, not so much to fit his pictures into a frame as to make them part and parcel of a monumental whole. It was his opportunity to meet the architect half-way and to co-operate with him in completing, rather than embellishing, the lofty rotunda of a vast fabric in stone. On his long experience of picture-making he has based the group of decorations I have now to describe — a group finer than anything he ever did before, and constituting a landmark in his career. It consists, to begin with, of four lunettes of heroic dimensions and as many circular panels set in the pendentives between them. They are placed midway between the drum of the great dome and the massive piers supporting the whole structure. The lunettes are recessed well back of the curving line followed by the pendentives, and the ceilings of the arches enclosing the larger paintings are richly coffered. The imposing cornice superimposed upon the piers forms a perfect base for Abbey's decorative scheme. He was, indeed, very fortunate in his architectural environment. Classical in style, it has been handled with a due sense of dignity, and no thin or frivolous details have been admitted. White marble rules below the cornice, save where the capitals are bright with gold. In the cornice itself, and in the conventional ornament on the pendentives around the artist's panels, blue is added to the arrangement of white and gold. The general ef-

fect is reposeful and cool. Abbey made his work a very harmonious part of it. His predilection for red comes out in the scheme, but not at all obtrusively. None of his decorations has been painted to "make a hole in the wall," and none of them contains a too assertive passage.

Their subjects bring us again to the point already mentioned, the artist's success in forgetting the preoccupations of years and in expressing the essentially modern genius of his native land. He had read the history of Pennsylvania, and in these decorations he summarized its salient chapters. The first of these, which he entitled "The Spirit of Religious Liberty," is a tribute to William Penn. He figures the pioneer's zealous venture in an ocean scene, showing us a fleet of ships advancing toward us under full sail with three white-robed wingless angels in the heavens leading the way. Facing this the lunette called "Science Revealing Treasures of the Earth" represents a number of miners lowering themselves into the pit, while, in the background, blind Fortune, attended by figures of Peace and War, floats poised upon her wheel. The third decoration, "The Spirit of Light," celebrates the discovery of oil and its tremendous potentialities. Against a web of dark lines, formed by a number of derricks, rises a crowd of aerial figures lifting upon their finger-tips small but brilliant flames. In "The Spirit of Vulcan" Abbey depicts the interior of a steel foundry, with the brawny god looking down upon the

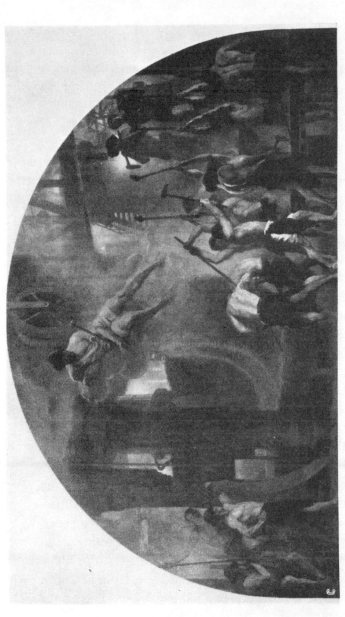

THE SPIRIT OF VULCAN

BY E. A. ABBEY

labors which have contributed so much to the prosperity of the State.  In these lunettes the artist presents specifically tangible elements in Pennsylvanian progress.  In the pendentives his medallions are dedicated to the great forces of civilization at large, to Religion, Law, Art, and Science, embodying each motive in a single figure with appropriate accessories and spreading an inscription over each golden background.

The foregoing brief summary will have made it plain that Abbey had, as always, something to say. Many episodes in the history of Pennsylvania might have yielded him suggestive material, many scenes involving famous personages and giving opportunity not only for portraiture but for drama.  In choosing themes of a certain impersonal significance, however, he secured the grandeur indispensable to monumental art, and, at the same time, was faithful to the interests of humanity.  The ideal of religious liberty symbolized in the first of his paintings is no unsubstantial theory, academically expressed; the hearts of men are behind the straining timbers of the ships that come bravely on to a new shore.  The natural forces treated in the remaining lunettes are those which in this country, and most emphatically in Pennsylvania, have enlisted the taming energies of a whole people.  The church, and then coal, oil, and steel — these things have made Penn's Commonwealth, and in going to them for his ideas Abbey ranked himself with those mural decorators of his time who are in the van.  He

is their comrade, too, where the technical solution of problems of the sort is concerned.

The modern mural painter is hard put to it to reconcile the immemorial claims of decorative tradition and the methods of the schools in which he is trained. His composition must be well balanced, but if, with this in mind, he follows too closely the classical formulas of the old masters, he is sorely apt to be stilted and uninteresting. Everybody knows the banality of the modern figure of The Arts, say, enthroned in the middle of a lunette like some matronly acrobat, embarrassed by unaccustomed garments but bent upon keeping herself at the precise centre of the canvas. The gesture of the figure on her right is repeated in the reverse direction by the figure on her left. Thus, the artist holds the scales even to the extreme limits of his canvas, and the decoration remains absolutely lifeless. But what if he uses the naturalism which he would otherwise practise? If he tries to vitalize his decoration as he would a casual note from nature, will the result not be equally out of place? It is hard to find the middle course, but it is there, as men like Besnard have shown, and Abbey found it. The Harrisburg decorations are admirably "centred," but not through academic pedantry. He gained his end by a right adjustment of masses, by a discreet arrangement of colors as well as of forms.

This is manifest at once when the observer enters the main portal on the east side of the building and is

confronted by "The Spirit of Religious Liberty," far up on the western wall. There is no crassly fixed centre here, but the design is beautifully unified. Across the bottom of it stretches a narrow strip of deep-blue sea. Narrow as it is it has enormous weight; smoothly but irresistibly you feel the pressure of an illimitable body of water. The foam rises, subtly suggesting the deep snore of the sea itself, under the forefoot of the nearest vessel. The ocean moves, it is alive with its color, its sound, and its sharp, salt smell. Abbey never did anything truer or more artistic than what he did here, painting the sea as it is and at the same time making it a sort of pedestal for the intensely decorative ships that tower above it. The broad sails relieve the dark hulls with breadths of tawny red. Something of their glow faintly flushes with rose the white draperies of the three celestial guides. Back of it all is a cloudless sky, vague, opalescent, spacious. Filled with the large airs of the open sea, eloquent of the wide horizons faced by the founder and his people, is this beautiful painting, a work to touch the imagination with a sense of an old hope gloriously fulfilled. And, withal, the lunette falls into its place as naturally, with as much of architectural balance, as though its component parts had been mathematically assembled.

The same well-pondered construction marks the eastern lunette, "Science Revealing Treasures of the Earth." The red earth itself provides the firm foun-

dation in this case, synthetized, like the sea in the other, into a simple, broad mass. The deep fissures in it are only dimly discerned. The miners are descending warily into unknown depths, and, accordingly, these are enveloped in the vagueness of mystery. The practically nude bodies of the workmen are not painted in too high relief. These delvers are coming close to Mother Earth with primitive toil, and their skins are subdued in color to the stuff they work in. One is aware of them as stalwart yet young and artless creatures, obviously the builders of a new world, eager upon the scent of discovery. Whether intentional or not, the treatment of the tree-trunks behind them is singularly suggestive in view of the allegorical figures filling the upper part of the canvas on the other side. The russet-winged Goddess of Fortune in her red robe, drifting over the abyss between Peace and War, with their thin, floating draperies respectively of blue and white, looms against a bright sky like a phantom out of the pagan mythology. She sets the mind momentarily on thoughts of classical antiquity, and, keyed to this mood, the bare tree-trunks raise a fleeting memory of some pillared Greek temple. Between these natural columns you catch glimpses of distant blue hills. The air seems very still. The explorers work as in a breathless wonder, tense with the excitement of uncovering a precious secret in one of the silent places of the world. Both in this and in the decoration traversed above, Abbey

links his design with the deeds of the men who made Pennsylvania, and generalizes his theme so that it has a wider scope. He lifts his local allusion to the plane of his purpose as the collaborator of the architect.

The northern and southern lunettes, conceived with equal imaginative grasp, are, nevertheless, designed in such wise as to bring more realistically home to us a sense of what Pennsylvania is doing to-day with the liberty sought in those red-sailed ships and with the treasures wrung from the earth. The hammer-wielding god in "The Spirit of Vulcan" wears his scanty blue garment after the careless fashion of the Olympians, and his ruddy limbs and shoulders rest appropriately in cloudy billows. But he broods over the scene less as a poetic figure than as the mentor and friend of the very human toilers beneath him. He seems, in very truth, the genius of the amazing chamber in which he finds himself, a place of giant machinery, dark, fantastic, and forbidding, of molten metal and eddying vapors, of grimy, sweating men who are children of this generation, but who, at their mighty task, wear, somehow, a grander, more elemental air. The management of the color in this decoration is superb, the prevailing darkness of the machinery being relieved to just the right extent by the warm flesh tints of the smiths, the glow of the flaming steel, the pearly tones of the shifting steam and the touch of lovely blue in Vulcan's tunic. But one dwells also with special appreciation on the modelling and drafts-

manship which the artist has brought to the portrayal of his figures. The linear habit proper to his illustrations made with the pen, and subsequently hinted, if not actually disclosed, in some of his paintings, is here conclusively abandoned. The figures are seen in the round and are so painted, freely and boldly, with close research into movement, the play of muscle, and the swiftly changing effects of light and shade. Nor has the painter's interest in detail distracted him unduly. He fuses his details into one moving vision.

Up to this point Abbey worked, so to say, on safe ground. In his fourth lunette, he let himself go in rather audacious vein. Baldly stated on paper, the idea of a company of light-bearers rushing up into the air, past the prosaic timbers raised above a number of oil-wells, hardly commends itself as suitable for a great mural decoration. It all depends, of course, upon how the thing is done. Abbey did it with success by concentrating his attention upon the inherent picturesqueness of his subject. He saw that subject against a dark sky, the deep blue of which is broken by rifts of gold. With such a background the black tracery of his derricks takes on a new aspect; it is no longer prosaic but, on the contrary, positively romantic. One thinks of the tall chimneys on Thames side which turned into campanili under Whistler's eyes. The derricks have something bizarre about them; beneath the shadow of those ghostly towers, almost anything might happen, and there is, after all, not audac-

ity alone, but, in some sort, an inevitableness in the sudden upward flight of the "Spirits of Light," golden-haired, ivory-tinted goddesses, swathed in diaphanous blue, and coming like exhalations from the deeps. The maze of their floating figures, all softness and grace, would lose half its value against a neutral background. The needed contrast, the element to make the balance true, comes from the rigid lines of the derricks. The eye rests upon this lunette with the same contentment as upon its companions.

If the four have, as it were, a common vitality, expressed in the same terms, their decorative integrity, as of work growing out of the construction of the walls, is in part supported by the medallions in the pendentives. These unite while they divide the canvases to which they are subordinate. They are necessary members of the scheme, embracing Abbey's zone of the rotunda in one chord of color. In them he sought to create four episodes of design without so far emphasizing them as to give them an independent existence. To this end he caused the figures to stand out against golden backgrounds, so that each medallion counts vividly in the ensemble, but none of these personifications is invested with too complicated a meaning. Religion, clad in the white robe of innocence and treading under foot the dragon of evil, stands with arms uplifted between her altar and the torch with which she passes on the sacred flame. Law, in heavy red habiliments, is blindfolded, but she, too,

has conquered the enemy at her feet. In one hand she bears the scales and in the other a sword. The owl of wisdom perches on the wrist of Science, whose right hand holds the lightning. The serpent coiled beneath the hem of her garment lifts its head above her knee. Her face is veiled. Religion and Law are tall, solemn, hieratic figures. Science is made more human. She is the most beautiful of the four. Her robes are bewitching in color, agleam with the deep greens of the emerald and the hues of a dark Egyptian scarab. The figure of Art is, somewhat surprisingly, the least pleasing of them all. It is statuesque; the laurel-crowned head and the columnar throat have a certain sculptural distinction, but the figure as a whole leaves a rather meagre impression which is only deepened by the insignificance of the accessories and the cold reds and greens in the draperies. All of the medallions suffer a little from the manner in which the inscriptions have been introduced into the background. The breaking up of the words ends by teasing the eye with a sense of unrelated letters. On the other hand, these inscriptions have been kept in so low a key with reference to the gold behind them that after one's first impulse of impatience they are summarily ignored and the medallions are observed in their broad relation to the lunettes and the architecture.

Through the designs I have thus far traversed the grand elements which have formed the destiny of the

Commonwealth are broadly embodied. In the later compositions, four with which I have now to deal, the theme changes. In one of them human history gives way before the majestic appeal of nature pure and simple; but in the other three Abbey comes to close grip with the very men who made his State, hailing them by name, painting their portraits, and, in a word, making the drift of his whole decorative purpose more and more intimate and poignant. In the rotunda it was his rôle to touch the imagination of every one entering the building with a sense of what Pennsylvania has owed to divine inspiration and to the bounty of the earth. These large motives belonged on the threshold, and in the Capitol's grandest, most aerial chamber. The very concrete, personal issues dealt with in the later decorations are explained by their positions. He had now to embellish the walls of the House of Representatives, and there he decided to confront the legislators with paintings recalling those who had before them labored for the State. Above the rostrum of the speaker he chose to place "The Apotheosis of Pennsylvania," which is really a painting in praise of famous men, a record of high endeavor. For the unification of his noble company of explorers, sea-captains, soldiers, religious leaders, and other constructive pioneers, he had to devise some linear web that would not only hold them together but bind them in the harmony of a room whose scale and character had already been fixed. It was a difficult prob-

lem, to introduce so many figures, and yet not make them into a crowd, to break the mass into small groups which should detach themselves without landing in isolation, to make the "setting" compose all the trouble and at the same time not unduly assert itself. He hit, I think, upon a phenomenally good solution, one which is the more surprising, too, when you stop to consider that Abbey was never a disciple of such old masters, say, as Veronese, who have so much to teach us on questions of academic balance in mural decoration.

Across the middle of his canvas and well back of his figures he drew, in a shallow and very beautiful curve, the lines of a classical entablature. Above them he unrolled a spacious sky, thus gaining at once the necessary depth and largeness of atmosphere. We feel rather than see the colonnade enclosing the actors in his scene; it unites them, but does not distract attention from them. So it is with the "Genius of State," enthroned beneath a cupola against the sky, at the apex of the composition. This presence manifests itself, and is, in fact, indispensable, but it is so placed and so kept down in the color scheme that it leaves Abbey's men to stand forth with no diminution of individuality. Neither are they dimmed nor are their messages muffled by the return to architectural motives in the foreground, by the fluted pillars which mark, as it were, an entrance to the colonnade. Like the latter, these pillars, surmounted by eagles,

enormously contribute to the orderliness of the assemblage while they leave it free. It is a goodly body that looks down upon us from this canvas. The first steps below the throne where sits the Genius of the State, steps on which laurel wreaths are shrewdly disposed, are occupied by the worthies who take us back to the earliest pages in Pennsylvanian history. There is the gallant figure, in cloak and ruff, of Sir Walter Raleigh, one of the first to obtain colonial grants, a man who foresaw the tremendous future of the New World. Near him are navigators like Hendrik Hudson, who discovered the Delaware, and old Peter Minuit, who on a memorable occasion sailed into the Chesapeake. To the right, Abbey remembers not alone the hardy path-breaker, trusting to his rifle, but the valiant pioneers who put their faith in a higher aid, Pastorius, Kelpius, and the other leaders of those various religious sects which have contributed some of the most mystical chapters to the history of the church in America. Just below these standing pioneers, marble seats are occupied by later servants of the State. John Dickinson is there, who had his doubts about the "Declaration," but approved himself a sound patriot when the time came. Judge Thomas MacKean sits in grave contemplation, with Provost Smith, of the University of Pennsylvania, and White, the first American bishop, for his neighbors. Place is found for old Pastor Muhlenberg, who knew so well how to strive for the right not only in but out of the pulpit;

and we see also Dallas, the statesman, who served as Senator, as Vice-President, and as Minister to Great Britain, and John Fitch, with the model of his engine. Grouped here, at the right, are other scientific types: Oliver Evans, with his road engine, David Rittenhouse, the astronomer and philosopher, Caspar Wistar, the noted surgeon, and those renowned botanists, the Bartrams, father and son. Tom Paine, waking such diversified memories, of oratory, and of hard work at Valley Forge, stands meditatively with his hand raised to his mouth. On this side of the composition Stephen Girard, the founder of the college for orphan boys, takes one of these under his protection. Conspicuous among the balancing figures on the other side is Mad Anthony Wayne, drawing his sword. Below him, carrying on the military thread, are soldiers of the Civil War, officered by Hancock and Meade, and cheered on by Governor Curtin and Thaddeus Stevens. On the same level, opposite to these saviors of the Union, we have an episode calling the mind back to the arts of peace, the workers in the mines and in Pennsylvania's outstanding industries of steel and oil, quietly playing their parts.

I have said that all these people are held together through the artist's faculty for composition. The homogeneity of the piece is assured still further through a subtly dramatic touch, which signifies not only good academic design but imaginative power. I refer to the grouping in the foreground, right in the

middle of the painting, of the three supreme Pennsyl-
vanians — William Penn, Benjamin Franklin, and
Robert Morris. With true culminating effect and
with perfect naturalness, they stand upon the rock
upon which is engraved the words from Deuteronomy:
"Remember the Days of Old, Consider the Years of
Many Generations: Ask Thy Father and He Will
Show Thee, Thy Elders, and They Will Tell Thee."
Surely the lawmakers who gaze upon this fabric of the
painter's art must recognize in it a living inspiration.
Far beneath that shining throne they may see at work
the humblest men in the State, and through the airy
colonnade they can catch glimpses of the ship upon its
stocks, the machines of the steel foundry, and the
towering derricks of the oil-field. But even more
urgent is the appeal of those men of genius and de-
votion whose hearts were set on the highest ideals of
civilization, who wrought for spiritual as well as
worldly things. It is this that stamps Abbey's deco-
ration as a noble work of art, the fulness and the sin-
cerity with which he placed all his faculties as a de-
signer and painter at the service of an idea. If there
is any moral force in art, then "The Apotheosis of
Pennsylvania" should help weightily in the making
of a better State. Flanking his central and largest
decoration, Abbey proposed to have panels illustrat-
ing "Penn's Treaty with the Indians" and "The
Signing of the Declaration," the first of which came
from his studio with the "Apotheosis." Here an

architectural background was of course out of the question. The historic tree at Shackamaxon was the obvious motive to employ. Indeed, "the only treaty between savages and Christians that was never sworn to and that was never broken," as Voltaire described the covenant, is so inseparably associated with the tree that the latter counts, somehow, as an actor in any picture of the event. Here in this panel you have a fine example of that gift of Abbey's for observing figures, scenes, and places in the historical past as well as in "the fairy-land of his fancy." And, as I have said before, the explanation lies in his American insistence upon living by reality. He could paint the scene so as to convey the impression that thus it had veritably happened because he saw it in his imagination with extraordinary vividness until, as one might say, he actually saw it happen just as he presented it to us. He could do this, I believe, because by dint of sympathy and study he knew Penn, grasped him in an intimate and human manner. Penn, of course, was himself intensely human. The antiquarian John Watson had from a lady who was present an account of the great Quaker's demeanor when conferring with some Indians near Philadelphia, and thus preserved it:

"She said that the Indians, as well as the whites, had severally prepared the best entertainment the place and circumstances could admit. William Penn made himself endeared to the Indians by his marked condescension and acquiescence in their wishes. He

walked with them, sat with them on the ground, and ate with them of their roasted acorns and hominy. At this they expressed their great delight, and soon began to show how they could hop and jump; at which exhibition William Penn, to cap the climax, sprang up and outdanced them all!"

Another mood governed Penn when he clasped hands with his Indian friend under the tree at Shackamaxon. But to look at Abbey's panel is to surmise that he, too, must have read that self-same reminiscence, for he gets in the bearing and gestures of his two figures the very spirit of that truth that "William Penn made himself endeared to the Indians." The soul of the event no less than the outward aspect of the scene is mirrored in his canvas. It is, too, a very charming composition, filled with the right sylvan sentiment. He gets the characters of his leading actors and he gets the atmosphere enveloping them and their followers. Over all is flung something of beauty, the beauty of the ancient wildwood.

In his "Training of the Soldiers at Valley Forge," he abandons the mode of design characterizing the two other paintings I have described. The subject in its very nature cried aloud to be handled without formality. There is no clearly defined centre here, such as is provided by the throne in the "Apotheosis" and by the tree in the "Treaty." The figures fall judiciously into a sufficiently balanced arrangement, and it is interesting to note with what adroitness they are

harmonized against the vertical lines of the bare trees in the background. This background, by the way, is extraordinarily well worked out, giving to the snowy landscape precisely the needed relief. But it is less of strictly decorative design than of purely human interest that we think in considering this work. Abbey seems to turn aside for a moment from the monumental key of the "Apotheosis" and to paint more in the vein of his old "Bowling Green" and the Grail pictures for Boston. He is now the master of pictorial narrative, absorbed in the story that he has to tell and telling it almost, one might say, in minute detail. He lingers over the fairly snug uniforms of the officers, but he is quite as much interested in the next-to-unpresentable rags of the men. Moreover, these men have character. In their faces and in their attitudes we may read the tale of the suffering and the courage at Valley Forge. There is something insinuatingly touching about this panel. It represents, again, Abbey's warmth of feeling for the annals of his country. Attacking the long series of decorations for Harrisburg and recognizing the majestic character of his leading themes, he knew, as I have shown, how to rise to the height of his great argument. But he never lost sight of the fundamental emotions that go with mere flesh and blood, and he was resolved to come back again and again to such every-day phases of our American drama as the one painted in the "Valley Forge."

It was easy for him to oscillate between the extremes involved in his work. From the panel I have just traversed he could turn to the great circular ceiling to be set in a shallow dome in the House of Representatives. In this he gave free play to the mediævalism which was part of his artistic character. Charting the heavens after the fashion of some old cosmographer, setting sun, moon, and a multitude of stars in a sea of color running from pale tints into darkest blue, causing the Milky Way to stream luminously across his canvas, and even thinking to bring in a vagrant comet, he unwound the procession of the hours, figuring them as maidens who open the day in light and gladness and close it in solemn draperies carried on still shoulders. Half the ceiling is all jocund beauty, the other half is all beautiful gravity. But it is, perhaps, unfair to speak of the "halves" of this painting. The truth is that light and dark are subtly fused. Variegated as it is in light and in color, the ceiling is nevertheless all of a piece, a poetic idea harmoniously and clearly expressed. In this, as in the rest of his paintings, Abbey is sure of himself, sure of what he wants to do; he is both imaginative and workmanlike.

Did these designs spring at a flash from his brain? Hardly. Abbey thought long over his ideas and worked them out not only with the research in matters of history, costume, and so on, to which I have referred, but with much pondering on technical prob-

lems. Moreover, this instinctively brilliant drafts-
man was ever solicitous of the integrity of his drafts-
manship. He liked to search out recondite mysteries
of form and to conquer them in his drawing. Hence,
the preliminary studies he was wont to make of the
figures in his decorations, posing the model nude, then
in costume, and not infrequently drawing an arm by
itself, to get a gesture, or the turn of a head, to make
sure of an expression. Notwithstanding this practice,
he was far from being dependent upon the laborious
elaboration of a figure. We had a talk once about
the advantages of preliminary drawings, and Abbey
told me that he was chary of making too many of
them, for, he said, it was so easy to overdo the thing.
By the time you came to paint your picture you had
exhausted the inspiration with which you started.
After all, he argued, to make a lot of drawings for a
picture before you painted it was very like over-
training yourself for a race. When the signal sounded,
you had nothing left to go on, and straightway col-
lapsed. It is true, of course, that where this matter
of the preliminary study is concerned, temperament
counts for much, and Abbey recognized the fact, hav-
ing no desire to lay down the law for anybody. That
was characteristic of him, characteristic of his virile,
wholesome nature. Those who did not know him
may rightly judge of his personality from Orchard-
son's beautiful portrait, an interpretation by a man
who painted him with the insight of friendship. The

sturdy frame in this portrait, the efficient, character-ful hands, the strong head and face, all speak elo-quently of Abbey as I knew him. He was very gay and likable, you felt in him honesty and force, and you could see just how his sterling nature poured itself into his work. In it he sought the truth, he wanted to make it live; with all his strength and with all his conscience he strove for a reality that would touch men, making them think and feel. He achieved this aim, and made his best monument, in the decorations at Harrisburg.

# XIV
Frederic Remington

# XIV

## FREDERIC REMINGTON

THERE are anecdotes in the history of art, episodes, or fragments of talk, which in illustrating the point of view of an individual also throw light upon whole "movements." It has been told of Ingres that when, in the streets of Rome, he detected the approach of some crippled or otherwise repulsive mendicant, he would cover his eyes with his cloak, and sometimes, if his wife first saw the unwelcome apparition, she would endeavor with a swift movement of her shawl to save the artist from the sight of ugliness. The story is eloquent of both the strength and the weakness of a temperament known to every age. Again, you may find the key to all poetized landscape in that famous letter of Corot's beloved of painters as an authentic expression of the artist's mood, though, as a matter of fact, he did not write it. "The night breezes sigh among the leaves . . . birds, the voices of the flowers, say their prayers . . . the dew scatters its pearls upon the velvet sward. . . . The nymphs are afoot." There you have the outlook of the painter whose naturalism may be unimpeachable, but who sees visions and dreams dreams.

The leading motives in the art of the present genera-

tion have been crystallized in the epigrams of more
than one spokesman. Amongst the terse and lumi-
nous observations of the modern Belgian master, Al-
fred Stevens, who dedicated his precious "Impressions
sur la Peinture," by the way, to Corot, there is one
to which probably every artist would be quick to sub-
scribe — "L'exécution est le style du peintre." A
kindred affirmation is that which Whistler made with
reference to the greatest of his portraits. "Take," he
said, "the picture of my mother, exhibited at the
Royal Academy as an 'Arrangement in Grey and
Black.' Now that is what it is. To me it is interest-
ing as a picture of my mother; but what can or ought
the public to care about the identity of the portrait?"
I suppose there are no words held in deeper reverence
than these to-day in countless studios. With them
we may cite Whistler's tribute to Rembrandt as the
high priest of art who "saw picturesque grandeur and
noble dignity in the Jews' quarter of Amsterdam, and
lamented not that its inhabitants were not Greeks."
It is a potent gospel, in the right hands, but in it
there lurks a certain peril for the artist who would
separate what Rembrandt *saw* from what he *felt*, and
in exalting the powers of the hand and the eye would
disdainfully ignore those of the soul. The stuff of life
as well as its appearances has a place in art. "One
is never so Greek," said Millet, "as when painting
naïvely one's own impression," but he said an even
more suggestive thing when, in a letter to Sensier, he

spoke of the weird things to be found by the imagination in "the song of night-birds, and the last cry of the crows," and then added: "All legends have a source of truth, and if I had a forest to paint I would not want to remind people of emeralds, topazes, a box of jewels; but of its greennesses and its darkness which have such a power on the heart of man."

These words of Millet's I take as testimony to a truth which endures despite the hypothesis, often so brilliantly confirmed, that "subject" does not count. Perhaps not, but Nature and life go on counting, sometimes to an extent which makes the appraisal of an artist in the dry light of technic the sheerest pedantry. There are artists who are "formed" by their experience of life quite as much as by the discipline of the schools, artists from whose subtlest touch the savor of "subject" is inseparable. Such a type was Frederic Remington. It is impossible to reflect upon his art without thinking of the merely human elements that went to its making, the close contacts with men and with the soil in a part of our country where indeed the atmosphere of the studio is simply unthinkable. He took one away from the studio and its convenient properties if ever a man did, and saturated one in a kind of "local color" which has its sources far beneath the surface of things seen. One of the books he wrote in the intervals of making pictures is called "Men with the Bark On." It is a happy phrase, pointing to a reality which is surely not pecu-

liar to the West, but which just as surely preserves
there a compelling raciness little known in the East,
if known at all. This is not the place in which to
embark upon a long analysis of American social con-
ditions with special reference to Western traits, but I
must pause for a moment on the particular value of
those traits in American painting.

In the search for the picturesque the artist is scarcely
to be blamed if he makes much of costume. There
are sketching grounds in Holland, in France, and in
the South whose popularity is legitimately enough to
be referred to the dress of the people. But the step
from these places to a room at home, well stocked with
clothes and accessories brought from abroad, is fatally
easy, as is the step from contemplation of one of
Whistler's masterly "Arrangements" to the hopelessly
factitious portrayal of a lay-figure, some draperies,
and a meaningless background. That both of these
infertile transactions have been not infrequent in
American art has been due to the fact that in the
pageantry of national life we have seemed to be
starved. The social graces, or rather their trappings,
went out with the Colonial period, when we were still
taking our cue in artistic matters from the eighteenth-
century English school. By the time we had begun
to find ourselves the frock coat had come in, with the
ineffable trousers and top-hat belonging to it. Cos-
tume as costume thereafter, and for a long period,
only had its chance in some such pictures as those

reconstructions of Puritan life which George Boughton was wont to paint. We did the best we could with our homespun material. Eastman Johnson and Winslow Homer extorted some not unpicturesque effects from every-day life in America. Professor Weir, in the sixties, anticipated in his foundry interiors that discovery of types and scenes of labor which has of late been getting itself recorded in our exhibitions. But throughout the transitional period which has not, perhaps, even yet come to a close, we have been much occupied with technical problems, and, under the influence of the Parisian school, we have, on the whole, neglected the life at our doors. As we begin to recognize it we are learning, fortunately, that the question of costume is not, after all, so prodigiously important. I think Remington hit upon this truth. When he went West and found picturesqueness he did not find it or make it an affair of Indians in warpaint and feathers.

Before Olin Warner made his remarkable series of Indian portraits in relief the American artist who used the red man as a model at all was, with few exceptions, disposed to make him a romantic figure after the literary fashion of Fenimore Cooper, or to invest him with a somewhat theatrical significance. Pieces with the simple sincerity of J. Q. A. Ward's "Indian Hunter" were rare. Warner's reliefs signalized a newer and saner conception of the one intensely picturesque type that had been left to us all along and

that we had foolishly sought to conventionalize. When Remington's opportunity came he faced it from this sculptor's point of view. He became interested in the Indian, I gather, because he became interested in life, the active, exciting life of the plains. The Indian appealed to him not in any histrionic way, not as a figure stepped out from the pages of "Hiawatha," but as just a human creature, sometimes resplendent in the character of a militant chief, sometimes unkempt, ill-smelling, and loathsomely drunk, and always the member of a strongly individualized race, having much to do with guns and horses. It would be stupid to be ungrateful for the Indian pictures which have happened to be idealized and have made the red man seem an exotic if not a legendary personage. Occasionally they have been very good pictures. But the tendency, the right tendency, has latterly been all in the direction which Remington from the start followed.

He was an illustrator when he began, a "black-and-white" man, and, as it turned out, he could not have had a better preparation for his work as a painter. For one thing it fixed his mind on the fact, and trained him in the swift notation of the movement which lies somehow at the very heart of wild Western life. Just as the cowboy, in the midst of a hurly-burly of cattle, shouting to his comrade words calling for instant action, has no time to employ the diction of Henry James or Gibbon, so the modest illustrator must use

a rapid pencil and leave picture-making to take care
of itself. He must get the truth. Other artistic ele-
ments must come later. I cannot think of Reming-
ton as strolling out upon the prairie with stool and
umbrella and all the rest of an artist's paraphernalia,
nor can I see him in my mind's eye politely requesting
Three-Fingered Pete or Young-Man-Afraid-of-His-
Horses to fall into an effective pose and "look pleas-
ant." I see him instead on the back of a mustang,
or busying himself around the camp-fire, or swapping
yarns with the soldiers at a frontier post, or "nosing
round" amongst the tribes. It does not much mat-
ter, in a sense, whether or not he put immortal things
into his sketch-books during those first campaigns of
his. For my own part, I do not believe that they
have the smallest chance of lasting, save as so many
documents. The important thing is not that he failed
to draw beautifully, which is precisely what he failed
to do, but that he got into a way of drawing skilfully
and cleverly, so that he put his subject accurately be-
fore you and made you feel its special tang. His suc-
cess was due not only to manual dexterity but to his
whole-hearted response to the straightforward, manly
charm of the life which by instinct he knew how to
share. I make a great deal of this outdoor mood of
his, this sympathy, because it reacts to this day upon
the purely artistic qualities of his work. Let us glance
for a moment at a bit of his writing, the opening sen-
tences of a brief Western story:

The car had been side-tracked at Fort Keogh, and on the following morning the porter shook me, and announced that it was five o'clock. An hour later I stepped out on the rear platform and observed that the sun would rise shortly, but that meanwhile the air was chill, and that the bald, square-topped hills of the "bad lands" cut rather hard against the gray of the morning. Presently a trooper galloped up with three led horses which he tied to a stake.

In choosing a passage from one of his half-dozen books I have purposely avoided anything in the nature of a "purple patch," though, to be sure, that form of indulgence is foreign enough to his taste. It is just for its directness and close-packed simplicity that I have made the foregoing quotation, just to show that he knew how to make an absolutely clear descriptive statement. Simple as it is, almost to the point of baldness, does it not convey a sharp and vivid impression? I should like to go on to speak of his writings, which are full of entertainment and are of positive value as reflections of a life that is rapidly disappearing, but I must go on to show how, as he wrote, he painted, simply and truthfully. He had, of course, to pay the penalty of the artist who turns from illustration in black-and-white to work in color. For a considerable time his pictures were invariably marked by a garishness not to be explained alone by the staccato effects of a landscape whelmed in a blaze of sunshine. I have seen paintings of his which were as hard as nails. But then came a change, one of the

most interesting noted in some years past by observers
of American art.  Remington suddenly drew near to
the end of his long pull.  He left far behind him the
brittleness of the pen drawings which he once had
scattered so profusely through magazines and books.
His reds and yellows which had blared so mercilessly
from his canvases began to shed the quality of scene-
painting and took on more of the aspect of nature.
Incidentally the mark of the illustrator disappeared
and that of the painter took its place.  As though to
give his emergence upon a new plane a special char-
acter he brought forward a number of night scenes
which expressly challenged attention by their original-
ity and freshness.

Two aspects of his ability as a painter of life were
brought out in sharp relief by this collection of pic-
tures — his authentic interpretation of the Indian,
and his fidelity to things as they are amongst our sol-
diers and cowboys as against what they seem to be
under the conditions of a Wild West show.  His pic-
ture of "The Gossips" is, I think, one of the hand-
somest and most convincing Indian studies ever
painted.  The scene is set in a grassy landscape di-
vided across the centre of the canvas by a still stream.
This river reflects the rich yellow glow that fills the
sky, and elsewhere there is naught save masses of
tawny reddish tone.  The landscape by itself possesses
a kind of lonely fascination.  The primitive teepees,
darkly silhouetted against the sky, have the appear-

ance of natural growths befitting the two mounted figures that fill the centre of the composition. These figures bring us back to his reliance upon life, upon the real thing. Looking at his gossips we feel that thus do the Indians sit their ponies, that thus do they gesture. Remington makes no use of feathers here or beads, nor is it the "noble red man" that he portrays. He gives us just the every-day tribesman, mayhap worthy of his heroic forebears, mayhap deeply tinctured with rum, and full of small tattle about affairs on the reservation and the unamiable practices of one of Uncle Sam's agents. It is another page from the familiar life of a people, and it is in that character that it speaks to us with genuine force. But enriching its historical value and its human poignancy is its beauty as a painted picture. I have spoken of Remington's necessary indifference to the strictly pictorial motive during his earlier experiences as a draftsman. It is interesting to observe that as he went on to handle this motive he familiarized himself with it, little by little, and with an unchanging faithfulness to the free, natural gait of open-air existence. Hence there was nothing about a composition of his to suggest a carefully built-up scheme. He filled his space pictorially, with a due sense of balance, and so on; but he preserved an impression of spontaneity, of men and animals caught unawares.

I say "men and animals" advisedly, for if there is one thing more than another which Remington's paint-

ings make you feel it is that on the plains white men
and red go, so to say, on four feet. I would not call
them centaurs because the associations of that word
are subtly in conflict with the emotion at the heart of
this painter's work. His men and his horses are em-
phatically of a practical, modern world, a world of
rough living, frank speech, and sincere action. I re-
call, in passing, a picture of an Indian upright beneath
a tree, and sedately piping to a maiden whom we are
to imagine dwelling in one of the teepees not far dis-
tant. "The Love Call," as it is entitled, is, if you
like, a romantic picture, an idyl of the starlight, but
I confess that I cannot dilate with any very tender
emotion in its presence. There is nothing languishing
about this lover; he carries his pipe to his lips with a
stiff gesture. In his ragged blanket he is essentially
a dignified, not a sentimental, image. It did not occur
to Remington to make his model "pretty" or in any
way to give his painting a literary turn. He busied
himself with his tones of gray and green; he sought to
draw his figure well, to realize, for example, the arm
concealed beneath the blanket. For the rest, his pur-
pose was simply to paint an interesting landscape,
enlivened by the right figure, and to paint it well.
Never was a picture bearing so poetic a title more
realistically produced. The note of intimacy that he
struck rested upon the firm basis of common things.
Returning to his mounted figures, consider again for
a moment the picture of "The Gossips." One does

not need to humanize animals or to look at them through the eyes of Landseer to see in them traits that are individual and even touching.   There is about the ponies in this picture a curiously strong suggestion of the patience with which beasts of burden await the pleasure of their masters.   They are full of "horse character," and in this respect the touch given by the little foal is perfect.

Again and again Remington brought out the interest residing in this factor in Western life and adventure.   I hardly know which is the more moving in his picture of "The Luckless Hunter," the stolidly resigned rider, huddling his blanket about him against the freezing night air, or the tired pony about which you would say there hung a hint of pathos if that were not to give, perhaps, too anecdotic an edge to an altogether natural episode.   Wherever he found them Remington made his horses stand out in this way as having something like personality.   They are lean, wiry, and mischievous animals that he painted in such pictures as "The War Bridle," "The Pony Tender," "The Buffalo Runners," and "Among the Led Horses."   You observe them with a certain zest. They move as though on springs.   Their heels play like lightning over the earth.   You feel them hurling themselves along in the hunt, going nervously into action to the crack of bullets, or struggling not unthoughtfully with the cowboy who would conquer their trickiness.   It all makes an exhilarating spec-

tacle, and these pictures are filled besides with keen, dry air and dazzling light. The joy of living got into Remington's work. Decidedly you cannot think of it as something apart from his art. It is his distinction that he made the two one. Partly this is due to the unfailing gusto with which he threw himself upon his task, the kindling delight he had in his big skies and plains and his utterly unsophisticated people; but a rich source of his strength lies in nothing more nor less than his faculty of artistic observation.

Under a burning sun he worked out an impressionism of his own. Baked dusty plains lead in his pictures to bare, flat-topped hills, shading from yellow into violet beneath cloudless skies which hold no soft tints of pearl or rose, but are fiercely blue when they do not vibrate into tones of green. It is a grim if not actually blatant gamut of color with which he had frequently to deal, and it is not made any the more beguiling by the red hides of his horses or the bronze skins of his Indians. In earlier times he made it shriek, and, even later, he found it impossible to lend suavity to so high a key. But that, of course, is precisely what no one would ask him to do. What was needed was simply a truer adjustment of "values" and an improvement in the quality of painted surface, and in these matters he made substantial progress. They still made you blink, but they left a truer impression, and that Remington developed a far firmer grasp upon the whole problem of illumination is shown

by the night scenes to which I have already alluded. These are both veracious and beautiful, and, as I have said, they exert a very original charm. He knew how the light of the moon or of the stars is diffused, how softly and magically it envelops the landscape. I find what I can only describe as a sort of artistic honesty in these nocturnal studies of his. He never set out to be romantic or melodramatic. The light never falls ingeniously at some salient point. Rather does one of his pictures receive us into a wide world, the boundaries of which, brought closer by the darkness, are still kept away from us by a cool, quiet, friendly gleam. Especially noticeable about the night, as he painted it, is the absence alike of anything to suggest an artificial glamour and anything indicative of heightened solemnity. The scene is wild, but it wakes no fear. One is close to the bosom of nature, that is all. The beauty of the painter's motive, too, has communicated itself to his technic. His gray-green tones fading into velvety depths take on unwonted transparency, and in his handling of form he uses a touch as firm as ever and more subtle.

In one of his night scenes, "The Winter Campaign," we have not only the qualities which have just been traversed, but an exceptionally good illustration of that truthful painting of the white man in the West which I have mentioned as constituting an important aspect of his art. The military painter has ever been prone to give ear to the music of the band. How can

he help himself? History invites him to celebrate dramatic themes. The lust of the eye is bound to lure him where the squadrons are glittering in their harness and the banners are flying. Even when he has but a single figure to paint he must, as Whistler once said to me of Meissonier, "put in all the straps and buttons." That way lies disaster sometimes. It was of a military picture by Meissonier that Degas remarked that everything in it was of steel except the swords. One antidote to the artificiality fostered by too great a devotion to a handy wardrobe and a multitude of "studio fixings" lies in the simple process of roughing it with the forces. It is to be gathered from Remington's books that he forgathered with the troops as he rode and dwelt with the cowboys, but, if we had no other evidence on this point, we would know it well enough from such pictures as "The Winter Campaign." It is a painting beautifully expressing the night cold and the mysterious gloom of the forest, and reproducing with positive clairvoyance that indescribable bond which unites the men and their horses around the comfortable glow of the camp-fire. Here once more I would emphasize the fusion of substance and technic. The spirit of the subject is superbly caught, but, equally with this achievement, you admire the adroit management of light and shade, the modelling of the bodies of the horses, the skilful painting of textures, the good drawing both in the trees and in the heads of the men, and the soundly harmo-

nized scheme of color. This painting alone would stand as a record of the kind of life led by our men on duty in the West, and as proof of Remington's gift as a painter.

He was, then, both historian and artist, and the more effective in the exercise of both functions because, when all is said, he painted merely to please himself. Long and close acquaintance with Western life of course stored his mind with lore. Doubtless he could be dogmatic, if he chose, on the minutiæ of military regulations and accoutrements. Indian folktales were familiar to him and he could be legendary if he liked as well as realistic. The full-blooded brave and the half-breed, the square cattle-puncher and the "bad man," all showed him their qualities. I do not remember the squaw and her pappoose as figuring to any extent in his compositions, but probably he observed them to such good purpose that he could have drawn them with his eyes shut. And yet, surveying the body of his work, one does not see that it was systematically developed, deliberately made exhaustive. One comes back to the artist who was an historian almost as it were by accident. The determining influence in his career was that of the creative impulse, urging him to deal in the translation of visible things into pictorial terms. He had enormous energy, which overflowed in more than one direction. Allusion has been made to his books and illustrations. He was, too, a fairly prolific sculptor, modelling a

number of equestrian bronzes, amazingly picturesque and spirited. At the time of his death he was giving more study to landscape, and in the northern country, both in winter and summer, made divers small sketches of uncommon merit. In one of these, "The White Country," a spacious scene is treated in simple, broad masses that disclose a striking power of generalization, and, what is more, there is a very delicate and personal touch apparent in the handling of nuances of white and russet tone. The picture is subtly filled with atmosphere. It is as though the painter had been stirred by a new emotion and had begun to feel his way toward a sheer loveliness unobtainable amid the crackling chromatic phenomena of the West. The old clearly defined range of "local color" was not enough. He would refine and, in refining, transform the notes in his scale. In doing this he unfolded new ideas and unsuspected resources. The little landscape fits naturally into one's conception of this American painter. It suggests a talent that was always ripening, an artistic personality that was always pressing forward. There was tragedy in its untimely loss.

# XV
# Frank Millet

# XV

## FRANK MILLET

On his return from a visit to Japan, made in the interests of the commission of the Tokio Exposition, Frank Millet lent me a book of pictures that he had brought from the East, explaining how it had come into his hands. He had met, of course, a number of Japanese artists and, he said, they were very kind. Not content with the many courtesies they showed to him from day to day, they wound up by preparing this album for him, each artist making a sketch in it. He had brought it home as a personal souvenir and he spoke of it as such, in his gentle, modest way, with pride and gratitude. But he hastened to lay stress upon the interest and value of the book, as showing the kind of work that contemporary Japanese artists were doing, and as he turned the pages he would pause to speak with warm appreciation of this or that individual. The whole episode was intensely characteristic of Frank Millet. It was like him to make those artists his friends, and it was like him to praise them in his own country, to show the book everywhere and to do what he could to increase public interest in the men who had made it. He had been doing just these things all his life, winning the sympathy of his fellow workers and rendering them ser-

vice. When he went down with the *Titanic* he gave
up a life that had been extraordinarily useful to
others, helping them in practical ways and adding to
their happiness.

This is the reflection that must first come home to
every one who knew him. Unselfishness was, with
him, a kind of energizing force. He played many
parts in the simple process of earning his living, but
somehow, no matter what his employment, he labored
always with the gusto that speaks of the man who is
serving a cause. He had the adventurous habit of
mind, the traits of the man who goes up and down
the world seeking fresh fields to conquer, looking
eagerly for constructive things to do. Imagination
boggles at the idea of Frank Millet's doing anything
merely to win a material reward. When he was a
war correspondent he was moved by the high disin-
terested ambition which marks the pure journalist.
When he filled an official position in the administra-
tion of one great exhibition or another his whole soul
was bent upon making the exhibition a success.
Countless committees and art juries found him indis-
pensable. He always knew what to do, and in the
doing of it he was anxious that he and his colleagues
should show common sense. Never was an artist
more human, more sympathetic, more reasonable.
Nothing in the world could ever have persuaded him
to sacrifice a principle to expediency, but neither did
he believe that his art required him to raise a barrier

of esoteric mystery between himself and his fellow
men. He painted what are commonly known as
"costume pictures," often finding his themes in old
English life or going even farther back for them, to
the classic period. But I can remember a talk with
him in which his enthusiasm as an artist was all for
the character and interesting modelling that he had
observed in the heads of a number of "captains of
industry" with whom he had just been forgathering.
The reader of his biography who wants to know why
Millet was so much in demand when matters of art
having a public interest were toward is easily an-
swered. It was because he was so open-minded, so
sure to see clearly and to act without prejudice.

Considering the immense amount of work that he
did as an executive it is not unnatural to wonder how
he got over the ground. The explanation lies in his
work as a painter. It is careful, deliberate work.
The temperament reflected in it is plainly that of a
man who would not be hurried. Such a man, sys-
tematic and thorough, accomplishes twice as much as
he who rushes through life. Frank Millet could not
have discharged all the duties he assumed if he had
not had a thoughtful, quiet way of managing each
day's responsibilities. And in the course of all his
activities he was forever accumulating knowledge.
There is a certain mansion not a thousand miles from
New York which is remarkable for the beauty and
general perfection of the old furniture with which it

is filled, furniture dating from an historic period. The collection was got together by Frank Millet. It happened on that occasion to be furniture, but it might have been almost anything else. If Millet undertook to deal with a subject he made himself its master. Once, in his studio, where he was painting a mural decoration for the Capitol at St. Paul, a decoration commemorating one of our treaties with the Indians, he explained to me how he had prepared himself for the task, studying Indian types, exploring the literature of the subject, and getting first-hand evidence in respect to costumes and accessories. The studio was crowded with "properties" which he was using, but before he took up his brush he had made every effort to ascertain the right way of using them. It was not enough to acquire an Indian blanket; he wanted also to get the "hang" of it as it was drawn over the shoulders of an Indian brave.

Art is an exacting mistress. She demands of the painter a devotion knowing no bounds and an active service broken by few if any interruptions. It is only thus that her votaries can hope to solve the technical problems that she sets them, save in those rare cases where the painter is dowered at his birth with all the gifts of a master. Here Frank Millet was at a disadvantage. He had to pay something for the very versatility which made his career so rich in effective work. He had a sound and adequate technic, adequate, that is, to the accurate representation of a

given object, and, so far as they go, his skilfully illuminated interiors, with the picturesque types of the comedies they illustrate, are workmanlike and pleasing. But a certain polish that not infrequently lapsed into a sort of hardness arrested his method at too early a stage of development. Brush-work more elastic and color more transparent, a broader and more personal style, would have doubled the charm of his art. In these matters and in these alone he remained unaffected by the artistic movements of his time. Yet while we note his detachment from newer technical ideas we recognize in it but another aspect of his profound sincerity. He had to be true to himself. His way of painting was, at any rate, his own. He spared no effort to strengthen it as time went on, and in the mural decorations which chicfly occupied his brush in his last years there are signs of a simpler and larger outlook, of a genuine artistic growth. It is hard to say farewell to that strong and tender spirit, that steadfast worker and that friend who was all loving-kindness.

# XVI
## James Wall Finn

# XVI
## JAMES WALL FINN

ARTISTIC repute does not come by exhibitions alone.
There are men who win it without sending a picture
or a statue to the public shows save on the rarest oc-
casions, if on any occasion at all. James Wall Finn
was one of them. When he died in August, 1913, at
Giverny, the lovely little place near Vernon, about an
hour's ride from Paris, where Monet lives in his won-
derful garden, he closed a career comparatively incon-
spicuous, but uncommonly rich in good work. As a
decorator Finn was a remarkable man, playing a sol-
idly constructive part in the development of our
school. He left, here and there, productions familiar
enough to most observers, the delightful mask of
Flora, formerly in the dining-room of the Knicker-
bocker Hotel, the cloudy ceiling in the great reading-
room of our Public Library, and a very important
scheme of decoration worked out for a Hartford bank.
But still his broad and essential contribution to Ameri-
can art remains unknown to the public at large. Be-
fore characterizing it more in detail it is perhaps worth
while to explain how the resources of this gifted man
were developed.

They were stimulated into activity at the outset in

an architect's office. When I first knew him he was busy at a drafting-board under Babb, Cook & Willard. With architecture, indeed, he was thenceforth always to be allied. But when he went abroad in his twenties he was full of an ambition to be a painter. I remember meeting him again at this time in Paris. It was at the Louvre, and "Jimmie," as his friends loved to call him, was hard at work in a paint-stained blouse among the solemn religious masterpieces of the gallery dedicated to the Italian Primitives. He was copying one of them and talked enthusiastically about the exquisite art of the Renaissance. The taste thus disclosed never left him. For years it fertilized his best work. But he had a surprise in store for me when he mentioned casually that he had been painting a picture for the Salon, and, as I was leaving town the next day and so could not see it, would send me a photograph of it. In New York I waited for the promised reproduction. It showed me a prize-ring subject, dramatically treated, and in the process it made me realize anew how "various" "Jimmie" was, with what courage and ability he could take up any task. That was intensely characteristic of him. He was a sound workman, and the sounder because of a practical, resolute way that he had, amounting in the upshot to a strong moral force. It was splendid to observe the manner in which he went to work on his return to this country.

He had suffered hardships in Paris, and his path

here was in the beginning none too smooth. He did not repine, nor did he attempt to paint pictures when once he had seen that he could not by this means discharge the responsibilities laid upon him. He did instead the work that came to his hand, and did it superlatively well. He did decorative painting, not the kind that means a big pictorial composition, but the unobtrusive kind which embraces all the walls and ceilings of a house, even those which bear nothing save a flat tint. He was, in his way, not only an artist but a contractor. The important point, however, was that the artist in him was constantly kept well to the fore. Stanford White spurred him on to reproduce in his ceilings some of the effects created by the masters centuries ago in Italian and French palaces. White told me once how he and Finn had labored together over a ceiling that we were looking at just then. The architect knew he had had a share in the beautiful thing, but he seemed to forget it in his affectionate rejoicing over "Jimmie's" talent. That talent went on from one fine triumph to another. The flat tints at which I have glanced became more and more of a minor detail, carried out under the chief's directions. He gave himself to larger problems, and in many houses, in many cities, his powers of design and execution produced superb interiors.

He could work in any key, but it was the style of the Italian Renaissance that especially interested him. The rich yet restrained method of Pinturicchio stirred

him to ardent emulation, and he used it in the Morgan library and elsewhere with extraordinary success. In recent years the zest of the painter returned upon him. He painted the designs mentioned above and others even more ambitious in the private chapel of Mr. T. F. Ryan. When he went abroad, not long before his death, it was not only in the hope that he might improve his health but to work at ease upon some important decorative commissions. He told me that he had given up forever the miscellaneous work that had long been eating into his time and energies and that for the rest of his life he meant to paint "big schemes" to please himself. It seemed cruel that Fate should cut short all his hopes. The operation for appendicitis which had laid him on his back in Paris years before had left him far from strong, but it had seemed that he would some day be his old robust self once more. If he had lived he would have done many a beautiful decoration. He had the skill and he had the brains. "Jimmie" was never so absorbed in his craft that he could not interest himself in other aspects of art. He is a grave loss to the American school of mural painting. Those who knew and loved him will never cease to miss him. In friendship he had a loyalty which amounted to a passion. In his grayest days, long ago, he knew how to be generous, and when success came he was as quick to help others. The spirit of fun dwelt in him, too, and his Irish wit made him one of the delightful-

est of companions. He will be remembered for all
this. But I like best to think of him just as the man
who knew his job and played the game. He could do
anything. The painting of a simple wall, the gilding
of Saint-Gaudens's Sherman, the Italianizing of a
grand coffered ceiling — whatever the task was, he
was equal to it. He was a good artist; in Kipling's
phrase, "a first-class man."

# XVII
## Edward Martin Taber

XVII

Edward Martin Taber

# XVII
# EDWARD MARTIN TABER

THERE died at Washington, Conn., in September, 1896, an American artist, Edward Martin Taber, who possessed something like genius, but of whose history and work the world at large knows next to nothing. Ill health was his portion, even in youth, and all of his thirty-three years of life appear to have been occupied in a struggle with death. Neither Europe nor the South gave him the strength he craved, but some comfort and respite he found at Stowe, in Vermont, where he ultimately made his home. There he painted, using the knowledge that he had gained under Abbott Thayer long before, but using even more a certain instinctive gift. There, too, he saturated himself in nature and jotted down his observations of her traits. These memoranda of his, with a few letters and verses, were brought together in a book called "Stowe Notes," the fragmentary text being accompanied by numerous reproductions of his paintings and drawings. The volume is a precious souvenir of a remarkable artistic personality.

In spite of Swinburne's dictum that there could be no such thing as an inarticulate poet or an armless painter, we cannot but recognize the appearance from time to time of a man who is an artist regardless of

the production of works of art.  Taber, as a matter of fact, painted pictures, but even if he had not done so this book would make it plain that he was an artist. He took nature for what she was, not investing her with poetic or in any way literary attributes, and in as flawlessly objective a spirit he wrote down his impressions of her or put them upon canvas.  Though he had imagination he did not allow it to run away with him.  When an association of ideas stirred him he contrived to get it into his prose without any of that clever, Stevensonian effect which has crept into so much of our recent descriptive literature.  Here, for example, is one of his vignettes, a winter scene at Stowe:

> The night of the eighth was windy and excessively cold. From my window, looking up the slope of the hill, I see the wind lifting the fine snow like smoke, and blowing it across the meadows.  In the shadowed and struggling moonlight it rises in waves, and sweeps like a procession of phantoms along the windy ridge.  The little house, the orchard, and the pine near the crest are enveloped and almost lost in the white gust.  The solid features of the scene appear like rocks smothered in spray.  There is a misty sparkle of the flying snow along the ridge-pole of the barn.  The wind is lamentably loud.

The pictorial zest is there, the eagerness of the artist to give some sort of tangible form to the truth as he sees it.  But this brief passage suggests what the book as a whole makes abundantly clear, that he thought only of the truth and left his diction to take

care of itself. His vivid, thumb-nail sketches are strangely simple and spontaneous. Always he is absorbed, inquisitive, keen upon exploring the woods and fields, but when he talks of birds or of trees and of the different keys in which the wind blows he is as disinterested and as exact as a mirror. This does not mean, either, that he is cold. On the contrary, there is a wonderful depth of feeling in his notes, and humor, too, crops out here and there. He was ill, but he was happy. Nature was inexpressibly beautiful, and he found her friendly. "The jays have a comic aspect," he writes; "a kind of goblin look, with their pointed caps and long noses." He was, it may be repeated, seeing pictures all the time. Let us cite a tiny barn scene:

Lambs. Maternal fulness and softness in the sheep's ordinarily cold eye; eyes of cows and of the sheep in the interior part glowing like jewels. The lowing of the cows suppressed, exactly like the low notes of a bass viol, sonorous and vibrant.

Very rarely he forgot to think aloud, according to his habit, and wrote, instead, like a professional author. Referring to two little barefooted boys prancing about in the spring, he describes them as "arrayed in what are but too evidently the garments of an elder generation, curtailed to their lesser dimensions." But he merely deviated into that Johnsonese as a recluse will occasionally stiffen up in unconscious remembrance of urban, artificial ways. In his familiar

walk and demeanor Taber did not know how to be
pompous and elaborate, which is to say that he did
not know how to take himself seriously. There is
very little about art in the book, and that little reflects
an essentially modest nature. Very like him is his
letter to Joe Evans about a picture on which he had
been working with tremendous ardor and ambition.
"I cannot deceive the public," he says, "in the pre-
senting of so noble a scene in so slight, so feeble, and
so wretched a counterfeit. . . . I was determined to
send it to you this morning [to be offered to an exhi-
bition] and abide by your decision; I even went the
length of having a box made for it, but at the critical
moment, as the cover was ready to place over it, my
sense of its utter inadequacy quite overcame all other
considerations, and now I am fixed in my determina-
tion not to send it." It is out of such a fine spirit as
that that beautiful work is done. Taber did very
beautiful work. His landscapes are portraits, painted
with an intensity of feeling which exalts and makes
doubly fascinating their marvellous fidelity to fact.
When he paints the snowy countryside, "all silence
and all glisten," he penetrates you both with its love-
liness and with its chill. The highest natural magic
is indeed his, the clairvoyance and the creative power
of the true artist.

# XVIII

## Five Sculptors

# XVIII

# FIVE SCULPTORS

## I

## J. Q. A. WARD

ONE of the finest things about the long and fruitful life of John Quincy Adams Ward was its absolute unity. More than half a century ago, when he entered the ranks of the sculptors, he founded his art on simplicity and truth, and from these virtues he never for a moment strayed. It is of the seriousness and dignity of his work that you think first as you recall the numerous monuments he produced. He could use a light touch, to some extent, if he chose, as witness the design he flung together for the top of the Dewey Arch, at the time of the great celebration in 1899, a design extremely vivacious and picturesque. But it is significant that he then set among his plunging horses, as his dominating figure, a free restoration of the Victory of Samothrace. It was like him to revert to such an heroic model. His interest was always in those souvenirs of the grand style which have come down to us from antiquity. And yet, by the same token, he was no sentimental follower of the antique.

There it was that he parted company with the American sculptors of his young manhood, the sculp-

tors who took their inspiration from Greece, via
modern Rome, and, succumbing to the tradition of
Canova, landed themselves in prettiness and insipid-
ity. Ward was clearer-eyed. He did not mistake
the blend of cleverness and mediocrity which sought
to fashion itself on the antique for the antique itself.
He had too keen an interest in nature for that. It
was his aim to make nature and art go hand in hand.
If, in the upshot, he lost something, he also gained
much, securing a vitality in his work which is by
itself precious. What he lost through his just reac-
tion against the nerveless style in vogue among the
contemporaries of his formative period was sensitive-
ness of touch in the subtleties of modelling. Their
technic was thin and suavely specious. It is easy to
understand how a man of Ward's strongly masculine
temperament rebelled against the superficially pleas-
ing workmanship of the pseudo-classical revival. But
in his distaste for conventionally rounded limbs and
"sweet" contours generally he lost sight of the fact
that beauty of surface is an essential ingredient of
great sculpture. It can be overdone. How empty
modelling for its own sake may become has been viv-
idly shown in some of the less thoughtfully pondered
productions of Rodin. But when that extremely un-
even sculptor is at his best his spirit is that which
runs through all of the best sculpture of antiquity
and is also to be discerned in the coinage of Greece.
The masters of that golden age generalized their sub-

jects and followed an extraordinary ideal of simplicity, but that ideal they proved to be compatible with consummate modulation of surface. In other words, their large conception of form was accompanied by a profound feeling for the last refinements of modelling.

The truth is that these refinements are to be neglected by the sculptor only at his peril, for they are part and parcel of the very language that he speaks. A sculptor knowing nothing of modelling is unthinkable, but, on the other hand, it is possible for a man to produce many a monument and still curiously ignore many of the possibilities of one of the chief resources of his art. There is modelling and modelling. That of the Italian Renaissance differs largely, in its greater freedom, its richer color, and its more personal character, from that of Greece, but at bottom the two epochs are united through the sculptor's sense of the charm to be got out of the caressing of surface. Ward would appear to have been somewhat suspicious of this charm. Perhaps he feared that it would lessen the breadth and power of his effects, though, as Saint-Gaudens showed in his Lincoln and in the Adams monument, the two elements of austere strength and delicate beauty may be perfectly reconciled. Whatever the origin of his decision may have been, Ward put behind him the niceties of modelling, and at the same time those subtler felicities of line and mass which have counted for so much in modern sculpture. To that extent he weakened the appeal of style in his

art. But, as has been said, this sacrifice still left him with sterling qualities.

It left him an exhilarating vigor, a wholesome reality, and, on occasion, a singularly racy fineness and nobility. The statue of Washington on the steps of the Sub-Treasury in New York is one of the outstanding achievements of American sculpture, a work in which the modelling, if not possessed of the subtlety and personal charm at which we have glanced, is at all events flexible and expressive. Moreover, the figure is splendidly composed, and, what is best of all, it is a superb embodiment of character. There we touch the key-note of Ward's career. No statue of his is an empty shell. From the picturesque "Indian Hunter," which marked the beginning of his repute, to the last fruits of his incessant activity, everything that he did was energized by his interest in his subject, his eagerness to express its human significance. It is this fervid sympathy of his that gives such forceful reality to works like the "Henry Ward Beecher," the "Horace Greeley," the "La Fayette," and the "General Thomas." It is his sympathy, and the simplicity which I cited at the outset. He saw his subjects largely and boldly, with the instinct of the true monumental sculptor. He may not give the beholder exquisite delight, but he gives him in full measure the sensation of life and dignity.

## II

## OLIN WARNER

Olin Warner's ties, in the matter of style, were with the earlier group whose taste was emphatically for the antique. Born in 1844, he grew up in contact with the Græco-Roman tradition which we had taken over from the eighteenth century. Like Saint-Gaudens, who was his junior by only a few years, he faced the parting of the ways, shared in the modernization of our sculpture. But where the genius of Saint-Gaudens took the direction of that realism and that grace which we associate with the Italian Renaissance, Warner's remained more faithful to classic precedent. On a superficial hypothesis you would call him academic. But that would leave out of account the entirely personal, unconventional fire that burned within him.

Back in the sixties he spent a period of several years in Paris, under Jouffroy and Carpeaux. They grounded him in a superb technic. He would always have been a shining type of manual skill. But Warner was essentially a human being. In France, when the Franco-Prussian War broke out, he couldn't resist the situation, and promptly entered the Foreign Legion. It is not fanciful to find in this episode an influence bearing upon the growth of his art. His military experience was a plunge into the realities of life. He never let go of them. The secret of his success

lies in the poignant truth underlying his classical re-
finement. This can be tested by reference to more
than one phase of his art. Look, to begin with, at
his portraits. They are as intimately expressive of
character as though he had been a pure analyst. The
busts of Cottier, Weir, and Brownell have an ex-
traordinary animation — the animation of life richly
and feelingly interpreted. But in the very moment
in which it seems as if he had given himself to the
recording of the nuance, you are struck by the large
and noble way in which he has generalized his subject.
To say that he used the grand style would be slightly
to overstate the case. It hints in sculpture at some-
thing a little cold, a little too abstractly classical, and
we have, as has been said, to reckon with real warmth,
real human idiosyncrasy in his work. Nevertheless,
there is a savor of the grand style about a bust like
the Cottier or the Weir. It is there in the lofty beauty
of the thing, in the translation of life into terms hav-
ing an even higher dignity and simplicity.

The nudes and the symbolical panels confirm this
idea of Warner as an artist dealing in the materials
supplied by the visible world, but spiritualizing them
through his sense of beauty and through his command
of style. There is positively a tonic in contempla-
tion of his austere truth after the pseudo-subtle mod-
elling which Rodin made the rage. Almost any ten-
derness in modulation was available to his skilful fin-
gers, but it had no lure for him. His mind was set

on a broader and serener interpretation of form. He states the fact with an almost antique economy and lucidity. He sees synthetically and so he models his figure, placing it before you as a whole, modelling it magnificently in the round and from the centre outward. None of our sculptors has ever had a truer faculty for organic structure. And Warner had, withal, a peculiar *flair* for linear beauty. His pure and flowing contours are exquisite.

Add to his depth and weight, his truth and his skill, the great quality of design, and you have some realization of the genius in Warner. I would not make him out to be a demigod in art. There were limitations to his ability. He could model a nude as lovely as his "Diana," but it is doubtful if he could ever have risen to the level of an imaginative masterpiece like the Adams monument of Saint-Gaudens. In idea he was, on the whole, rather conventional. The figures he made for the Congressional Library, fine as they are, prove that, and the big "Tradition" is hardly more original. In decorative grace he is somewhat lacking. Compare, too, his medallions in relief with the similar productions of Saint-Gaudens. In touch the latter is more delicately eloquent. Warner is nearer, as regards this important matter, to the spare dignity of David d'Angers, whom he recalls. In short, he is often more impressive than charming. But I note the distinction with no disparaging thought, only to indicate that the difference is there. In his

own way, a fine and elevated way, Warner is triumphant. We have had no master quite like him. In workmanship and in style he is one of the glories of American art.

## III

## LOUIS SAINT-GAUDENS

The fame of this sculptor was overshadowed by that of his brother, Augustus, and its growth was retarded also by the shy, retiring habit of the man. Left utterly to himself it is doubtful if the world would ever have heard of him at all. But he had warmly appreciative friends, his brother and Stanford White among them, and they did something to draw him out of his shell. It was worth while. He had powers which, when he chose to exercise them, placed him on one of the upper levels in American art. I met him more than once, and now and then had some converse with him, but never enough to disclose much of what lay behind his taciturn ways. He was a handsome man, with a fine head, and there was something subtly attractive about him. But it must have taken a long intimacy to penetrate his shy reserve. All the friendly gaiety of their French and Irish forebears seemed to have been withheld from Louis and embodied in his elder brother. Augustus Saint-Gaudens knew that sensitive, retiring disposition and respected it. He knew, too, the abilities lurking behind a proud quie-

tude, and it was good to hear him speak of them, to witness his solicitude for a career which could receive no great acceleration from external influences. Nobody could have made Louis Saint-Gaudens famous by main strength, and he was himself indifferent to such matters. But when alone with his gifts and the mood was upon him he could do beautiful work.

Now and then an artist does something the peculiar charm of which he never surpasses, even if he manages to equal it in a long and busy life. So it was with Dubois when he modelled his little "St. John" and his "Florentine Singer." So it was with Louis Saint-Gaudens when he made his "Pan." That was many years ago, so many that I wonder if he was not still in his twenties, or at any rate in his early thirties, at the time. The little statue started a kind of legend. It was heard of here and there before it was at all widely known, and then it created a stir which only became the more interesting in retrospect as nothing of consequence followed it and people talked of Louis Saint-Gaudens only as a more or less mysterious man of talent in the background of his brother's life. Time passed and he affirmed himself in other statues. His name was revived and his repute was extended when he did the lions for the Public Library in Boston, and later when he undertook the series of monumental figures for the Union Station at Washington. He was an artist with a streak of inspiration in him. Because he would not speak out, the world practically passed

him by. "He was a recluse and a dreamer," a friend
who knew him well writes to me. Such men take
long to assert themselves. But when they do they
leave a serious mark.

Seriousness, or perhaps we should say a fine sin-
cerity, was the essential quality of Louis Saint-Gau-
dens. The beauty of his "Pan" lies partly in its
sweetness and grace as an interpretation of the spirit
of blithe childhood, and it lies even more in the pro-
found sculptural feeling which went to the making of
the statue, in the modelling which is so full of knowl-
edge and strength and is at the same time so subtle,
so fine, so instinct with style. It is a little piece, yet
the man who made it unmistakably approached sculp-
ture with a certain largeness of view. He ennobled
the slender, fragile form. Portraying it, it was as
though he had arrived at an almost Greek synthesis
of his subject. One would, indeed, call this a work
of Greek beauty if it were not even richer in the more
sensuously human quality which we associate with
the Italian Renaissance. On this occasion, if ever in
his life, the sculptor was both a master and a poet.
Here he had his one unmistakable gust of creative
genius. In the rest of his life's work he missed that
purely exquisite rapture. But in sheer strength and
dignity his art waxed the fuller, gaining in breadth
and simplicity and taking on especially the bold vir-
tues of monumental structure. There is good compo-
sition in his figures, the draperies are handled with

energy and judgment, and, above all, a statue by him has character. He knew how to be decorative, but not in any thin or merely pretty way. Vague traces of the grand style creep into his conceptions. It is sorrowful to think that Augustus Saint-Gaudens could not have seen the statues for Washington. He would have been the first to acclaim their merits, always eager as he was to acknowledge his brother's power and to crave for him the rank that he deserved. Some day the balance will be redressed.

## IV

## ANDREW O'CONNOR

In any exhibition of sculpture the thing above all others for which one instinctively looks is good technic. Without it the most carefully pondered conceptions in bronze or marble are only pathetic monuments of misspent labor. Mediocrity sometimes puts on an amazingly specious air in painting and almost succeeds in evading detection. It cannot disguise itself in plastic art. There you must know your trade or perish. There technical proficiency is veritably as the breath of life. Yet there is no other art in which mere adroitness is so soon found out or so barren of charm, and hence the searcher after technic in sculpture is also inevitably a searcher after character, after the personal quality which forms, so to say, the very

grain and texture of technic. That is the type that you find in Andrew O'Connor, one of the youngest and one of the most brilliant members of the American school.

The value of his work lies peculiarly in the fact that it always has something to say to us, is never an arid exercise in manual dexterity. One reason for this, if we may judge from the sculptures that he has shown to the public, must be ascribed to a kind of precocity. In his youth he made, I dare say, the usual uncertain experiments, but I have never seen, in his studio or out of it, anything of his that savored of immaturity. From the start he would seem to have possessed unusual skill, and this, I think, has encouraged him to let himself go, using his brains as well as his fingers. Trained in Mr. French's studio he was bound to be subjected to a wise and fruitful discipline, but though that distinguished sculptor must have taught him much, it seems to me probable that if he was the young man's instructor he was even more his guide. Once a young sculptor like O'Connor has been well grounded in the rudiments, all he needs is to be set in the right path. He was fortunate in the opportunity which first brought him into notice, the decorative scheme worked out at St. Bartholomew's Church in New York. Stanford White and Mr. French were the chief collaborators in this design, which was to make an ecclesiastical portal in America comparable to some of those noble works in architecture and sculpture which enrich

European cathedrals, and when O'Connor was called in to do his share he did it under the steadying influence of one large and majestic idea. How well he acquitted himself may be inferred from an anecdote. When Saint-Gaudens saw O'Connor's work he hunted up his junior's name and address and straightway called upon him with words of the warmest appreciation.

These reliefs of his have a triple virtue. In the first place, they are part and parcel of the architecture with which they are associated. Secondly, they abound in fine and characterful modelling. Lastly, they are full of life and movement. This final merit is, perhaps, the one which makes the most immediate appeal. Even the casual passer-by must be arrested by the scenes from the Old and New Testaments in which the sculptor has contrived to give all of his figures, human and celestial, ebullient individuality. One pauses full of curiosity to pick out the meaning of this or that figure, just as one pauses to trace the symbolism carved by some Gothic craftsman centuries ago above the door of a French church. And yet, as I have already indicated, one comes back to the technic, the style, and rejoices in a triumph of pure sculpture. There is no formalism here, and yet there is perfect harmony. There is vivid movement, and yet there is no violation of convention. Here you see simply the natural sculptor using his mother tongue. Form is his language, and he expresses himself easily,

spontaneously, and with a true sense of measure. His reliefs are, indeed, just variations on the beauty of form, designs in which bodies and limbs are exquisitely caressed and developed into a rich arrangement of line and contour, throughout which the play of light and shade gives the last touch of artistic magic. It is workmanlike to the last degree, consummately right, and it is, into the bargain, wonderfully original. One can imagine how White and French must have been delighted, recognizing in O'Connor a true constructive genius. He worked with them in complete understanding, and at the same time gave to his reliefs his own stamp.

It is by his essentially creative power that one is most subtly attracted. Rarely does an artist emerge from his pupilage with so clearly defined a style and one so free from borrowed influences. There is nothing in his work to recall his master, nor is there anything to suggest that he was affected by the example of Saint-Gaudens. I have wondered sometimes what particularly he may have gathered from the experience which he had for a while in the studio of John Sargent. If that painter colored his ideas at all, the fact is not clearly visible in any of his sculptures. Nor does Paris appear to have left any mark upon him. One might say that he was at least in sympathy with the art of Rodin, but he has unmistakably escaped the current temptation to adopt the mannerisms of the French sculptor. I well remember a talk with the

late Paul Leroi, the veteran critic, at the time that O'Connor was showing his "General Lawton" at the Salon. He told me that the statue detached itself from its surroundings like the work of a genius midst a wilderness of commonplace things mechanically produced by journeymen. He spoke of the beautiful sincerity of the piece and especially of its original force, and not only from Leroi but from other sources I heard of the profound impression which O'Connor had made in a city where modern sculpture has had its culmination. Perhaps it is worth while to mention at this point that in spite of his prodigious success in Paris, where he has labored now for some years, he has remained the same quiet and modest student that he was at the outset of his career. He is, by the same token, an artist with a conscience. I have known him to reject an important commission because the architect who sought his aid wanted him to adjust his style to that of a certain period; in short, to make his technic the vehicle for a kind of sublime hack work. O'Connor was not so modest that he could thus suppress himself.

To return to the "General Lawton," it is interesting to observe that O'Connor is very much the "all-round" sculptor, attacking with the same confidence problems of portraiture, imaginative sculpture, and decoration. Moreover, he can combine all these resources of his, as was shown by his model for the Barry monument. The figure of Barry is kindred to

that of the "General Lawton" in its virile simplicity,
its unforced picturesqueness, and the rest of the monu-
ment, both in its architectural and sculptural aspects,
had in the model a very fresh and interesting charac-
ter, besides being full of dignity.  It is, I may add,
upon just such heroic undertakings that O'Connor is
destined to wreak himself in the years to come, for he
has the instincts of the true monumental sculptor,
and abilities like his are too exceptional to be neglected
by the civic and other bodies that are responsible for
large enterprises in plastic art.  But it is to be hoped
that he may be never so closely occupied upon designs
of the sort as to neglect those more intimate qualities
which come out in a figure of his like the "Inspiration,"
in a group like the "Crucifixion," and in his portrait
of the old painter R. L. Newman, and his several other
busts.  Especially do his studies of feminine types,
through their delicacy and their poignant human in-
terest, inspire the wish that he may always find plenty
of time and energy for very personal sculptures on a
small scale.

In them, as in some of the individual figures of his
St. Bartholomew reliefs, you are aware of the sensi-
tiveness that belongs to this exemplar of masculine
power.  He is not precisely a dreamer or a poet, illus-
trating romantic themes.  The truth is that a note of
sternness, or at least of a certain gravity, runs through
nearly everything that he does.  But just as he avoids
the cloying grace which the cult of Rodin has made

unduly popular, so he avoids the rude and even un-
couth weightiness which has been mistaken for a
nobler trait by the ill-advised imitators of Meunier.
It is the golden mean that is his ideal. Following it
he is not vaguely adventurous where subject is con-
cerned, but neither is he afraid of the motive which
demands imagination in the sculptor. His religious
compositions offer splendid proof of his ability to move
with sureness on a high plane and further evidence of
his spiritual grasp may be discerned in the "Inspira-
tion," or the helmeted figure modelled for the Liscum
monument. That he can be positively daring, too, is
obvious from the cyclopean funerary monument, sur-
mounted by a gigantic owl, which remains unexecuted,
but ought some day to be set like a pharos on the bor-
ders of the Hudson or some other stately stream. One
thinks of the future as well as of the present in think-
ing of Andrew O'Connor. He is the kind of artist
that grows. Considering what he has already done,
it is natural to look with eagerness and with confidence
for the fruits of his coming years.

# V

## PAUL MANSHIP

If it is a sign of something vitalized in the work of
an artist that he "gives us furiously to think," then
Paul Manship is a figure of some significance in Ameri-
can sculpture. From the time when he left the Acad-

emy in Rome and came back to this country, bringing his sheaves with him, he has not exhibited a single bronze which has failed to invite serious reflection; and this provocative quality of his art has been the more interesting because it has excited admiration and doubt in pretty nearly equal measure. My first impression, received on the occasion of his public début, was decidedly mixed. His brilliance was obvious. So was a certain want of original force. Later it appeared that Manship's archaic traits and his preciosity were not so much factitiously cultivated mannerisms as the sincere expression of a natural taste, and it was credible that if he succeeded in monumental sculpture as in his figurines he would prove a great artist. Still later an occasional piece by him revived the original dubieties; one questioned the value of a *tour de force* as an indication of well-grounded powers. All the time there was a certain comfort in the mere fact that he raised these questions. There is something terribly depressing about the artist who finds his humdrum level at the outset, sticks to it through thick and thin, and produces year after year the perfectly respectable but perfectly dull work which is more deplorable, perhaps, than work immitigably bad. Manship has a style in the making, and when that is rooted in genuine gifts the spectacle presented to the observer is one of the most exciting I know.

How beautiful his sculptures are! To recognize the fact is possibly to pay Manship the best of all

tributes. Matters of detail come after; the process of distinguishing between an invention and a derivation waits upon the beholder's enjoyment of something akin to genius. With what lesser epithet are we to appraise a gift so rich and so strong? We know that the creative freshness which belongs to genius, which is its hall-mark, is not visible amongst his sculptures. But we do not think of it as irrevocably absent; it occurs to us, rather, as a thing latent, elusive, exerting an influence even while it fails unmistakably to manifest itself. Hovering in the background, too, is the consciousness of all this achievement as an achievement of youth. Why in the world should not Manship do almost anything as time goes on? To know beauty as he knows it is to have won half the battle, and with such a technic as he has at the tips of his fingers the victory seems secure. It is a complex order of beauty that his art embodies. To say that it embraces grace of form, that in this matter of form he depends more upon purity of line than upon subtlety of surface, that he has the ingenuity of a Renaissance goldsmith in the application of ornament, that his designs have a bewitchingly decorative quality, and that the whole fabric of his work is animated by a positively realistic feeling for nature, for movement — to say all this is decidedly to say a good deal.

And yet it leaves the full tale untold. For the rounding out of that we have to turn to an element not plastic, specifically, but broadly personal; we turn

to a state of mind. If Manship was not so clearly possessed of an instinct for his craft, I should be inclined to describe him as a kind of literary man in art, a master of all the cultures, an eclectic to whom the schools have given precisely the sort of inspiration commended by Stevenson to his "sedulous ape." Just as an Austin Dobson, say, can take the measure of Pope and do with it what he will, so can Manship seize the idiom of another age and fairly abash us by his use of it. Consider, for example, his "Sun Dial," one of his most charming things, and, by the same token, one of those which most frankly confess their exotic derivation. Its prototypes are easily discoverable in Indian art. Mr. Havell's book on that subject illustrates a Nepalese Bodhisattva, a copper-gilt statuette in the art gallery at Calcutta, which will take us very close to the source of Manship's inspiration. In that the immobile god sits cross-legged on his pedestal, his head enhaloed and his whole figure surrounded by a wreath conventionalizing the sacred bo-tree. Manship's watcher of the passage of time is a semi-nude woman, her body is set in a quite different composition, she wears a different nimbus, and in place of the wreath aforesaid there is a wheel-like pattern of dancers, in low relief. In the base the beaded and foliated decoration of the Indian piece gives way to the signs of the zodiac, unrolled beneath the simplest mouldings. Mr. Havell describes his Oriental god as holding in one hand the *amrita*, or nectar of

immortality. The uplifted hand of the woman of Manship's sun-dial is similarly provided with an emblem, in her case a flower. She, too, with downcast eyes, broods over her endless vigil. Now I find it impossible to think of the one sculpture existing in the absence of the other; yet I delight in the later work, it is so lovely in itself — and it is executed with such superb skill.

To Manship's skill and to his taste I am always coming back. Let us accept once for all his intense sophistication, his *flair* for things Greek, things Egyptian, things Roman, things Renaissance, and with it his way of making us feel that we are not in the workshop of a modern artist, but in some European museum of old bronzes. It is, at all events, an enchanting museum. What he does there he does, as a rule, superlatively well. It would be hard to beat the decorative felicity of his terra-cotta flower-boxes. How justly he places the animals that adorn the front of one of them! How perfectly are the rims and bases embellished! The wonderful little relief portrait of the artist's daughter is almost too consummate. A sculptor of the golden age in Florence would have left it with a softer bloom, a finer simplicity. But both in the marble and in the frame Manship gets about as near to the art of that period as it would seem humanly possible for a modern man to get. One recalls Bastianini and his marvellous revival of the Renaissance spirit, which "took in" the *cognoscenti*.

Manship does not take us in.  He does not try to.
He simply turns Italian — and justifies himself.  He
is equally persuasive in all his smaller pieces, save the
medals, which are a little "tight," a little too crisp,
and suggest on the whole that he is really not sympa-
thetic to the form.  His work on a large scale is simi-
larly disappointing.  The scale is large, but not the
manner.  A group like the "Dancer and Gazelles"
misses the true monumental accent and feeling; it
gives one momentarily an uncomfortable sense of a
statuette magnified.  The "Infant Hercules," when I
first saw it, left an impression of being overdecorated,
overwrought, and this view of the matter was only
confirmed when I saw it again months later.  The
"God of Hunting," an Indian figure casually attrac-
tive in its rich lapis-lazuli tone, ends by asserting itself
through bigness without grandeur.

Not yet has Manship mastered the secret of heroic
sculpture, and as we wonder why, seeing that these
very statues, so wanting in authority, are yet so ac-
complished, so interesting, we are thrown back upon
the general tendency of his work and begin to discern
a clew.  Is it not possible that this gifted sculptor,
paradoxically, does not see his subjects sculpturally,
does not grasp the masses in form as a sculptor grasps
them?  The distinction, if on the surface somewhat
arbitrary, is at bottom defensible.  All the great mod-
ellers — Donatello, Michael Angelo, to say nothing of
the Greeks — have had a way of making you feel the

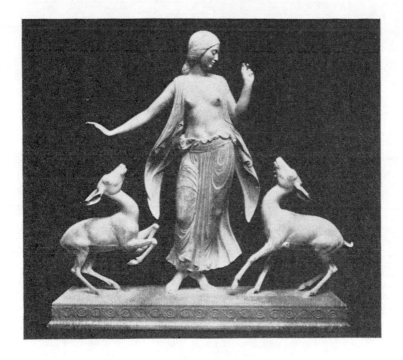

DANCER AND GAZELLES

BY PAUL MANSHIP

depth and solidity of form; the contour has but followed the mass. Manship is too willing to stop at the contour, to seek the sharp, pictorially expressive outline. His figures, his draperies, his animals, invariably strike one, in the first place, as being *drawn* instead of modelled. Every work of sculpture in the round might be said to lure the eye to its edges, but the light slips around them like water, and the eye by some magical process goes with it. In Manship the silhouette is triumphant. I refer the bronzes to life because I cannot help myself, their vitality is so authentic, but I refer them also to the painting on Greek vases, to an ideal of art in which the linear motive was like the corner-stone of a building.

In comments like these I may seem to be travelling a portentous distance away from the gusto with which I hailed Mr. Manship's heaped-up offering of sheer beauty; but the reader must surely have perceived that there is in them no disparagement. This artist must pay the penalty of his preoccupation with what other men have done before him. No man can traffic as he has trafficked in the historic styles and expect criticism to ignore his artistic origins. Indeed, work as eclectic, as *raffiné*, as his brings such questions as I have traversed immediately into the foreground, where they threaten to obscure indubitable merits. They can be dealt with the more freely because those merits, as I have shown, exert in the long run a compelling power. I look back as I leave his work, across so

many hesitancies, so many queries and reservations, and as I look I say once more — how beautiful these sculptures are!

# XIX
## Stanford White

# XIX

## STANFORD WHITE

I THINK of Stanford White as a bright flame, a guiding light to his fellows in the arts, a flame at which those who were his friends warmed their hands and their hearts. He has more than one memorial. In 1921 a number of artists and others mindful of his genius dedicated a pair of bronze doors to his name at New York University. The models for the panels were contributed by sculptors who had collaborated with him. The design as a whole was prepared by White's son. Lawrence White has also collected in a folio the architect's "Sketches and Designs," prefixing some invaluable biographical notes. And then there are the monuments to White which exist in his buildings. I must allude to two of them as specially symbolical. They stand near to one another in Fifth Avenue, the Tiffany Building and the Gorham Building, beautiful structures, both, and the symbolical thing about them is that where they are placed, where the tide of our city life runs high, they lift up a noble standard of architecture by which every one is bound sooner or later to be touched. The best tribute that can be paid to Stanford White is recognition of the influence of his artistic standard upon New York and

upon the whole country. You have a clearer sense of what we owe to him if you recall the state of American taste in architecture when he began. We, too, have had our "mid-Victorian" era, the era of brownstone and black walnut. It lasted down into the eighties. White had an enormous share in making it over and he had it in a dual sense. In the first place he had architectural genius and erected beautiful buildings for all men to see. In the next place he was an extraordinary driving force, an extraordinary source of enthusiasm for good art. You've only half reckoned with White when you've reckoned with the designer of this or that work. You have also to reckon with the man, the personality, that stirred other artists.

He was born in New York City in 1853 and entered his profession as a young man just when the status of that profession was being made over, when American architecture stood at the parting of the ways. Certain potent seniors of his had already started our Renaissance. One of them — a master whose ministrations must ever be gratefully remembered — was Richard M. Hunt, who drew his inspiration from France and the Ecole des Beaux-Arts, and left an indelible mark upon his time. Another was H. H. Richardson, who drank deep at the springs of the Romanesque period and attracted to his atelier in Boston many of the young talents coming into view in the eighties.

White had begun with the aspirations of a painter. John La Farge told me that these aspirations were to some extent rooted in natural gifts, but that on the whole, when White came to him for advice, he felt that in architecture the young man would go farthest. The choice made, White entered Richardson's office as a draftsman, and there met McKim, who was filling the same rôle. His son points out that it was also at this time, when Richardson was working on Trinity Church, in Boston, that he formed his friendship with Saint-Gaudens. There followed in 1878 travels in Europe which are noted as having marked a turning-point in White's career. They widened his horizon, fertilized his mind, and enormously enriched his imagination. When he returned from them and formed a partnership with Charles F. McKim and William R. Mead, he was equipped to play a leading part in the reformation of American architecture, then approaching its most critical stage.

Lawrence White gives some admirable indications of the distribution of qualities among the members of the new firm. McKim was the "calm, deliberate scholar"; White was "exuberant, restless, a sky-rocket of vitality"; Mead, with a genius for planning, was also the indispensable balance-wheel. "There is a story in which Mead is quoted as saying that it took all his time to keep his partners from 'making damn fools of themselves'; and Saint-Gaudens once drew an amusing caricature of Mead struggling to fly two kites,

labelled White and McKim, which were pulling in different directions." The matter of direction was all-important in that crisis.

I have spoken of the reformation of American architecture. To think of Stanford White at this point is to think of something which might perhaps be called the reformation of American taste. Architecturally speaking, we swerved in the eighties a little from Hunt's Ecole ideas and even more from Richardson's Romanesque. It was a swerving that went on most significantly "behind the curtain," if I may so express it; that is to say, professionally, among the younger architects who were to determine the evolution of a style in the United States for at least a generation. I can vividly remember, for I was a youth in the midst of it, the ardor with which men of talent in the formative period enlisted under the banner of White and his partners. To come to it from Richardson's office was literally like going from one camp to another. Those were exciting days. Architecture was the only art on earth and its sanctuary was at 57 Broadway, corner of Tin Pot Alley, where the new and soon powerful partnership held sway. I cannot forbear an allusion in passing to one or two other personalities then counting heavily. Just across the way George Fletcher Babb was doing fine things of lasting value, and in White's own office there was a man whose name should never be forgotten in any chronicle of our architectural renaissance, Joseph M. Wells. Wells was as

authentically a man of genius as Richardson or Mc-
Kim or White.  He was both creator and critic, by
White's side, the helpful colleague as well as the be-
loved friend.

And, I may add, it is on this note of friendship that
we may appropriately turn to that larger aspect of
White's career which I have indicated.  Possibly the
best thing that could be said of him is this: that he
was the friend of every sound current flowing into the
broad stream of American art and taste, the comrade
of the best men we had in the arts, and hence a source
of energy for artistic betterment.  We hear of him
specifically in his son's pages as collaborating with
Saint-Gaudens, for example; as designing covers for
books and magazines, or picture-frames, or in some
other way manifesting his versatility.  This is perti-
nent, but it is even more important to dwell upon
White's range as promoting the solidarity of good
taste.  Good taste prevails through the efforts of the
men at the top, and the men at the top flocked around
Stanford White.  Who were they?  In architecture
rather than naming names I would choose the juster
process of citing almost *en masse* the leading spirits all
over the country, who will confess that if they have
been designing creditable buildings it is because they
worked for a time with McKim, Mead & White, or,
as observers, profited by a great example.  In paint-
ing, White's intimates were such men as La Farge, Sar-
gent, Thayer, Dewing, Bunce, and Weir.  He knew,

in fact, all of our most accomplished painters, and they were his friends.

The last word needs to be emphasized, for it bears upon the creation of an atmosphere, the stimulation of those mysterious forces which do far more than any formal teaching to make a school of art.   White's influence counted because he erected beautiful buildings.   It counted still more because he diffused the joy that belongs to the making of all beautiful things.   Nothing was alien to his genius.   Besides his picture-frames and covers he designed tombstones and stained-glass windows.   There is a clock and there are articles of jewelry from his hand.   In the matter of house decoration his influence has not been altogether steadying.   The current craze for antiquities which he did so much to foster has led many a "decorator" to give to a private drawing-room the air of a hotel lobby.   But when White started this movement there was nothing meretricious about it.   He served only a cult for beauty.   In one of the letters quoted by his son he goes into ecstasies over the famous wax bust at Lille.   In another he refers with admiration to the descriptive magnificence in the Book of Job. That is very like him.   I had a memorable talk with him once about the cornice of the Tiffany Building, one of the most severely beautiful things he ever did, but presently we branched away from that to his cornice on the Gorham Building, his success in a totally different vein, and before we got through White was

going into dithyrambs over the old farm buildings of
France, rising to a climax with the famous Manoir
d'Ango.

He could be classical when he chose, as classical as
McKim; but I think he was a romanticist at heart, a
sworn devotee of the picturesque. The trait comes
out even in so careful a drawing as his sketch of the
cathedral tower at Coutances, and it lies more obvi-
ously on the surface of the bulk of his drawings from
French churches and chateaux. There is a rich, en-
dearing personality that seems positively to vibrate
through all of White's work. His was a warm, gen-
erous spirit. I have indicated the manner in which
other loyal workers in the arts gathered around him.
It was because they responded to his ideas and to the
everlasting boyish, lovable comradeship in which he
excelled.

# XX

## The American Academy in Rome

# XX

# THE AMERICAN ACADEMY IN ROME

IN a brief reminiscence, I think I can give a clew to the secret of the American Academy in Rome. That institution sprang from the genius of a great architect, Charles F. McKim. He invented the Academy; he fostered it. It is his legacy to American art — added to the magnificent series of buildings he left us. The little anecdote I have to tell relates to McKim. More than thirty years ago, several years before the Academy was launched, I made my first visit to Rome. I had been, in my youth, in McKim's office. In Rome I met my friend William M. Kendall, who is a McKim man to this day, a partner in the old firm. Well, while we were forgathering, we heard that McKim was coming down to Rome and we planned to take charge of him for a day at least. We did so, and one of the particular things we managed was to take him to the Villa Doria Pamphili, with which we were both in love. It was a miraculous day in spring. The sky was never more perfect. The trees and turf and shrubs and flowers were all in a blissful state. Presently we were standing about near the big grottoed fountain. A great white peacock stepped on the parapet above it and spread wide his tail. We seemed in

the presence of some lovely picture, which grew love-
lier even as you watched. McKim sat him down on
the edge of the fountain, looked about, and fell into a
revery. He came out of it in a moment and, turning
to me, he murmured: "How beautiful it all is; how
beautiful it all is." It was out of that emotion, I ven-
ture to assert, that he developed the idea of the Ameri-
can Academy. It set him to thinking of what young
artists from America might perhaps accomplish if
they, in their turn, could be initiated into the beauty
of Rome.

You have to hold fast to that matter of beauty if
you want to understand what McKim was driving at
when he planned the Academy. He was, no doubt, a
practical man, as an architect is bound to be, and I
can recall how on that very visit of his he was careful
to obtain tangible records of things that interested
him. He had one of his young draftsmen with him.
When McKim saw a cornice, or a window, or a portal,
that he wanted to remember, it was the draftsman's
duty to make a drawing of it, and to take measure-
ments giving the drawing a value higher than that of
a photograph. McKim had an eye for facts. But
above all things he had an eye for beauty, for elements
in the great spectacle of Rome which you cannot mea-
sure, which you cannot draw or photograph, which
you can only feel. It was to bring those elements
within the range of an educational scheme that he
invented the Academy. It was that divine, impon-

derable force which we call "inspiration" that he had
in view, the inspiration we needed then, that we need
now, and that for the purposes of the artist you can
find nowhere as you can find it in Rome. Technical
training we can get here at home or we can get it at
the Ecole des Beaux-Arts in Paris — and let me re-
mark, in passing, that McKim was always a friend to
the educational advantages of Paris, which he had
himself enjoyed. But he realized that neither at home
nor at Paris could the young artist obtain from the
atmosphere enveloping him the lessons in taste, in
judgment, in scale and proportion, which are so potent
in Rome.

There is a droll story about Dan Burnham which is
apposite. He was an expert where the skyscraper was
concerned. Some one took him to look at a new
building of the sort. "Well," said Burnham, "it
makes me think of a wrestling-match. It is Greek in
the first stage, Græco-Roman in the second, and catch-
as-catch-can the rest of the way up." Haven't we all
seen buildings in the United States to which that anec-
dote applies? One of McKim's purposes in founding
the Academy was to lessen, if possible, the number
of such violations of the architectural decencies. He
saw that if there is one thing more than another which
we need it is some influence restraining our designers,
helping them to better ideas of balance, of good taste.
Our opportunities are prodigious. With our immense
area and population, with our civic pride, we are con-

stantly engaged in the erection of public buildings. The country is full of state capitols, city halls, school-houses, theatres, skyscrapers, huge apartment-houses, railroad-stations, all the bulkier types of buildings. To keep them sane and to see that they at least make some approach to beauty is one of our first responsibilities. The schools of architecture and design in the world do a little to teach us how. But the example of Rome teaches us more.

That is why McKim wanted the Academy to be created. That is why he wanted the young American artist to go there, the young architect, the young sculptor, the young painter. He didn't want these youths to go to Rome to study the rudiments of their professions. On the contrary, he wanted them to go with the rudiments at the tips of their fingers. The Academy is a place for picked men, men who know their crafts. What the Academy confers upon them is the opportunity to live in contact with masterpieces and so to fertilize their imaginations. The painter will not derive benefit from sitting at the feet of Michael Angelo, say, alone. He will gain something as precious when he sits beneath Tasso's oak on the Janiculum and looks out upon the great sea of tiled roofs spread before him, the myriad towers and domes, all saturated in some indefinable air which you can only identify as the air of beauty.

John La Farge once told me that study of the old masters was invaluable to him because, while their

styles differed, they initiated him into the golden vir-
tue of "style" which they all had in common. Rome
does that for the artist. He observes there the most
diverse types, but every one of them brings home to
him the magic of style. If he is himself weak and
imitative, he will fall into the pit of merely copying
what he sees around him. But it is the picked man
for whom the Academy functions. True talent will
not be blanketed by Rome. Consider for a moment
some of the artists who have flourished in the Roman
atmosphere. Mariano Fortuny was one of them, a
painter whose art was absolutely antithetical to the
art of the Sistine Chapel. But he drew a rich stimu-
lus from his Roman environment. Glance at the his-
tory of music. Could you think of "Carmen" as
touched by the genius of Rome? Not for a moment.
But some of the most important days of Bizet's life
were spent at the Villa Medici. "Everything here is
so beautiful," he says in one of his Roman letters.
Berlioz was absolutely unhappy as a winner of the
Prix de Rome. There are passages in his correspon-
dence and memoirs which incline me to think that he
had flashes of actual hatred for the city. Nevertheless,
it was in his Roman period that he got the inspiration
for perhaps the finest thing he ever wrote, the "Har-
old in Italy." There is one other historic denizen of
Rome to whom I must allude, Gibbon. In a famous
passage he says: "It was in the gloom of evening, as I
sat musing on the Capitol, while the barefooted friars

were chanting their litanies in the temple of Jupiter, that I conceived the first thought of my history." Can't you see that marvellous little snub-nosed man of genius, so dapper, so precise, so intensely "eighteenth-century," lifted out of himself, exalted, made one with the beauty around him? The sublime glamour of Rome penetrates to his imagination, sets it aflame, and he writes his sublime book.

It is to exert some such influence as that that the American Academy in Rome exists. Technically we are extraordinarily advanced. We have caught up with and even outstripped the English and French schools in the purely technical aspects of art. We paint, we model, with amazing skill and aplomb. This fact is visible in almost any large miscellaneous exhibition of American painting and sculpture. But some things are still missing. Distinction in design is one of them. How much originality, how much inventiveness, goes with our vaunted manual dexterity? And even more solicitously may we ask, how many fine things are being expressed through our excellent technic? Very few, I fear. Rome shows you the path, at any rate, to fine thinking.

It does so, some commentators will tell you, in ways that have crystallized into conventions. I cannot agree with that. It is only, I repeat, the weakling, who can get nothing from Raphael or Bramante but an impulse to copy them. Your picked man, your man of genuine gifts, and he is the only man who

ought to go to Rome, will simply be led by the masters of Rome to a new sense of law and order, to a new sense of grandeur, of line and mass, of discreet detail, and, especially, of style and beauty. He may for a little while feel overpowered by the might of the heroes of the past. But he will soon begin to feel his own wings and to beat them in an atmosphere which gives them a peculiar lifting power. One thing, too, I cannot forbear mentioning. The artist who goes to Rome may take some littlenesses with him, but once there they will fall from him. You cannot be common or vulgar in Rome. It is unthinkable. You acquire there — if it is born in you to acquire such things — a broader horizon, a nobler outlook, a higher ambition. When you go to Rome one of the first things you discover is that you know very little about art and that that little is wrong. When you come away you have learned a great deal that is right. And what you do is not unlikely to be a little nearer right than if you had not had your Roman experience. Observe certain men who have returned in their time from the American Academy in Rome. Think of John Russell Pope, who built the superb Scottish Rite Temple in Washington. Did not his Roman studies help him to make that a masterpiece? Look at the decorations which Ezra Winter painted for the Cunard Building in New York. Would they have been so beautiful if he had never seen the Borgia apartments in the Vatican? Would Paul Manship have produced so many

beautiful sculptures if he had never been in Rome?
I doubt it.

I count myself an old Academy man, although I
have never been enrolled amongst its members. I do
so because I have been from the beginning, from a
date earlier even than its foundation, a passionate be-
liever in the gospel of beauty for which it stands.
Long ago, in ignorance of the fact that McKim was
brooding over his scheme, I had dreams of it myself
and went about in Rome seeking light on the subject.
I went to talk with the directors of the French, Span-
ish, and German academies. They all told me the
same thing. Artists didn't need to come to Rome to
learn how to paint, how to model, how to design build-
ings. There were other and better places in the world
for that. But they united in the conviction that study
in Rome was indispensable to the imagination, that it
was a divine adventure, that it brought an artist closer
to the secret of great art. They protested that Rome
never could mean a system of teaching. It meant,
they said, inspiration, beauty. That is what McKim
meant when he founded the American Academy in
Rome.

# XXI

## New York as an Art Centre

# XXI

## NEW YORK AS AN ART CENTRE

"Listen," said Whistler. "There never was an artistic period. There never was an art-loving nation." It is a suggestive saying, but specious, and still in debate. Whether Whistler was right or not, there is one thing of which we may be sure — the artist does not function in a vacuum. Between him and his period there is some alliance, if it is only that promoted by the economic law of supply and demand. Art is, after all, a social thing. If it is unimaginable without the artist it is almost, if not quite, as unimaginable without the patron. Why, otherwise, speak of it as an element of civilization? New York is not yet, by any means, a Renaissance Florence, but the history of art in America is largely a history of its life. Art has grown here as the city has grown. To say that it has grown by the proverbial leaps and bounds is to make a very mild statement. Progress started late, but when it came there was no stopping it.

It may be dated from the Centennial Exposition at Philadelphia. Prior to that time the development of taste had been impeded by the intervention of the Civil War. In the seventies conditions improved. Painters began to throw off the dry conventions of a school which had practically lost touch with what was

constructive in the work of our eighteenth-century founders, and in finding new contacts with Europe they discovered new aptitudes in themselves. But it is not so much with the artists as with the public and the collectors that I have now to deal. The interesting thing about art in New York, in the large sense, is the rapidity with which we adjusted ourselves to progressive ideas. The years may have seemed long in which, having bought the anecdotes of the Düsseldorf school, we jumped from the frying-pan into the fire and bought the fripperies of the Salon. Comparatively speaking, as such things go in the history of a community, they were brief. Moreover, even while the Salon type of picture was in the ascendant, revivifying influences were at work. When the change first began to declare itself its prospects were in a few hands. Memory recalls only a small group of galleries serving as clearing-houses for the realignment of the schools.

The late Samuel P. Avery was the dean of the picture-dealers. He was the first among them to sense the necessity for a deeper conception of art. Without breaking altogether away from the Salon, he nevertheless plunged where the Barbizon school was concerned. "Bill" Hunt had already discovered Millet and his group and had done something to enlighten Boston on the subject. Avery saw his chance when he aided the late W. H. Vanderbilt in forming a collection and bought pictures placing it in the van. Another wise

dealer of that period was the late Daniel Cottier, who not only bought the Barbizon men but specialized in the modern Dutch school, then just coming into view, and at the same time had the prescience to help in the introduction of some of the best of our American painters, like Bunce, Ryder, and Weir. The late William Schaus was a useful pioneer. Like Avery, he trafficked in miscellaneous modern French art, but imported the painters of 1830 and was one of the first to bring over important old masters. It was Schaus, I believe, who bought Rembrandt's "Gilder" and sold it into the Havemeyer collection. Still one more eclectic was Michel Knoedler, supplying clients with pictures of the old anecdotic character that it took a generation to dislodge, but recognizing immediately the trend toward better things.

After Barbizon came Impressionism. That was in the eighties. Durand-Ruel made a memorable exhibition at the American Art Galleries, followed it in the next year with one at the old building of the Academy of Design, and presently established himself here in quarters of his own. The reception granted his spade-work was of a mixed nature. The time for Manet and Monet was hardly ripe. The few canvases he sold fetched very modest prices. But the innovations of the Impressionists made, again, comparatively rapid headway. If the figures of the auction-room could be reduced to some sort of statistical order they would eloquently tell the story. Tersely summarized, they

mark a clean-cut development. For a little while the French school of the conventional stripe seemed absolutely established. I forget for how many thousands "The Communicants" of Jules Breton was sold, but I vividly remember the sensation it made. Meissonier was in high favor. So was Bouguereau. Then the Barbizon painters and the French romanticists forged dramatically ahead, till it was a case of Eclipse first and the rest nowhere. All the time the Impressionists, too, were gaining ground, and in our own school George Inness, if not commanding the highest figures, was at all events taking a new rank among collectors. Thomas B. Clarke devoted himself to the collecting of American art and did invaluable work in placing our school on the map. He was followed in the same path by the late W. T. Evans, the late George A. Hearn and others. In the nineties it was plain from the records of the sale room that American art was coming to be regarded more and more as a stable asset. About this time, also, a new factor in American life came to play a decisive part in the world of pictures.

When the history of art collecting in America is written, some of its most important pages will touch upon the waxing of our material prosperity, the increase in luxury, and, particularly, the erection of new and more spacious homes. A large percentage of our development in the matter of painting, sculpture, antique furniture, tapestries, bibelots, and so on, is but

the reflection of our architectural growth.  It was once said of an individual that he had lots of taste and that some of it was good.  The classical colloquy denoting what was dubious in our æsthetic history not so long ago is the one between the bragging hostess in a gorgeous mansion and a guest of rather a mordant wit.  "This is our Louis Quinze room," quoth the chatelaine.  "What makes you think so?" asked her visitor.  There were plenty of errors made when we began magnificently to "furnish."  But the point to remember is that we began — and that the errors were, comparatively once more, well-nigh negligible. Europe poured a positive avalanche of riches into the American market, which is to say chiefly into New York.  It has been gaining in volume and momentum ever since.  Some idea of the demand here may be judged from the fact that at the Lawrence sale not long ago the sum of seventy thousand dollars was paid for a panel of thirteenth-century English glass.

A fashion in decoration has had a good deal to do with these accretions to the store of works of art in America.  It largely accounted for the phase of our collecting in which the court portraits of the eighteenth-century French and English schools grew conspicuous.  Period paintings entered happily into the embellishment of period rooms.  Our first adventures among the masterpieces of Rembrandt, Hals, and other artists of the Low Countries were genuine adventures.  They were succeeded, prosaically enough,

by transactions in which a Reynolds or a Nattier had a status not unlike that of an old cabinet or screen. It was not long, however, before the early schools were cultivated simply and solely for the sake of the beautiful things they had produced. One or two collectors had shown the way. John G. Johnson, in Philadelphia, had specialized in the Italian and Flemish primitives for the love of art, and he won his reward in seeing his collection of pictures take on an extraordinary beauty. Henry G. Marquand, in New York, bought with enthusiasm and wisdom. To his sagacity we owe, for example, the glorious Vermeer in the Metropolitan Museum, as well as divers other masterpieces in that institution. Then came super-collectors like Morgan, Altman, Frick, and Widener. They proved the mightiest competitors in the world's market, but not the only effective types. Archer Huntington, less sensationally, but very potently, entered the field, as the amazing group of paintings at the Hispanic Museum attests. Out in California Henry E. Huntington has gathered together a perfect galaxy of gems, his purchase of Gainsborough's "Blue Boy" making a climax to a sequence of acquisitions previously calculated to fill the director of a public museum, here or abroad, with envy. Mrs. Gardner, in Boston; Mrs. Emery, in Cincinnati; these and other names too numerous to be cited here provide an index to phenomenal progress in the fostering of good taste.

Nor is it in painting alone that American collectors

have won some of the richest prizes offered by the gradual break-up of European galleries. What we have gained in earlier sculpture may be judged from the bust of Lorenzo the Magnificent, by Pollaiuolo, in the collection of Mr. Clarence Mackay, which is among the finest masterpieces of Italian sculpture in the world. And there are others, things of Donatello, of Verrocchio, of Mino, which if they could be gathered in one room would rival any group in the public museums of Italy. We have been growing more and more appreciative of the drawing, one of the surest signs of penetrating connoisseurship. Twenty-five or thirty years ago, when I first began to write of this phase of art, it was almost never with reference to works in American collections. Little by little as time has gone on the drawing has made its way. Societies for its reproduction, established in Paris and London, obtained occasional subscribers on this side of the water. Examples of the French school were tentatively brought over by far-sighted dealers, and these souvenirs were the more successful because they fell in a peculiarly harmonious way into association with the French interiors becoming more popular. Morgan bought fine drawings. The Metropolitan Museum gave increased attention to them. More dealers perceived their value. To-day the vogue of the drawing is practically established. Its disciples may not be as great in number as those of the cult for paintings, but they form an impressive company. It

is the same with connoisseurs of mediæval sculpture.
They form a respectable group now, where for years
a Burgundian marble was a drug on the market.

All the phenomena at which I have been glancing
spell an astounding play of taste, of judgment, of gen-
uine artistic wisdom.   It would doubtless be easy for
some radical commentator to brush aside the whole
mass of artistic treasure concentrated in this country
as nothing more nor less than a symptom of Medicean
pomp and pride.   It would be easy and stupid.   The
development I have sketched has too many of the
traits of organic growth for that.   The American art
market, which has become the great art market of the
world, does not simply absorb the old masters — it
sifts them.   This is proved by the leading motives in
the years I have briefly traversed.   We began scarce
forty or fifty years ago to collect works of painting
and sculpture; we made a false start, but our connois-
seurship got its bearings and has from year to year
shown finer discrimination.   It has been accompanied
by immense commercial activity.   Looking back at
the dealers who prevailed in the eighties and nineties,
one sees only about a dozen shops, those of Knoedler,
Schaus, Avery, Cottier, Reichardt, and a few others.
To-day upper Fifth Avenue and the adjacent streets
are packed with them.   They have kept pace with
every phase of our æsthetic experience.   I have
stressed the purchase of the antique, for this has un-
questionably led in the whole affair, but in recent

years the American artist has been fetched well into
the foreground. The tremendous price paid for the
"Blue Boy" has not been the sole sensation of recent
seasons. Winslow Homer's "Eight Bells" sold for
fifty thousand dollars. Abbott Thayer's "Half-
Draped Figure" sold for forty thousand dollars. In
the multitude of exhibitions held during the winter
in New York it is the American who almost in-
variably covers the walls. He, too, as well as the
old master, has his market, and it is a rising one.

My allusion to the market is deliberate. It is the
place where, as I have indicated, artist and patron
meet. It is the place in which we may note one of
the most significant contacts between art and life.
And, noting it, one may observe the preservative in-
fluence which I emphasized at the outset of these re-
marks, the fidelity to sound principles, which is our
insurance against the subversiveness of modernism.
Consider in retrospect the period surveyed above.
Can there be any doubt of its thoroughgoing progres-
siveness? While the American school of art has been
gaining in strength have not all the conditions upon
which the artist and the collector rest been growing
in just one direction, toward better and better things?
Look at the history of the Metropolitan Museum.
Consider what our various galleries, schools, and clubs
have done in the interests of art. Consider the drift
in the auction-room and among the dealers. Has all
this tended toward good taste or bad? The question

answers itself. Moreover, when you come to look closely into the matter, you see nothing more active than "conservatism," than adherence to wholesome tradition, than belief in what is normal and sane. Modernism, of late, has broken loose upon the scene, raising a disturbance and diffusing deleterious elements through the atmosphere. But to reflect upon the events of the last half-century in New York is to feel a certain reassurance. They point to a good taste which has not failed us yet. They point also to a sterling common sense. America has a passion for learning. It will examine into any new thing. But if the facts I have touched upon show anything they show that artistically America has had a wonderful instinct for maintaining a high standard in art. We have too poor an opinion of ourselves if we fail to realize that sober truth.

# XXII

## Theodore Roosevelt and the Fine Arts

## XXII

## THEODORE ROOSEVELT AND THE
## FINE ARTS

In the summer of 1919 there was held in Avery Hall, at Columbia University, an exhibition in memory of Theodore Roosevelt. It embraced the productions of painters, sculptors, and other artists who portrayed him, but these were present primarily as personal souvenirs of the man. Certain bronzes commemorated old friendships, or their associations directed the beholder to sentiments and ideas having nothing to do with art. Only in a case containing coins and medals were there specific reminders of Roosevelt's interest in its principles. Yet the collection as a whole vividly brought back that interest, and the occasion was full of suggestion. It invited reflection on one of the most characteristic traits of a great man. Did he care for works of art? If so, how far did they occupy him and in what way? When he came to the presidency and to power was this stanch American a friend to American art?

In the appreciation of art three distinctly marked points of view are to be recognized as operative. There is, to begin with, that of the artist. It is influenced greatly by questions of technic, of method.

Its strength lies in what can only be described as a matter of professional initiation. Its weakness is determined by the temperament of the individual. If he has a liberal turn of mind his appreciation is valuable. Frequently, however, he is handicapped by an inability to transcend his individual experience. He judges a work too much in the light of his personal practice. Paintings, for example, lying outside his own school, his own habit, are more or less sealed to him. The critic, who shares the artist's passion for technical processes, has in his turn a source of strength which is also a source of weakness. He is sometimes handicapped by knowing too much. It is a good thing to be intimately acquainted with, say, all the paintings of a given master, to have studied practically every inch of the canvas covered by a Velasquez or a Vermeer. But what he has to guard against is a coldly judicial "placing" of each work in the sequence. If he gives himself too much to the fixing of early, middle, and late periods, to the differentiation of "manners" and so on, he risks the loss of a lot of artless pleasure. There is no spoil-sport like the pedant who would break in upon a conversation about a master with an example in some remote gallery which none of those present save himself has ever seen, as though knowledge of the painter were hopelessly incomplete without a glimpse of the sequestered picture. Boiling in oil is too good a quietus for that type of "specialist."

John La Farge used to chuckle over this form of "scientific" criticism. He glances at it in one of his letters to me, saying: "Our Japanese friend Okakura wrote to me once from Seville, where, as he said, he was listening to the songs of the nightingales and the cries of the gulls. He said that he had abandoned his party of commissioners sent over by the Japanese Government; all museums, he said, were the same; all curators of museums were the same; he had seen two hundred Rembrandts and two hundred more would not teach him any more about the importance of this very great master." Taste may be smothered in the accumulation of too much data. There is, of course, the possibility that taste may be starved, on the other hand, if it has too little. Hence the traditionally precarious situation of the layman, the holder of the third point of view, who is often content to let the data go and to rest in complacency upon the conviction that he "knows what he likes." Theodore Roosevelt was a layman in these matters, but he was not complacent. Therein lies the appeal that he makes to us in matters of art. He was genuinely interested in them. When he wanted light on them he did as he did in politics, sought the counsel of others, and in art as in politics he believed in just one thing — a high standard.

An eloquent testimony to this may be found in certain episodes in our coinage. Homer Saint-Gaudens, in his memoir of his father, the famous sculptor, has told how the latter came to make his gold pieces.

"The scheme for the United States coins," he says —
"the cent, the eagle, and the double eagle — originated at a dinner with President Roosevelt in the winter of 1905. There they both grew enthusiastic over the old high-relief Greek coins, until the President declared that he would have the mint stamp a modern version of such coins in spite of itself if my father would design them, adding with his customary vehemence, 'You know, Saint-Gaudens, this is my pet crime.'" Roosevelt himself has an interesting passage in his "Autobiography" on this subject, when referring to some of the achievements of his administration:

The things accomplished . . . were of immediate consequence to the economic well-being of our people. In addition certain things were done of which the economic bearing was more remote, but which bore directly upon our welfare, because they add to the beauty of living and therefore to the joy of life. Securing a great artist, Saint-Gaudens, to give us the most beautiful coinage since the decay of Hellenistic Greece, was one such act. In this case I had power myself to direct the Mint to employ Saint-Gaudens. The first, and most beautiful, of his coins were issued in thousands before Congress assembled or could intervene; and a great and permanent improvement was made in the beauty of the coinage. In the same way, on the advice and suggestion of Frank Millet, we got some really capital medals by sculptors of the first rank. Similarly, the new buildings in Washington were erected and placed in proper relation to one another on plans provided by the best architects and landscape architects. I also appointed a fine arts council, an unpaid body of the

best architects, painters, and sculptors in the country, to advise the government as to the erection and decoration of all new buildings.

So far from there being any vainglory in this passage, it understates the case. Roosevelt might justifiably have expanded on the influence which he exerted upon the coinage. Saint-Gaudens, working in gold, marked the beginnings of a great reform. If Roosevelt had not engaged his genius and definitely placed the question of the coinage before the people we would perhaps never have had the subsequent steps in reform, the Weinman pieces in silver, Fraser's "Buffalo" nickel, and Brenner's "Lincoln" penny. The merits or defects of this or that coin in the series need not now be discussed. The important point is that to Theodore Roosevelt we owe the constructive consideration of the question as to whether we should take account of merits or defects in this field at all. He took the initiative. He saw that the element of art in the coinage was an element which "bore directly upon our welfare"; he saw that it added to "the beauty of living, and therefore to the joy of life." He believed in art as a force in our civilization and sought to enlist it as such.

The remarks in the "Autobiography" on matters of building also require extension. The Park Commission plan for the District of Columbia, which was framed to make the national capital a truly beautiful city, basing upon Major L'Enfant's historic scheme

one of positive grandeur, received wholehearted sup-
port from Roosevelt.   When Charles F. McKim died
and a meeting in his memory was held in Washington,
Mr. Root's speech included these significant words:
"Our President needed to add nothing to the many
reasons that I have for respect and affection for him;
but he did add to both of those by the steadfastness
and general appreciation with which he stood by
McKim in his strenuous efforts to prevent the park
system plan from being overslaughed and rendered
impossible by subsequent inconsistent construction."
That was Roosevelt's way with the fine arts — to
range himself "on the side of the angels," and then
to fight with all his strength for the realization of
their aims.   Save for Jefferson, we have had no other
President so clearly committed to ideals of good taste
in the sphere of public architectural design.   It was
in Roosevelt's administration that McKim remodelled
the White House.   Projects for this remodelling had
been mooted years before.   The idea was not invented
by Roosevelt.   But it was nothing less than a god-
send to the American people that when the decisive
step was taken he was there to influence its direction.
It is worth while to cite here Mr. Root's description
of the manner in which McKim executed the delicate
task:

McKim, with his reverent spirit, his self-restraint,
sought in the history of the White House and the history
of the time from which it came the spirit in which he was

to work. Time and time again he has come to me and talked about what he had found at Monticello, what he had found here and there all over the country in the way of remaining buildings that expressed the spirit of the time of Washington and of Jefferson. He sought for the foundations of the old east wing, which was destroyed, I suppose, and never rebuilt after the fire of 1814; at all events, it had long disappeared, and he put back the White House as nearly as possible as it was originally, except that he took out all the poor material and put in the best material; he took out all of the gingerbread confectioner's work that had been put in in the course of years and replaced it by simple and dignified work, and he left us the White House a perfect example of an American gentleman's home on the banks of the Potomac.

The work done at the White House was McKim's. But it is important to remember that in the doing of it he could count upon Roosevelt as upon a tower of strength, sympathizing with his high aims, giving every possible aid to their fulfilment.

There is one more artistic debt that we owe to the great President, the story of which brings out his feeling for fine things and his devotion to the public good. I refer to the gift made by Charles L. Freer to the nation. His collection has a status that is unique. When he decided that it should become the property of the people of the United States he was naturally concerned as to how its interests should be safeguarded in perpetuity, made forever secure in a museum in Washington. Nobody knows what might have happened to it if it had been left to the tender mercies of

ordinary procedure in a world too often tinctured by politics. Roosevelt settled the problem. He called in the Chief Justice of the Supreme Court, and with his aid saw to it that every last detail in the making of this princely gift was placed beyond the hazards of political chance. Freer, like McKim, could carry a great artistic enterprise to success because he was dealing with Theodore Roosevelt.

The foregoing notes are sufficient to show that as a public man Roosevelt played a well-defined and effective part in the artistic development of his time, serving devotedly as the friend of good work. Officially he was interested not in that fearsome thing, "official art," but in the art of first-class men. In his private relation to the subject it is apparent that he was sympathetic to art, but gave it no such place in his daily life as he gave to literature. It is not evident that he was ever a collector of artistic things. Such of them as were added to his life were gathered round him through the play of life itself, not because he had acquired them from the impulse of the dilettante. A good clew to the subject is offered again in the "Autobiography." Speaking of the mementos at Sagamore Hill he says:

There are various bronzes in the house: Saint-Gaudens's "Puritan," a token from my staff officers when I was Governor; Proctor's cougar, the gift of the Tennis Cabinet, who also gave us a beautiful silver bowl, which is always lovingly pronounced to rhyme with "owl," because that

was the pronunciation used at the time of the giving by the valued friend who acted as spokesman for his fellow members, and who was himself the only non-American member of the said Cabinet. There is a horseman by Macmonnies, and a big bronze vase by Kemeys, an adaptation or development of the pottery vases of the Southwestern Indians. Mixed with all these are gifts from various sources, ranging from a brazen Buddha sent me by the Dalai Lama. . . . There are things from European friends; a mosaic picture of Pope Leo XIII in his garden; a beautiful head of Abraham Lincoln, given me by the French authorities after my speech at the Sorbonne. . . . Then there are things from home friends — a Polar bear skin, from Peary; a Sioux buffalo-robe, with on it painted by some long dead Sioux artist the picture story of Custer's fight. There is a picture of a bull moose by Carl Rungius, which seems to me as spirited an animal painting as I have ever seen. In the north room there are three paintings by Marcius-Simons — "Where Light and Shadow Meet," "The Porcelain Towers," and "The Seats of the Mighty"; he is dead now and he had scant recognition while he lived, yet surely he was a great imaginative artist, a wonderful colorist, and a man with a vision more wonderful still. There is one of Lungren's pictures of the Western plains, and a picture of the Grand Canyon, and one by a Scandinavian artist, who could see the fierce picturesqueness of workaday Pittsburgh, and sketches of the White House by Sargent and by Hopkinson Smith.

The reference to Marcius-Simons is the sole indication of a *flair* for the imaginative strain in painting. The artist in question was a curious follower of Turner. Groult, the great French tapioca king, was one of his patrons, and bought many of his pictures. There is a legend that Groult, who was devoted to Turner,

first bought the place commanding the view at St. Cloud painted by the Englishman, and, years afterward, discovering Marcius-Simons, commissioned him to come down and paint the same subject.  Roosevelt delighted in the Turneresque qualities of the disciple, in his color and in his romantic fancy.  But the other things cited in the lines just quoted point to his more familiar taste, and give, indeed, the very secret of his artistic predilections.  You are aware of it in Proctor's cougar, Macmonnies' Rough Rider statuette, and Remington's bronco buster.  Looking at these pieces the observer realizes that they are precisely what one would have expected Roosevelt to care for, and turning the thought over one sees why.  They drifted naturally into his cosmos, through the agency of friendship, because they struck *his* note, the note of life, of vigor, of naturalness, of manly sincerity. Roosevelt would have been amused, probably, by any one who had termed him a connoisseur.  He was too intensely absorbed in the myriad issues of an active life to give any time to the mint and cummin of connoisseurship.  But art as part and parcel of the daily human round he grasped with discernment.  He liked it to be honest and vitalized.  He honored most in it the truth to which he paid tribute in every phase of life.  He couldn't have been an æsthete if he had tried.  But an instinct for the charm of æsthetics was in his blood.

He was lucky in his various artistic belongings.

They are the works of capable artists. Conversely, it
seems rather odd that he should not have had, on the
whole, particularly good luck with the artists who
portrayed him. Some succeeded. More failed. Sar-
gent made an admirable study of him in what I may
call his presidential aspect. Gari Melchers, who made
a full length of him, drew closer to the character of
the man. One or two others painted him to good
purpose, but their canvases are not in general very
satisfactory. Reich's two etchings of him, one drawn
during the governorship and the other much later,
are both admirable, and there is an engaging quality
about the print by Nuyttens. The best of the sculp-
tures, perhaps the best of all interpretations of Roose-
velt's special picturesqueness and power, is the bust
by James Earle Fraser. It is a superb impression,
tingling with the characteristic Rooseveltian energy.
But we get our final clew in Roosevelt's profoundly
human personality, in his strength and humor, his
courage and his resourcefulness, his devoted patriot-
ism and his homely sympathy for everything in the
life of America. Recognizing these things, one better
understands how he felt about the arts — that they
"bore directly upon our welfare," that they were not
esoteric preoccupations, the property of a narrow cir-
cle, to be cultivated aloof from the ordinary affairs of
men, but blessings valid only in so far as they minis-
tered in natural, unpretentious fashion to every-day
existence. Nothing seems more like him than his

saying that they add to "the beauty of living and therefore to the joy of life." The joy of life — that was his cue in art.

Roosevelt's favorite cartoon was one drawn by A. L. Lovey for the Chicago *Chronicle* when Roosevelt was in the White House. It depicts a type of homespun Americanism sitting before the fire with the newspaper in his hand and reading the President's message. Technically, the drawing has little to say. Of anything like style it is pathetically innocent. But it drives home a wholesome American idea, and Roosevelt, being a wise human being, knew when to dispense with technic. Once, in an artistic matter of some importance, he paid perhaps insufficient attention to purely technical elements. This was the matter of his difference with Abbott Thayer over the latter's hypothesis of protective coloration in the animal kingdom, an hypothesis which has turned out to be the corner-stone of camouflage. I went much into the subject with Thayer himself and talked about it with Roosevelt. I saw that the painter's arguments had not cleared up the knotty points between him and his critic. The reason seemed plain. The position of Roosevelt was that of the naturalist pure and simple. The position of Thayer was that of both naturalist and artist. Harmony on the technical issue might have cleared up all the confusion between them.

The tenacity of Roosevelt in this debate about protective coloration recalls the resolute independence

which was inalienable from his nature. A sentence in one of the letters of John Keats is apposite here. Speaking of his own work and of what certain critics had made of it, he says: "When I feel I am right, no external praise can give me such a glow as my own solitary reperception and ratification of what is fine." When Roosevelt identified what was fine his fidelity to it knew no conventional obstructions. If he felt it in great works of art, as in the works of a Saint-Gaudens or a McKim, he felt it also in the crudely drawn cartoon I have noted. Moral qualities exist in art as in literature. They are not deliberately injected, like some elixir poured out of a bottle. They are implicit in the grain of a work, breathed into it unconsciously by the soul of the human being who makes it. There is a moral quality in Theodore Roosevelt's relation to the fine arts. When you have pondered over his sympathy for the artistic improvement of public works, his appreciation of the works of art in his home, his response or indifference to questions of technic, you return at the end to his rich personality and think only of what is eloquent of his inner self. Look, for that, at the letters to his children, in which the droll delightful text is embellished by little pen sketches, themselves delightful and droll. There is fun in them and there is tenderness. There is character. There is the touch inseparable from everything that Roosevelt did, the touch of a strength that is also lovable. Again we recur to Keats and

one of his noble ejaculations — "I would jump down
Etna for any great public good — but I hate a mawk-
ish popularity." So in all artistic things "T. R."
sought steadfastly the public good with sincerity and
disinterestedness, remaining always himself.

# XXIII

## The Freer Gallery

XXIII

The Freer Gallery

# XXIII

## THE FREER GALLERY

A FAMILIAR figure in American life is the successful man of affairs who spends most of his energy enriching himself and then in old age is at a loss as to what to do with his leisure. In most cases he gives up the problem in despair. He goes on accumulating millions until he drops. There is a lesson for this type, and, indeed, an inspiration for all of his countrymen, in the story of the late Charles L. Freer, who gave to the nation a gallery at Washington filled with beautiful things. There are collectors and collectors. Some fulfil their purpose in the mere pride of possession. Others really love beauty and, into the bargain, early develop the idea that when they must leave the scene they will hand over their belongings to be applied to the public good. Even in this latter group Freer held a position that was unique. In his prime, having made a fortune in business, he put business behind him. At forty-six, when most millionaires are getting into their financial stride, he deliberately adopted connoisseurship as a career, fixing as his goal the establishment of an educational collection at the heart of our national life.

The opening of the museum in Washington meant more than the dedication of another public institu-

tion.  It meant the rounding out of a singular chapter in the tale of human ambitions.  Freer's retirement from prosaic work and his absorption in what was, nominally, play was, as a matter of fact, the assumption of a heavy task.  He was resolved to create what existed nowhere else — a museum of Oriental art which would illustrate with something like adequacy the development of Chinese sculpture and painting, the whole evolution of æsthetic taste in the East.  To do this he became a laborious student and a tireless traveller, crossing the Pacific again and again, hunting masterpieces with the enthusiasm characteristic of his friend Theodore Roosevelt on the trail of big game, and in the acquisition of his quarry spending money like a Medici.  Nor was this enough.  All the time he had in mind the erection of a home for his treasures which would enshrine them for the benefit of every American and European inquirer, a true fountain of knowledge and delight for posterity.  Could any piling up of money in the ordinary paths of industry or commerce yield a sensation half as thrilling as that which this devotee of beauty sought — and found?

It is the wisdom, the intense spiritual activity, and the high direction of human endeavor in Freer's splendid adventure that must touch the imagination.  He had the same creative impulse that has urged on the leaders in our constructive life, the same far-seeing sense of things that has overcome formidable natural

obstacles, built our railroads, harnessed water-power as in the superb fabric at Niagara, and, in a word, substituted civilization for the wilderness. Only he saw that the whole intricate and potential machinery without which we couldn't exist is but a mockery if it is unillumined by the light that never was on land or sea, that the comfort and convenience of the body are but the subordinates of the things of the mind.

Money, place, power, all that men call progress, faded in his view beside the elements in life that gladden men's souls. What was physical well-being if the inner vision were blurred? Mechanical appliances were fine things. Freer knew all about them. His fortune was, to some extent, derived from them. But he saw that the jade sceptre of a once mighty Oriental monarch endured after long dynasties had crumbled into dust and that the craftsman's passion for pure loveliness stayed on. With a kind of sacred ardor he brought the old masterpieces together, the jades and the sculptures, the paintings and the potteries, gloriously radiant things, the sources of endless happiness to those who love beauty as he loved it. Then he assured their arrangement in perfect order and gave them to the people. In all the history of our public benefactions there has been no nobler gesture.

Freer's experience in business was of service to him when he came to the erection of his museum. He wanted it to be good to look at, but he was equally concerned about all the practical issues involved. The

architect, Charles A. Platt, forthwith designed the building from within outward. Prevailing climatic conditions in Washington gave him an inspiring point of departure, playing into his hands. His plan developed around a central court, with an arched corridor intervening between it and the exhibition rooms. This at once did away with the frigidity so characteristic of museums. It brought into the scheme precious elements of light, air, and color. One is constantly aware of the green things in the court, the big fountain in the centre that wakes a memory of the great flat bowl on the Pincian, and the influence of a bland sky is always there. The curator, John Lodge, has added two or three peacocks to the picture. They delightfully enrich its warm, intimate character. The visitor must be aware of the court the moment he enters, and its friendliness remains near him. Externally the museum has a certain severity, as befits a monumental edifice, though the arches and pilasters of the main entrance and the balustrade running around the low roof considerably lighten the effect. A similar influence is exerted, too, by the manner in which the masonry has been treated. The surface is neither too rough nor too smooth. A heavier rustication might have caused the walls to resemble those of a fortress. As they stand they have all the weight they need, but leave the façade with the grace and charm belonging to one dedicated to the arts.

The exhibition rooms opening off the corridor

aforesaid leave an altogether satisfactory impression. One observes first the perfection of the illumination that falls from the skylights, then the excellent proportions of the galleries — never too large or too high — and then, perhaps most cheering, the absence of superfluous mouldings and other decorations. A positively ascetic simplicity rules throughout. The exhibits are the thing; there is nothing to distract attention from them. Alone in the painting rooms some delicate panelling in the frieze is just touched with gold, relieving the gray tone that covers the walls. The heating contrivance is out of sight, and the only furniture consists of a few oak settees. Such objects as must be shown in glass cases are set upon bases of walnut, not too dark. I remember how Freer studied with Platt all questions of material. He would have rejoiced, I fancy, in the floor. It is of particles of black Belgian marble, set in a brownish cement. It is comfortable to walk on and it makes one of the handsomest floors I ever saw.

If Freer would have been happy over the framework supplied for his collections he would have been equally happy over the arrangements made in the basement for the care of such objects as must take their turn in storage. The American paintings thus withheld from public view at the moment are hung on meshed screens of metal, easily pulled in and out, which give these works of art all the benefit of light and air. The Oriental material is stored in great cabinets in the study

rooms provided for research. These study rooms, already containing the nucleus of a library which will be energetically developed, are enough to fill the writing man with wistful thoughts. They invite him to luxurious convenience; again, the light is abundant and the quietude is by itself inspiring. They are down-stairs, on the administrative floor, whose windows make the only openings in the façades apart from the entrances. A lecture hall is there, with numerous other rooms. Nothing is forgotten. How Freer would have loved the artistic finish and rightness of it all!

In a leaflet Mr. Lodge gives a handful of facts and figures indicating the objects of Freer's enthusiasm as a collector. He bought Oriental paintings, potteries, sculptures in stone, wood, and bronze, lacquers, jades, and other things. (The first exhibits that meet the eye on the main staircase, by the way, are two gorgeous early Chinese velvets.) There are more than twelve hundred Chinese paintings, and from Japan come about eight hundred, including a number of screens. There are about fifteen hundred pieces of pottery from China, Japan, and Corea, the sculptures in stone and wood make a body of nearly three hundred, and there are about nine hundred bronzes. Of Eastern art there are still other illustrations, and the Western contingent would alone furnish forth a museum. This embraces an extraordinary array of the works of Whistler, including the famous "Peacock

Room," and it is made up also of large groups of paintings by Abbott Thayer, Thomas W. Dewing, and Dwight W. Tryon respectively. Then come pictures by Winslow Homer, George De Forest Brush, Childe Hassam, Willard Metcalf, Albert P. Ryder, and others. Obviously all this material could not be shown at once, even in a building of the scale of this one. Some visitors may wonder why Freer did not therefore erect a museum twice as large. The answer is simple.

When he travelled in the East and made friends with a collector there the latter would entertain him in a room to which his works of art were brought one by one. Freer learned to like that practice and to follow it himself. In that way he showed his belongings to friends who came to him in Detroit. The idea was hardly applicable in a public museum, but he did not entirely discard it. He decided that the walls at Washington should at least not ever be crowded, and Mr. Lodge adheres absolutely to this wise policy. Sooner or later all the things in the Freer collections may be seen. In the meantime students may exhaustively explore them in the rooms I have already mentioned as set aside for the purpose. What has been done is to unfold in the galleries enough to disclose every aspect of the Freer cosmos and at the same time to show every piece to advantage. A picture has space around it. It may be appreciated in and for itself. One more touch is thus given to what Freer had in mind, something like museum perfection.

He sought a certain unity, a felicitous balance between the building and its contents. And this unity went deep in his conception. Mr. Lodge says that "from the West he acquired principally American paintings by men, inheritors of European traditions, in whose work he found qualities and tendencies sympathetic with those of earlier painters in China and Japan." The alliance suggested might superficially appear to have something recondite about it. Some inquirers might be tempted to pursue the subject through all manner of speculative subtleties, seeking in Thayer, for example, traits clearly to be found in an antique Chinese painter. Whether Freer thought they were there or not, in any esoteric sense, I do not know. But I suspect that what he was driving at was not, after all, in any way mysterious. He simply looked, in the West and in the East, for artists who loved beauty and knew how to express it. It is the beauty in his collections that welds them together. Whistler knew what he was about when he identified the same magic in the art of the Elgin marbles and in that of Hokusai. That, I believe, was Freer's idea. It made him equally at home in two nominally separated worlds.

It is not unlikely that there will be in some quarters debate as to the particular thing giving the Freer gallery its status. I can imagine, for example, that the Whistlerians will regard it as a monument to their master. The disinterested observer will take another

view of the subject. He will want to know, in the
first place, what it is that is destined to attract to this
building specialists from all over Europe and the
United States, and this, he will immediately conclude,
is the museum's astounding representation of Oriental
art. No other institution anywhere else can touch it
in this respect. In some charming recollections of
Freer, which Mrs. Havemeyer contributed to *Scrib-
ner's*, she tells of his heroic persistence in the tracking
of masterpieces, his five visits to China, his resolute
competition with dealers. He bought good things —
and bad. But he was forever studying, and the bad
things were promptly discarded. When I spoke to
him once about his familiarity with his subject, he
deprecated the idea that he knew very much. He
had only scratched the surface, he said. But, as a
matter of fact, he knew a great deal and he had the
courage to back his knowledge and his *flair* for the
really fine thing. He told Mrs. Havemeyer about the
purchase of one of the greatest of his Chinese land-
scapes, a Sung masterpiece. "I had heard, when I
was in Japan," he said, "of this painting, and I was
determined, if possible, to find it. After I was once
on its scent I had to work quietly and quickly. I
knew I would have to pay a large sum for it; but
when I found the price was forty thousand dollars, do
you wonder I was staggered?" He was staggered,
but he carried the affair through.

The result of this episode, and of hundreds of others

like it, is that the Freer gallery constitutes a rare anthology of Oriental art, a place of reference which London, Paris, or Berlin might envy. There is a little amusement in thoughts of the distance he quickly travelled. We find no trace on these walls of the Japanese print which meant so much to Whistler and the Goncourts and to Freer, too, when the beauty of the East first began to make itself felt in the West. Once he had gathered impetus on his quest he drove straight at the fountainhead, and the reason why this museum is of unique value is that it saves the uninitiated a lot of weary preparation, taking him systematically along the path that he should travel. Consider for a moment the matter of jade. There is much to learn from the Bishop room at the Metropolitan Museum, but the Freer jades show you the sublime ancestry of those glittering pieces. They take you back to the Chou dynasty, some of the objects dating from more than a thousand years before the Christian era, and in the Han jades, which carry the subject nearer to our times but still leave it prodigiously antique, you see miracles of simple dignity which no modern craftsmen have ever dreamed of touching. It is the same in the other departments of Oriental art.

Everything is carefully labelled, and it is possible to follow the historical development of this subject, each phase profiting, as I have indicated, by isolation in different rooms and by a judicious hanging for which the public must be deeply indebted to Mr. Lodge.

One great hall is given to early Buddhistic figures and reliefs in stone; another is assigned to smaller images in metal, and in one case a glorious sixth-century Bodhisattva in stone is placed in a little room by itself, which it fills with its serene beauty. The paintings also are displayed with solicitude for the student, the arrangement enabling him to follow the chronological sequence and make his comparisons. There is a group of landscapes in one of the rooms having an indescribable splendor. In it you may trace Sung grandeur and Ming delicacy, and from the power of Chinese art in these studies of ground forms you may turn to a fourteenth-century floral subject, making the transition from mood to mood as well as from technic to technic, and coming in the process a little closer to the genius of the East. There lies the secret of these marvellous collections. They have a wide range. Add to the jades, the sculptures, and the bronzes the rich color of Sung pottery, the heavenly notes of blue, black, and cream, and those tones which simulate the sullen beauty of an orchid. Add the Rakka vessels, the Indian miniatures, and go on to the great hall in which the Japanese screens make a stately procession. Study out the historic relations of these things. Slowly, and with the difficulty that must always attend cultivation of an alien idiom, the remote, exotic inspiration of the Eastern artists and craftsmen makes a new harmony in the Western mind. You may glut the eye in the Freer gallery. That is

one of its joys. But the important point is that you cannot linger in these rooms without feeling that here, in a deeper sense, is to be achieved an extension of one's spiritual and intellectual experience.

Whistler has a great deal of space, beginning with the "Peacock Room." One of his pictures hangs therein, the "Princesse du Pays de la Porcelaine," the portrait of Miss Spartali, which he painted in the early sixties. From the Pennells' indispensable book we infer that it was hanging there when Leyland turned Whistler loose upon the decoration of the walls in 1876. There are thirty paintings in the first of the Whistler galleries at Washington, all studies from nature. They include the celebrated "Thames in Ice." Three or four of the most beautiful of the "Nocturnes," among them the "Valparaiso," have a wall to themselves, and besides a number of important pictures there are even more of those tiny "Notes" in which the artist surprises you by the minutely delicate precision in his statement of facts. The next room, with twenty-three paintings, is devoted to portraits and figure studies. The full-length of Leyland is here, balanced by "The Young American," and there are some kindred pieces on a smaller scale. Some of the best known of Whistler's major achievements appear in this group, like "The Music Room" and "The Balcony." Then follows a room of forty-four water-colors and pastels, not a wholly successful room, because there are too many small exhibits. The some-

what heavy framing, too, though Whistlerian, is harmful to the general effect. A narrow moulding would be more agreeable. Finally, there is a room hung with a selection from the etchings and lithographs, a few fragments, so to say, from the mass.

What impressions do the Whistlers convey? To what extent has Freer served the memory of the artist to whom he was for many years bound in close and affectionate friendship? Speculating on this subject in anticipation, I used to think that the Freer gallery would make a shrine for Whistler resembling that which exists at Madrid for Velasquez or that at Haarlem which preserves the fame of Hals. If the analogy now breaks down it is not exactly Freer's fault. At Madrid and at Haarlem you see a master at full length. At Washington there are necessarily crucial omissions. The "Mother" is in the Luxembourg. The "Miss Alexander" is in London, and I suppose "At the Piano" and the "Mrs. Huth" are there, too. The "Carlyle" is at Glasgow, the "Sarasate" at Pittsburgh, the "Yellow Buskin" at Philadelphia, and so on. No, you don't see Whistler at full length in the Freer gallery; too many of his most characteristic things are absent. It might even be said that, on the other hand, too many of his lesser things are present, too many sketches, tentative studies. This is especially the case as regards his figure work. Whistler was never a master of the nude, a fact which would of course be scouted indignantly by the Whistlerians,

for whom he was a master of everything, but a fact nevertheless. You may see it writ large across more than one of these canvases. Perhaps an example as eloquent as any is the little nude with a high-sounding title, "Purple and Gold. Phyrne the Superb. Builder of Temples." It is technically only a middling performance. But beauty is there, like some filmy veil half thrown on, and in this you have a clew to the whole Whistler exhibit. It is full of beauty and originality.

It was George Moore, I believe, who once remarked that if Whistler had been fifty pounds heavier he would have been an abler artist. The saying seems a bit impossible. What has an artist's physique to do with his painting? Nothing, no doubt, but there is a hint in Moore's epigram. What he missed in Whistler was a certain weight, a certain power and volume, the kind of sheer energy which marks many of the old masters. Just once on this occasion we feel the stirrings of something like force. It is in the "Princesse du Pays de la Porcelaine," a thorough cleaning of which has liberated some extraordinarily plangent color. The painter is here really strong, where as a rule he is content to be exquisite. I note the phenomenon, however, only in passing. It was not his rôle to be strong. To be exquisite was for him to realize his genius. Freer could not repeat the consecrating process of Madrid or Haarlem because he could not turn Whistler into a man of might —

even if the omissions to which I have alluded could
be repaired. But he could make manifest the ex-
quisiteness of Whistler, bringing out what is essential
in the artist, exposing a gift in him as distinguished
as that of either the Spaniard or the Dutchman. Let
the visitor concentrate on the "Nocturnes" and he
will realize this.

In them Whistler made his true bid for posterity.
The portraits are fine things. Let us take them for
granted. "The Music Room" draws us nearer to the
painter's secret, inasmuch as it is more original, and
in the "Nocturnes" we complete the journey. They
are unique masterpieces of creative art. They em-
body visions of nature absolutely personal and new.
In color and atmosphere they denote an observation
carried miles beyond anything that Whistler could
learn from the Courbet who influenced him for a time,
and in style they exhibit the same detachment from
all precedent and tradition. In this quality of the
artist making an entirely independent adventure and
expressing himself in consummately beautiful terms,
one of the "Nocturnes" is worth a dozen "Peacock
Rooms." The truth is that this renowned episode
from the Leyland house is charming but relatively in-
consequential. The room itself is a graceless con-
catenation of vertical lines, of old-fashioned "East-
lake" cabinetwork which no magician could conclu-
sively redeem. Whistler improved it greatly with his
blue and gold, and the dazzling peacocks facing the

"Princesse" from the opposite wall are no doubt engaging. But a good half of the significance of the "Peacock Room" lies in the anecdotic literature that has gathered around it. It reminds me of the people who think that Whistler is a great artist because he wrote "The Gentle Art of Making Enemies." As well credit him with an immortal brush because he was good to his mother. He was a great artist because he knew how to etch magnificently and because he could paint the "Nocturnes," because he could take a moment in nature and make a divinely lovely pattern of color out of it. It will be in bringing home this truth that the Freer gallery will in the long run do him the service that Freer had in mind. It will not make him the peer of Velasquez. It will not transform him into a giant. Whistler had too much weakness as a technician for that. But it presents in its fullest form that enchanting faculty at which I have glanced — the note of creative originality, of beauty exquisitely felt and interpreted, which you recognize in the "Nocturnes," "Symphonies," and "Variations," based on nature, and in the best of the water-colors.

I have touched upon the element that attracted Freer in both Eastern and Western art, the element of beauty. It is the key to the groups of paintings continuing the series begun by Whistler. Abbott Thayer was never a designer of compositions having any narrative substance. He painted the figure as

he painted the landscape, imaginatively, spiritually, extorting from it a beauty which was awakened by his own clairvoyance. "The Virgin," which is perhaps his masterpiece, rivalled only in my memory by the "Caritas" of the Boston Museum, dominates the room given to him with no religious meaning but with a supernatural glory. The maiden advancing as she leads two children by the hand may be an inhabitant of earth, but there breathes through her a spirit knowing no earthly trammels. There are landscapes on the walls, but apart from these the paintings are all variations on Thayer's chosen theme, character. It does not matter whether he is painting a portrait or is giving the figure a definitely angelic rôle — the note of sublimated character is always there. Womanhood was to him a mystical poem, which he read and reread in different keys. For Dewing, who likewise has a room of his own, woman is again the theme, but with nothing mystical about her. She is a delicate apparition, fragile, flower-like, though occasionally she asserts herself with decisive reality. "The Blue Dress" and the "Portrait of the Artist's Daughter" — the latter a superb study in blacks — are instances of Dewing's ability to give singular body and substance to his work when he chooses to do so. But as a rule the beauty in his paintings is of a diaphanous texture, exquisite as the beauty of Whistler is exquisite, refined to the last nuance, quivering with the subtle fragrance of some evanescent bloom. He, possibly more than

any of his colleagues, gains perceptibly by this demonstration which Freer made possible. We have had large memorial exhibitions of Whistler and Thayer. I have never seen so many of Dewing's pictures assembled together, covering so many periods. Particularly welcome are two large canvases dating from the nineties — "Before Sunrise" and "After Sunset" — pictures in which figures are limned against vaporous landscape. They remind us of the breadth of this remarkable painter's scope, which includes the large effects of the open air and the denser color of costume studied indoors. The matter of color will be better appreciated for the room at the Freer gallery. He seems there to turn about and about a more sumptuous opal than would always be divined from a single picture of his.

Tryon, like Dewing and Thayer, has personality, yet he is not so lucky at the Freer as are his comrades. The special savor of his landscapes is due to a poetic feeling refined into the most elusive terms, and the pictures by him which are brought together at Washington are a trifle ill at ease in their splendid isolation. He suffers somewhat as Whistler suffers from being held up as on a pedestal. An artist must have a more or less assertive, affirmative energy in him for that. He must speak with a certain self-confidence and even emphasis. Emphasis in Tryon is unthinkable. The world was a solid familiar place for him when he began to paint. I remember a moonrise of

his, "The Road to the Sea " I think it was called, which was as tangible a transcript from the visible world as it was a sensitive interpretation of a romantic hour. There is something but not much of this old concreteness in the group of landscapes at the Freer gallery. There is more than of a subjectivity which has been carried too far, so that the juices of nature seem to be threatened, if they have not actually been dried up. Besides the specially assigned rooms I have traversed there is space given to a miscellaneous number of paintings by American artists, Sargent, Homer, Brush, Melchers, and so on. They point to the fact that there was no narrowness of outlook about Freer. It is of a very broad, liberal soul that I think as I leave this beautiful building. But musing on his traits I cannot but recall with peculiar vividness his passion for Oriental art. I can see him amongst his treasures from the East. He used sometimes to send me word that he had just received a new batch of old paintings from across the Pacific, and we would go through it together. It was an unforgetable privilege. His love for those works of art was enkindling. So was the knowledge through which, in buoyant talk, he would often throw a flood of light upon the trophies of his endless search after beautiful things.

The excitement would begin before the painting was unrolled. He would dilate upon the loveliness of the picture as he unfastened its silken wrappings.

Then, with the glee of a boy, he would suspend it from the contrivance up near the cornice and stand off with a sigh of enjoyment to watch your appreciation. A question would unlock stores of analysis, based upon knowledge, and of reminiscence, too, for the picture would sometimes take his memory back to collectors and scenes in China. He loved to talk of his adventures as a collector. He did so without boastfulness, but it was plain that the recondite ground over which he had travelled knew no surer foot than his. Once he showed me a small but prodigious bowl, prodigious in that it was so radiantly beautiful. It seemed incredible that so exquisite a thing could be false. The claim originally made for it — that it belonged to an epoch of the potter's art of which only one or two other specimens existed — seemed to be made good on the face of the object. But the mere weight of the bowl had put Freer on his guard. It was too light for a piece of pottery. He pleaded for the dangerous privilege of testing it by a smart rap with a pencil. The rap settled it. He showed me how obvious it was — once you had found out — that the bowl was made of lacquer, cunningly redeemed from utter lightness of weight by an inner ballast of zinc or some such malleable material. It had been offered to him for a large sum. He bought it for a song, to be placed among the forgeries which he was careful to collect as warnings to the seeker after knowledge.

It is the seeker after knowledge for whom he chiefly

labored, but he was no pedagogue, and I remember, above all, the happy, spiritual ardor in him. I sat by his bedside a few days before he died. He showed me a Chinese landscape and a tiny prayer-stone that had once belonged to an Eastern potentate. We talked of the beauty in them, of the beauty that is all that matters in any work of art. He was very ill, but his eyes were full of light, his rapture as strong and as exultant as ever. He loved beauty all his life long. It is a cruel thought that he could not live to see in its perfection the temple of beauty that he bequeathed to his fellow men.